ERNEST W. WATSON'S
COURSE IN PENCIL SKETCHING

FOUR BOOKS IN ONE

DRAWING COURSE

Ernest W. Watson, Editor Emeritus American Artist

VNR VAN NOSTRAND REINHOLD COMPANY
NEW YORK CINCINNATI TORONTO LONDON MELBOURNE

Copyright © 1964, 1957, 1956 by Reinhold Publishing
 Corporation

Copyright © 1978 by Van Nostrand Reinhold Company
 Inc.

Library of Congress Catalog Card Number 78-19178
ISBN 0-442-29229-5 paperback
ISBN 0-442-29230-9 hardcover

Printed in the United States of America.

Published in 1978 by Van Nostrand Reinhold Company
135 West 50th Street, New York, NY 10020, U.S.A.

Van Nostrand Reinhold Company Limited
Molly Millars Lane
Wokingham, Berkshire, England RG11 2PY

Van Nostrand Reinhold
480 LaTrobe Street
Melbourne, Victoria 3000, Australia

Macmillan of Canada
Division of Gage Publishing Limited
164 Commander Boulevard
Agincourt, Ontario M1S 3C7, Canada

16 15 14 13 12 11 10 9 8

**Library of Congress Cataloging in Publication
Data**

Watson, Ernest William, 1884-1969.
 Ernest W. Watson's Course in pencil sketching.

 "Perspective for sketchers": p.
 1. Pencil drawing—Technique. I. Watson, Ernest
William, 1884-1969. Perspective for sketchers. 1978.
II. Title. III. Title: Course in pencil sketching.
NC890.W29 1978 741.2′4 78-19178

 ISBN 0-442-29230-9
 ISBN 0-442-29229-5 (pbk.)

Contents

4 *Buildings and Streets*
66 *Trees and Landscapes*
112 *Boats and Harbors*
162 *Perspective for Sketchers*

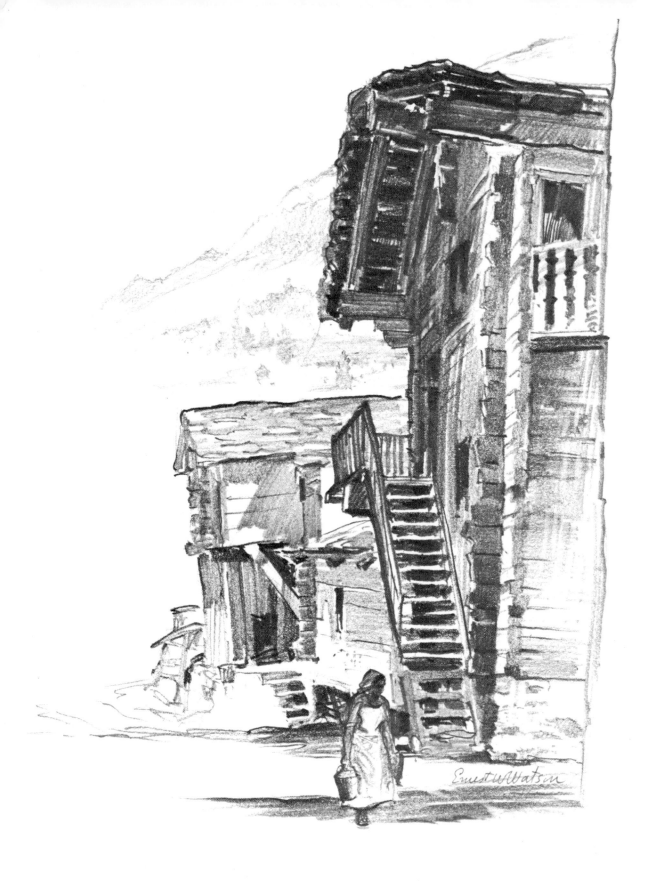

In ZERMATT
SWITZERLAND

Contents

6 Course in Pencil Sketching
9 The Pencils
11 Sharpening
11 Demonstration
12 The Paper
13 The Stump
13 Erasers
13 Size
14 A Few Pointers
16 Vertical and Horizontal Boards
21 Your Subject to Render
22 How to Render Openings
26 About Windows
28 The Roof
30 Masonry
32 Shadows
34 Composition
42 Pattern
48 Legibility
56 Ruins of a Country Fair
57 Old Mill at Lime Rock, Connecticut

COURSE IN PENCIL SKETCHING

I call this series of books a *Course* in pencil sketching because its instruction follows the same method I have employed successfully during many years of teaching pencil drawing to thousands of students in Pratt Institute, New York, and in private classes. I do not hesitate to promise that anyone who follows the course consistently and persistently will have gratifying results. The course is presented in a series of books of which this is the first.

There are many ways of handling the pencil. Each artist evolves his own characteristics in this medium as in all other mediums. So the techniques that I have developed are personal. However, the "broad-stroke" method, as it is appropriately called, is generally employed by artists who use the pencil seriously rather than as a scumbling medium for rough and casual sketches. Because it is the most practical way to teach, I use my own drawings as examples, rather than those of other artists. I know that any serious student, having learned from these demonstrations what the pencil will do, is certain to develop his own individual characteristics.

Quite naturally, we begin with directions for the proper use of the tools: pencils, papers and erasers of various kinds. Then come demonstrations, with my own pencil, of different ways of rendering the materials of which buildings are made: stone, brick, stucco, clapboard, shingles, etc.

Next follow lessons in composition, pointing out such picture-making factors as pattern, legibility, light and shade treatment, silhouette, emphasis and vignetting.

Now these demonstrations in themselves would hardly constitute a *Course*, however instructive they may be. A course of study implies assigned work for the student. After being shown *how*, he must put the teaching into practice. For this purpose I always supply students with photographs of subjects similar to those I use in demonstrating. That is exactly what I do in this printed course. Turn to page 29, for example. Here you see pencil renderings of tiled and shingled roofs. On the opposite page is a fine photograph of an old tile-roofed building which serves as a similar subject for the student's practice. The student may wish to copy the pencil drawing first. There is no harm in that, but he should certainly make several renderings from the photograph until he feels satisfied that he has "got the hang of it." It would be a good idea to vary the sizes of his drawings in order to discover whether he works better in small or in large scale.

For another example turn to pages 48, 49, 50, and 51. My sketch of an Italian fountain on page 49 gives a suggestion for rendering a similar subject shown in a photograph on page 51.

Now the main difference between studying with me, personally, and learning through this printed instruction, is in the opportunity for criticism afforded by class instruction. This difference is not as important as it might seem. The student who diligently pursues the lessons

in this text soon becomes his own critic. By comparing his own work with the pencil demonstrations, he cannot fail to discover his own mistakes and through more practice he can correct them.

Occasionally someone asks, "Is it good to work from photographs? Is it not better to draw directly from nature?"

My answer is that photographs are perfect for purposes of study, provided they are excellent photographs carefully chosen to illustrate an assignment. Photographs offer a wide range of challenging subject matter that otherwise would be out of reach of the student. It is our good fortune in this course to have for student practice a wealth of superb photographs taken by Samuel Chamberlain, internationally known artist, who before he touched a camera had become recognized as a leading pencil and pen illustrator and a famous etcher. Later he adopted the camera as yet another tool, and he has taken thousands of photographs at home and abroad to illustrate articles and books written by himself and others. So it is not surprising that Mr. Chamberlain's photographs have been created with esthetic discrimination. By means of these choice pictures the student is taken to places carefully selected for his "sketching trips."

In sketching from a photograph the student does not "copy" the picture; he uses it creatively, as he would if he were drawing from the objects or scene itself. From my long experience of teaching, I highly recommend drawing from photographs as a *study method;*

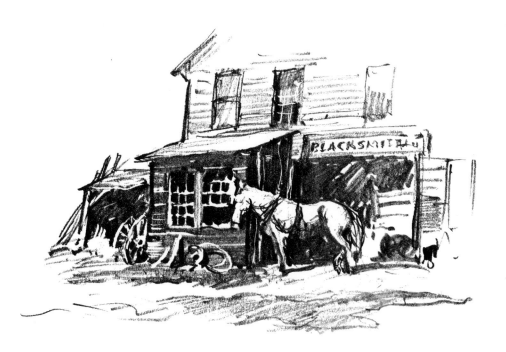

though it goes without saying, the student will want to draw from nature as much as possible.

One of the first things the student should learn is that the whole purpose of sketching is to make an interesting drawing, rather than a strictly realistic representation. So he takes great liberties with the subject. Areas that are dark in the subject may be left white; the logic of light and shadow can be violated with impunity; the entire scenery can be shifted at will.

I realize that not all students will have the same purpose in taking this course. Perhaps the ambition of the majority will be to learn the art of sketching for general illustration rather than for a specific application, such as architectural rendering. But many readers are likely to be architectural students eager to acquire skill in making renderings of buildings. The problems of the architectural renderer are different from those of the illustrator. The renderer is given the task of depicting with great accuracy the details, as well as the over-all effect of buildings in the planning stage. He has the problem of constructing his drawings from blueprints—an undertaking which involves full knowledge of mechanical procedures.

Architectural rendering is a highly specialized field outside the province of this book. But the renderer none the less must learn how to use his pencils. He also needs a free and nonmechanical training that will give his renderings sparkle and vitality. So I believe that the exercises here presented, are as useful for him as for the illustrative sketcher who will work outside the restraints of professional architectural delineation. I can say this with assurance, because the majority of students who in the past have come to my pencil classes have been architects and architectural students who felt the need in their professional practice for just this kind of instruction in free sketching.

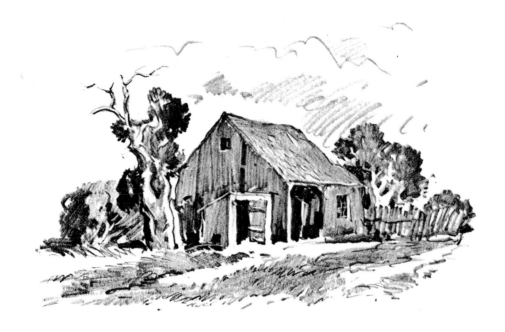

THE PENCILS

There are graphite pencils, the kind you are most familiar with, and Wolff's carbon pencils. Each type has its own devotees. I have always used, and continue to prefer, the graphite pencil. In my opinion it is more flexible and more fluent. However, students may wish to experiment with both and make their own decisions. The instruction given here applies equally to both kinds of pencils.

Pencil leads are made in many degrees of hardness and softness. The H pencils are in the hard range; the B pencils in the soft range. The entire range is from 9H to 7B. The hardest grades are for architects and engineers; they are not suited to our study. The sketching student ought to be supplied with, say, nine of the softer grades, beginning with 2H.

Do not be discouraged by all these pencils. Seldom will you need more than three in any one sketch; often one will suffice. It will depend upon the paper. But you need all of them to suit varying conditions of paper, character of subject, and atmosphere. In damp weather the paper absorbs moisture and calls for use of softer leads.

Unfortunately, the grading of pencils by various manufacturers is far from accurate and there is no dependable standardization common to the different brands; the B pencil of one brand may be the equivalent of 2B or even 3B in another brand. Furthermore, the grading in any one brand may be inaccurate: an HB may be found to be exactly as soft as the B. In consequence, there will be a gap in the tone scale that will have to be supplied by a pencil of a different brand. This is unfortunate, but it is a fact that has to be reckoned with.

9

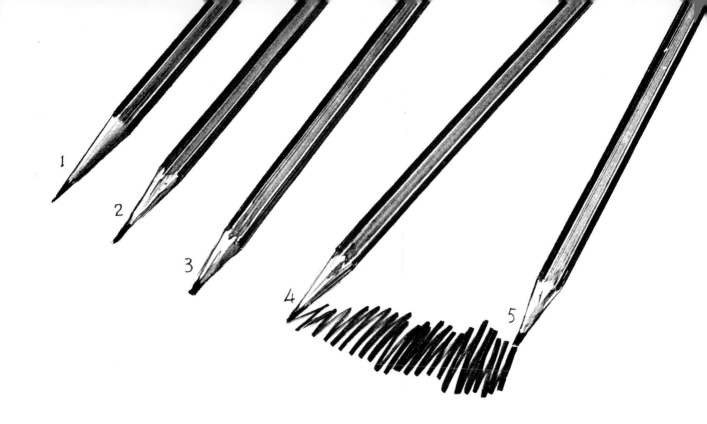

ASSIGNMENT 1

Get acquainted with your pencils! Fill several sheets of different kinds of paper with swatches of tone, learning what the hard and soft grades will do for you. Note that the very soft pencils make "grained" tones. For smooth tones use the harder grade leads. Bear down on the pencils; iron the surface of paper with strokes.

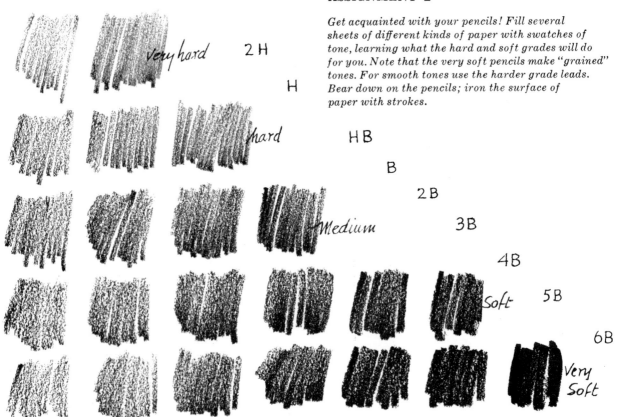

Very hard 2 H

H

hard H B

B

2 B

Medium 3B

4B

Soft 5B

6B

Very Soft

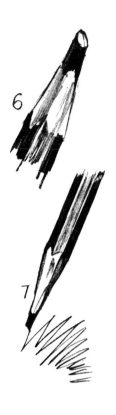

SHARPENING

A pencil sharpener points the pencil like that in #1. A sharp knife does a more suitable job, giving something of a point to the lead—though not a sharp one—instead of leaving the lead unsharpened, as in #3. With the pencil sharpened, as in #2, wear the point down on a scrap of paper (#4) until it makes a broad firm stroke, as in #5. The lead will then look like the enlargement in #6. Such a point will make a broad flat stroke or, when turned over (#7), will produce a thin sharp line, a line that is in frequent use along with the broad stroke.

DEMONSTRATION

The sketches on page 12 demonstrate effects resulting from use of hard and soft pencils on rough and smooth papers. Sketch #8 was made on a rough-surfaced paper with a soft pencil, giving a "grained" effect. The same soft pencil was used in #10 but that paper had a very smooth surface. Note here the smooth quality of the tones. Sketch #9 is on the same paper as #8 but two pencils were used; one very soft for the darkest tones and a much harder lead for the light tones on the front of the shed and on the ground. The drawing of the old farm buildings on page 16 was made with one very soft pencil on kid-finished bristol board.

Diagrams #11 and #12 demonstrate conditions present in sketches #8 and #9. In #11 the soft pencil, in making light tones, rides on the surface of the paper, producing a series of dots that give that grained quality. When a hard lead, sharpened to a broad point, bears down on the paper, *ironing it out* as it were, as in #12, we have a smooth tone, usually a desired effect. Now when the paper is ironed out that way with a hard lead, it not only makes a smooth tone, but each pencil stroke is given a sharp, crisp edge (a lively quality) in contrast to the strokes of a soft lead on rough paper. If there are several sheets of paper underneath the drawing, the edges of the strokes become sharper. This gives the drawing a direct, positive character and the pencil flows with greater facility.

THE PAPER

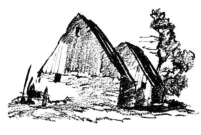

8

It may surprise those who have not made a serious study of the pencil to be told that the kind of paper used to draw upon is a more important factor than the pencils themselves. Good pencils are essential of course, but without a responsive sheet of paper no pencil whatsoever will give a decent result.

On practically all papers the soft leads (5B, 6B, 7B) are needed for the darkest tones. Only on a clay-coated paper like *Video*, which has a surface suggestive of extremely fine sandpaper, will the harder leads provide black and very dark tones.

Now a soft lead (5B, 6B, or 7B) will produce a complete range of tone from black to light gray on any paper; but on papers having any "tooth" or roughness (papers like *Aquabee Drawing 812* and Strathmore *Alexis*) the middle and light tones will have a grained appearance which usually is objectionable although there are times when one may desire just that quality. On such papers the 3B or 4B will be needed to produce middle tones of smoother quality but the light tones made with these medium soft leads will be grained. To make pleasant, smooth, light tones we have to go to HB or H leads, seldom harder. Thus it will be seen we have to use three or even more degrees of leads—when working on the rougher papers—in order to have good quality of all tones throughout the sketch. Refer to the diagram of tone swatches on page 10 in this connection.

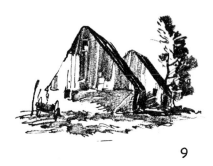

9

But there are smooth-surfaced papers upon which we can get velvet-smooth tones from the darkest to the lightest with a single soft pencil. This naturally is desirable; one can work more freely when holding but one pencil in the hand.

The best smooth-surfaced paper that I have found is *Aquabee Satin Finish*. Your dealer will probably get it for you on request; if not you can write for it to the Bee Paper Company, 100 Eighth Street, Passaic, New Jersey. It will pay you to insist upon this paper which comes in 11 x 14 inch pads. Don't accept something else "just as good." I've tried dozens of papers, and this is it!

On *Video* paper, already mentioned, you can get splendid tonal quality with but one or two pencils; an H or even a 2H will give both jet black strokes and good smooth light tones. This paper is sold by Arthur Brown's art supply store at 2 West 46th Street, New York, New York. It may be available in other shops. The 11 x 14 size pad is a convenient one. This is an expensive paper but it is a delightful surface to draw on, and its clay-coated surface permits the scraping-out of white lines or areas with the edge of a razor blade.

10

Generally speaking then, smooth surfaces are best, provided they are not hard surfaces. The ideal paper has a degree of softness which lets it "give" a little when the leads bear down upon it as they must to produce smooth tones. *Results are greatly improved when a number of sheets of paper lie under the work sheet to give added resilience.* Nothing is worse than a hard-surfaced paper or any paper lying directly on the hard drawing board. Yet the paper must not be *too* soft.

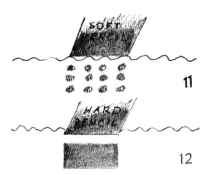

11

12

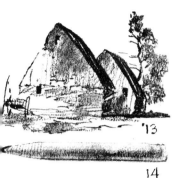

'13

14

THE STUMP

I hesitate to introduce the tortillon stump, a rolled and pointed paper rubbing tool (#14), because its use so easily can become abuse. Yet it is a good tool when employed with discretion. In #13 we see what happens to the sketch in #8 when the stump is touched lightly to tones here and there, giving them a smooth quality. But too much use of the stump will give the drawing a smudged character that weakens it. Although I do not often resort to the stump, on occasion it gives a pleasant flavor to the drawing. Note its use on page 57.

ERASERS

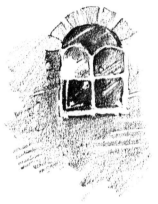

15

Yes, the eraser is a tool, too; not so much for erasing errors but as a creative adjunct to the pencil. I refer now to the kneaded rubber. Unlike most erasers it "lifts" the pencil tones without smearing them. Kneaded erasers come in rectangular blocks. Cut or tear off a piece the size of the end of your thumb and knead it between thumb and fingers until it becomes soft and pliable. When in this condition a tone may be lightened with it by pressing down lightly upon the area and lifting up without rubbing. Pinch it to a fairly sharp edge and it will, by gentle rubbing, take out white areas that might inadvertently have been covered; such as the windowsill in #15. Furthermore, used in this fashion it is good to break into tones with eraser strokes as was done under the window in that same sketch. Look for such use of the eraser in other drawings throughout the book.

A drawing that needs a lot of *correction* by erasure is not likely to end up successfully. It is better to start over than to labor too long over any drawing.

SIZE

What is the natural size for a pencil drawing? There is no minimum size; a sketch two inches square can be satisfying and charming in a jewel-like way. A pencil drawing eight or ten inches in either dimension is about as large as I recommend; a little smaller is better. Remember that your pencil point, even at its broadest, is a relatively small tool for covering a large area. A very large drawing becomes a laborious operation. Another thing—and this is important—the width of the pencil strokes, related to the entire drawing, is pleasanter when the drawing is not too large. For the student of this course I recommend working on a sheet approximately 11 x 14 inches, confining the drawing to 8 or 9 inches in its largest dimension. Some artists are temperamentally inclined to work small, others to work large, and this personal predisposition should be considered. And, of course, when one becomes expert with the pencil he can draw in a very large scale, as do architectural renderers whose drawings have to be large enough to illustrate buildings in considerable detail. But even if the student in this course intends to become a renderer, he will be well advised to make his student drawings relatively small. When a degree of technical mastery has been achieved in smaller scale, it will not be difficult to apply it to large renderings.

A FEW POINTERS

The purpose of the sketches on page 15 is to stress a number of technical points that deserve attention in pencil rendering.

The first is *values;* that is, the relative degrees of light and dark tones in the drawing. It will be noted that in each of these small sketches there is a full range of values—from the blackest notes to the lightest grays. This complete range of values is fundamental. It is advisable to lay-in at least one of the black tones first to give assurance that the sketch will have pep and brilliance. With the black note before you, it is much simpler to plan the intermediate and light tones. In the roof sketch there is not much pure black; but the few black touches are indispensable. And these were put in at the beginning. In the pile of market crates covered with a tarpaulin, the black areas are of foremost importance, giving sufficient contrast to the shadow tones of the tarpaulin which are intermediate.

The rubbish-can sketch is useful to demonstrate the effectiveness of sharp-edged shadows which, with the sunlit areas, gives an interesting play of dark and light pattern. Also, to demonstrate that any subject can be interesting, if artfully presented.

Note that the shadows here and on the chimney are kept alive by small sharp accents of white. These accents are vital, as you will discover in studying the pencil drawings throughout this text. We seldom use solid tones; to do so gives a heavy, unatmospheric effect.

In these sketches the shadows are emphasized where they meet the light.

I would call attention also to the thin lines of light on top of the rails of the gate and to the stone joints in the market curb—emphasis on such factual, minor details gives the drawing an impression of reality.

Consider the treatment of the fountain's base. Those diagonally swept-in strokes do not follow the contour of the form. Indeed they camouflage it somewhat. You will find yourself doing this often, as conformity of strokes with the directions of forms gives a hard, mechanical effect if used without variation. A study of many of the drawings on following pages will reveal how serviceable this technical device is. Observe that the shadow of the fountain base does not extend to the contour line at the right; the white area left close to the contour, representing reflected light, accentuates the effect of roundness.

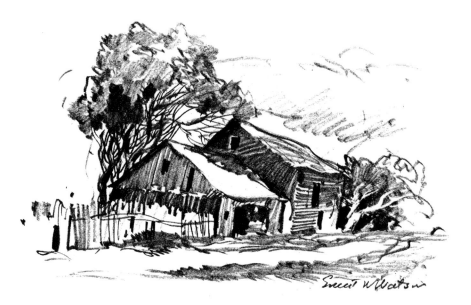

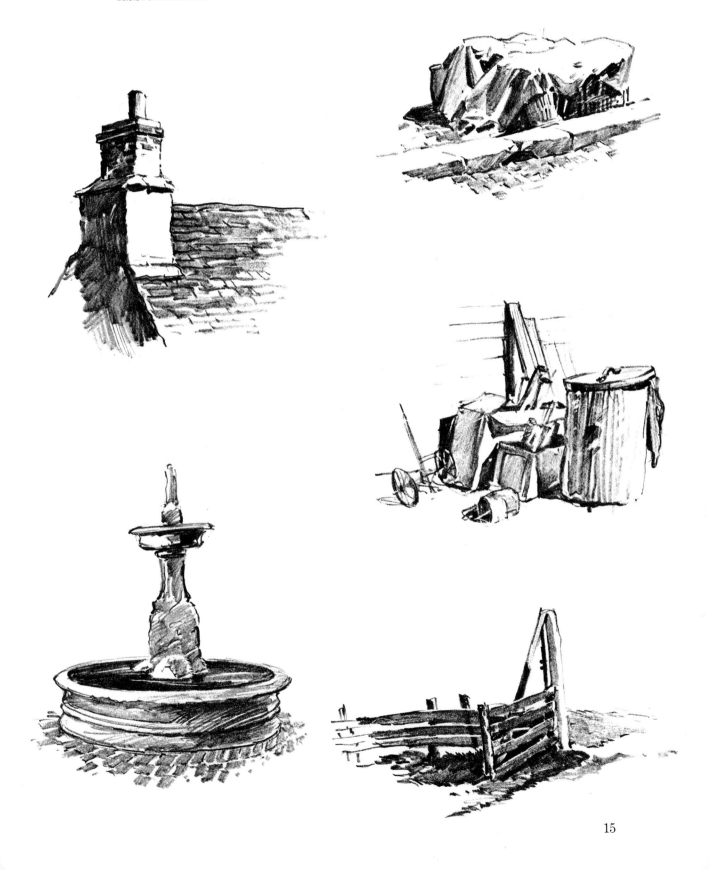

VERTICAL AND HORIZONTAL BOARDS

Let us begin by learning how to render the different materials of which buildings are made: boards, brick, stone and stucco. We will at the same time be getting acquainted with the pencils and discovering what they can do.

The weathered boards of an old building are good to start with. We don't have to be too concerned with detail and we can work fearlessly. The barn which I have drawn has much the same character as the ruined windmill on the opposite page that I have provided for your practice. The rendering problem is identical.

I suggest making your sketch the same size as the photograph. I made my sketch of the barn the size of the reproduction in order to have the pencil strokes appear exact size of the originals. Make a line drawing of the mill on tracing paper. Turn the paper over and with a sharp soft pencil, pencil-in the outlines seen through the paper. Now lay the tracing right side up on your drawing paper and rub off the outlines. You should Scotch tape the tracing down to keep it from slipping as, with the back edge of a knife or your fingernails, you rub over the outlines, transferring them to the drawing paper.

Why the tracing paper routine? Because you can transfer the drawing to several sheets of drawing paper and thus have the outlines for a number of trials. You will be interested to see how much better your third rendering is.

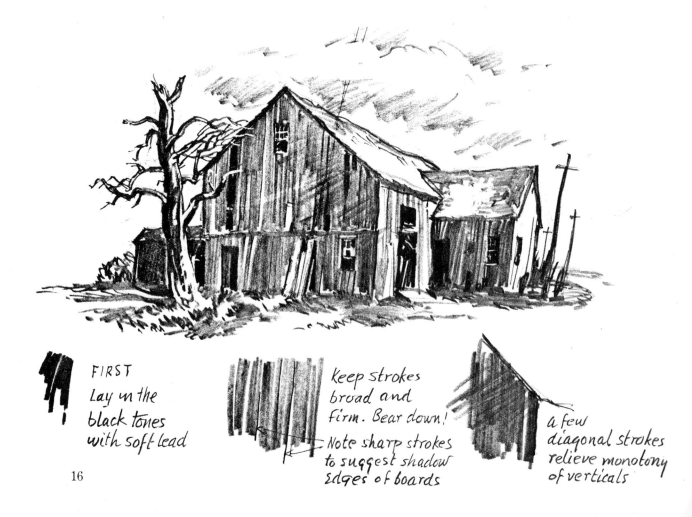

FIRST
Lay in the
black tones
with soft lead

keep strokes
broad and
firm. Bear down!

Note sharp strokes
to suggest shadow
edges of boards

a few
diagonal strokes
relieve monotony
of verticals

Talcy, France

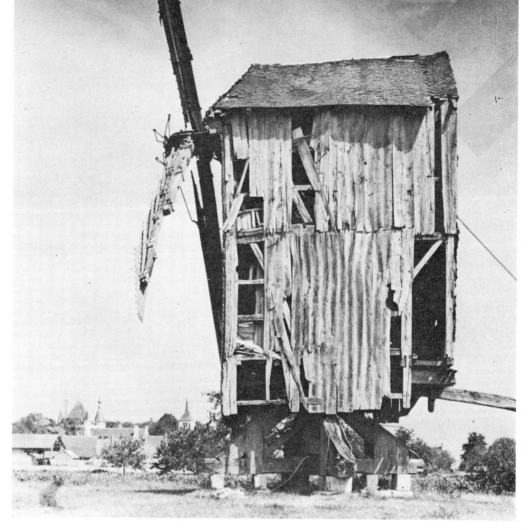

Samuel Chamberlain

You will probably use three pencils on this drawing, a very soft one for the darks, a fairly hard one for the lightest boards, and a medium soft one for the roof and its shadow on the boards. This depends upon the kind of paper you are using; if you are working on a very smooth surface, a single soft pencil may do, but I suggest the use of several pencils in these exercises so that their use will be learned. If you can master the technique involving several pencils it will be easy to perform with one. You should experiment with different grades of leads to find those that give the best tones. It is advisable to use as hard a lead as will give nice tonal quality without too much effort. You will discover that several sheets of paper under your drawing give much better tones than when working on a hard surface. When the drawing surface is resilient the leads sink in a trifle and produce sharp edges.

In the photograph, all the openings in the windmill are the same black tone. Probably your drawing will be more pleasing if you vary them somewhat. Consult the instruction on "openings" on page 22.
Try leaving the roof nearly white in one of your experiments. Possibly the upper left boards might be left white; they are actually much lighter in the photograph. Play around with this subject until you feel satisfied with a result. Keep all of your sketches for later comparison.

In rendering horizontal boards (clapboards) we naturally carry our strokes in the direction of the boards. Having selected the proper grade of pencil to give the desired value of tone, we wear the lead down—on a scrap of paper—to a point, as in #6 page 10, and make practice strokes on the scrap of paper until the pencil gives a good wide stroke of the right quality. Bear on hard, so that the tone is smooth and clean-edged. Your strokes will sometimes run together, sometimes they will separate slightly leaving thin white lines between. Occasionally, thin dark lines underlining the broad gray clapboard strokes will accentuate their structural character. Where the strokes run together, forming a rather unbroken area, indicate the separate board effect by occasional horizontal, sharp lines.

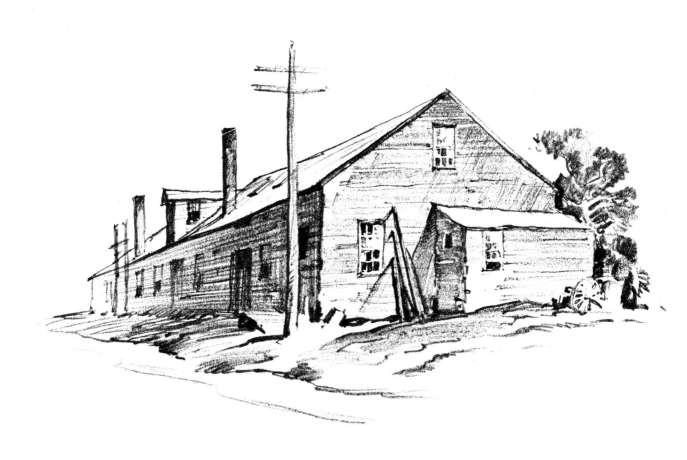

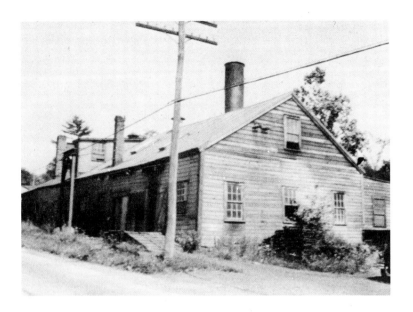

When the subject is an old weathered structure, like the building in my sketch, one certainly need not be too meticulous in trying to keep the strokes exactly the same width or evenly spaced. And the antique character is helped by leaving some white areas here and there. Note also the diagonal strokes laid over the horizontal lines to relieve monotony and give greater rendering variety.

Where you have a narrow area like the end of the shed and the space on the long wall between the telephone pole and the dormer of the building, it is easier to lay-in the tone with vertical strokes; then go over them with sufficient horizontal strokes to give the clapboard indication.

Note that in my sketch on the opposite page, I have taken various liberties with the photographic subject. The lean-to on the end was added to give more interest at that point; the chimneys have been made larger, and the cylindrical stack has been eliminated; the foreground has been made more interesting.

When stroking-in the clapboards around windows it is awkward to have to stop the stroke exactly at the window casing, although when you have become adept this is no problem. If the strokes do lap over the window, they can easily be erased with the kneaded eraser, laying a piece of paper down at the window side and erasing up to it.

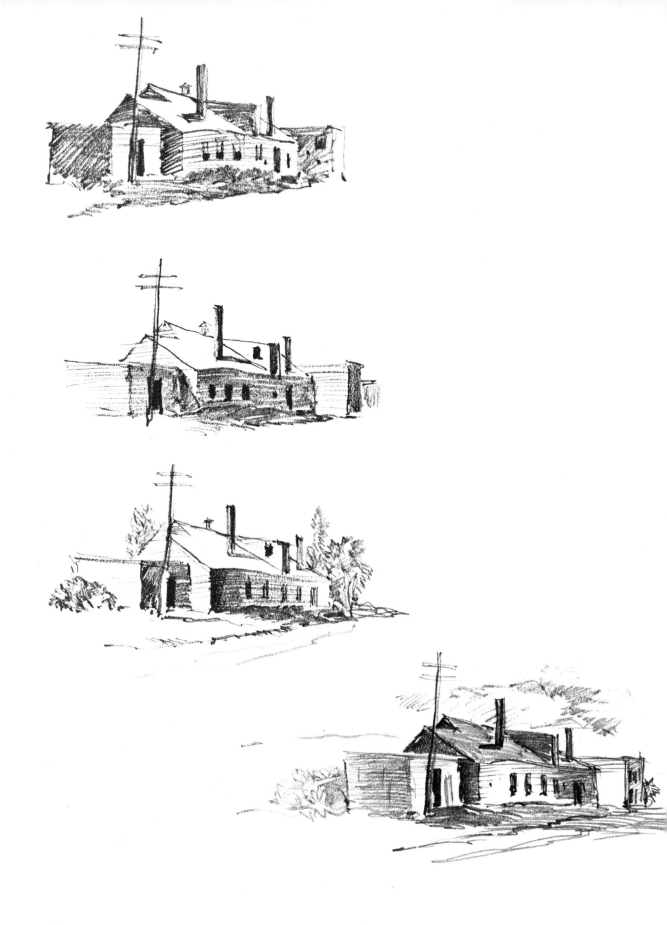

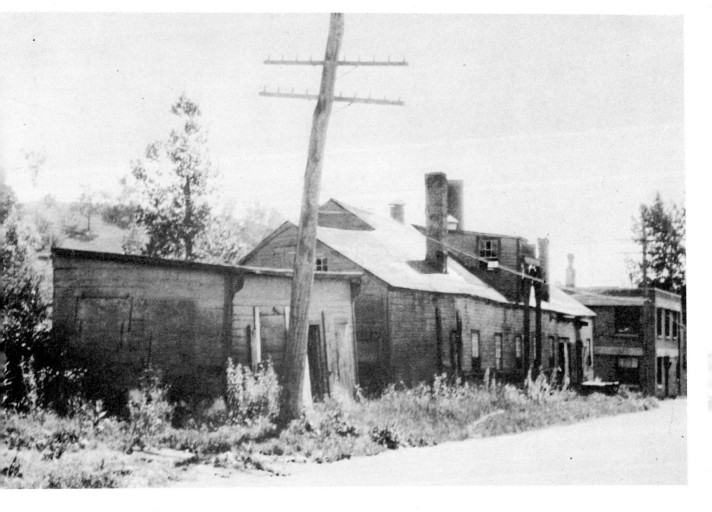

ASSIGNMENT 4

YOUR SUBJECT TO RENDER

This is the same old mill that was the subject of my sketch in a preceding page, the photograph being taken from the other end. It is not a very good photograph, but it will serve your purpose nicely. Since it was a rather gray day, there is no clearly marked light and shadow on the building; it is all one gray monotonous tone. So it is up to the artist to use his imagination and put life into his sketch by bringing out the sun and making the old structure sparkle.

On the page opposite, I have made a few rough sketches just to indicate some possibilities in dark and light handling. I purposely made these very rough, avoiding any definite suggestion of rendering, leaving the pencil treatment to your own ingenuity. Why not render this subject in all four of these compositional arrangements? Make your sketch about the same size as the photograph. Trace its outlines, if you wish, and transfer them to your paper as many times as you want to render the subject, using the tracing means explained on page 16.

HOW TO RENDER OPENINGS

This often takes ingenuity. An open door frequently appears as an unbroken dark area. If we treat it that way in a sketch, the effect is labored and uninteresting. Furthermore, it will not look atmospheric; it will not look like an opening. Somehow we have to break up the area with pencil strokes that have variety both in direction and in value. Usually we leave some touches of clear white paper between some of the strokes.

Now in the photographic subject on this page we see that the light does get into the opening slightly on the left wall. That gives us a hint. We certainly want to keep the area very dark at the right to silhouette the edges of the steps emphatically. Likewise the top of the opening ought to be kept black in order to give contrast with the arched stone platform above. Note that we have made this lighter in the sketch than it is in the photograph in order to insure this contrast.

In the open barn door, the wagon breaks up the dark area to some extent and certainly lends interest, but we still have the problem of a rather large black mass that calls for some technical resourcefulness.

The student is advised to make his own rendering of the cellar entrance and the open barn door; they will be as different from mine as other renderings I might make of these subjects would be. Then

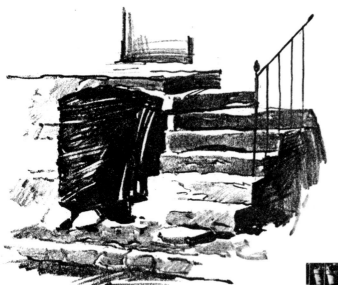

Burgundy, France

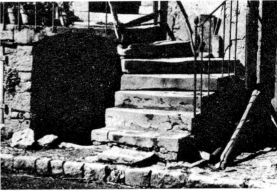

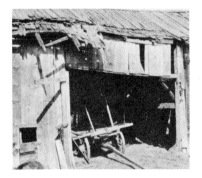

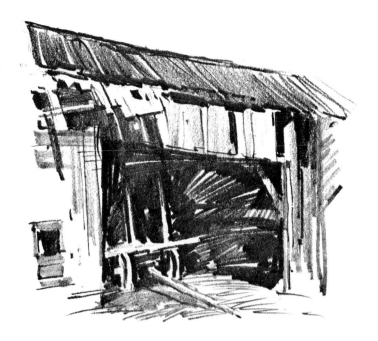

experiment with the blacksmith shop door, which is the assigned subject in this lesson.

That black, rectangular doorway should be broken up in some way. If you care to lead that pair of horses into the shop, letting just their rumps break up the right side of the opening, that will help. But it will not be enough; what is left of the dark interior will need the atmospheric treatment of broken tone, as demonstrated. Reference to a similar subject on page 9 will give a suggestion as to the finishing of the sketch at its edges. Study other drawings throughout the book for ideas. How to "get out" of the sketch is an art in itself. We have to treat the edges of the drawing in such a way as to suggest the indefinite continuation of the scene beyond the confines of our rendering. And when working from photographs which give no information beyond the print itself, we have to improvise.

ASSIGNMENT 5

ASSIGNMENT 6

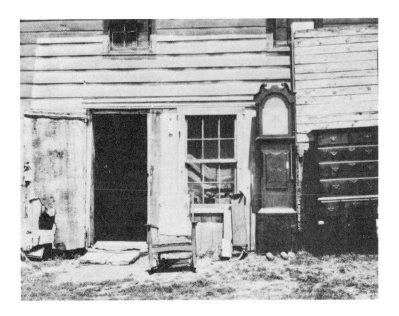

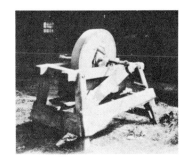

ASSIGNMENT 7

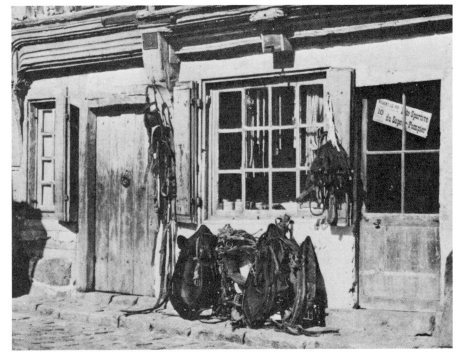

Nogent-Le-Roi, France

Samuel Chamberlain

ASSIGNMENT 8

Chapaize, France

Samuel Chamberlain

In assignment #6 the grindstone may help to make the foreground more interesting.

In assignment #7 it might be well to show more of the cobbled street. The treatment of the curbstone on page 15 should give a suggestion.

Assignment #8 is a tougher one. Perhaps the tiny sketch below will stimulate your approach. Here we have let a lot of sunlight into that dark shadow.

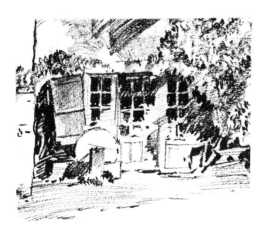

ABOUT WINDOWS

Ideas for rendering windows will be found in several drawings throughout the book. Usually there is considerable variation in the tonal values of the windowpanes. At times the sunlight reflects pure white on some panes; often something within the room will make the panes appear gray. Where it is desirable to have them all black, as in the large arched window of Wells Cathedral, they can be varied by the way strokes are rendered and by accents of white paper.

Architects sometimes employ a tricky method of indicating window mullions. A blunt point, like a toothpick, drawn with considerable pressure across the window area makes a series of embossed lines which will remain white when the pencil goes over the surface. The device is seldom advisable in free sketching but it is sometimes useful.

Another method of taking white lines out of a penciled area is to make a stencil through which the desired lines can be erased with kneaded eraser. A sharp razor blade will make the cuts in a stiff piece of transparent parchment, which is ideal for the stencil.

It might be a good idea to copy the drawing on the opposite page.

wood toothpick

lines made
with a rule

Razor Blade

Piece of
stiff paper

lines
made
freehand

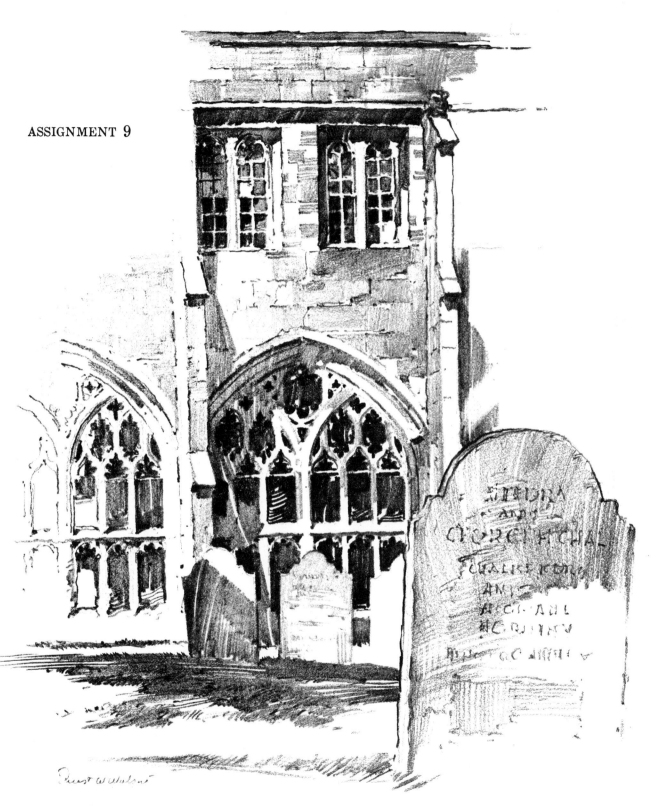

CLOISTER WINDOWS
WELLS
CATHEDRAL

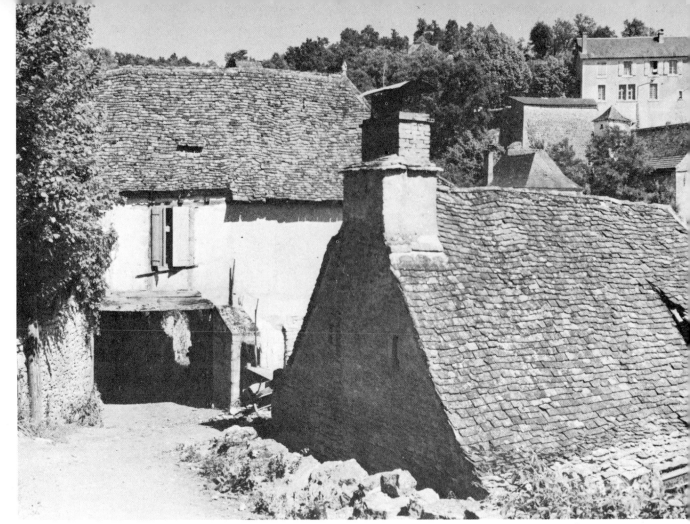

ASSIGNMENT 10 *Montvalent, France*

THE ROOF

The roof is always an important element of any drawing of buildings. Suggestions for rendering roofs will be found in several drawings on these pages. Roofs in near foreground can be rendered with considerable detail but distant roofs, like those in the background of the photograph above, are too small in scale for any detailed treatment; they can be treated only as tonal masses. Usually the roof is most effective when the shingle or tile treatment does not cover the entire area—the introduction of white not only avoids monotony but it gives a strong suggestion of sunlight.

In sketching the above subject, improvise the part of the building that goes out of the picture at the right. And perhaps the road and wall brought into the foreground would make a more graceful entrance into the picture.

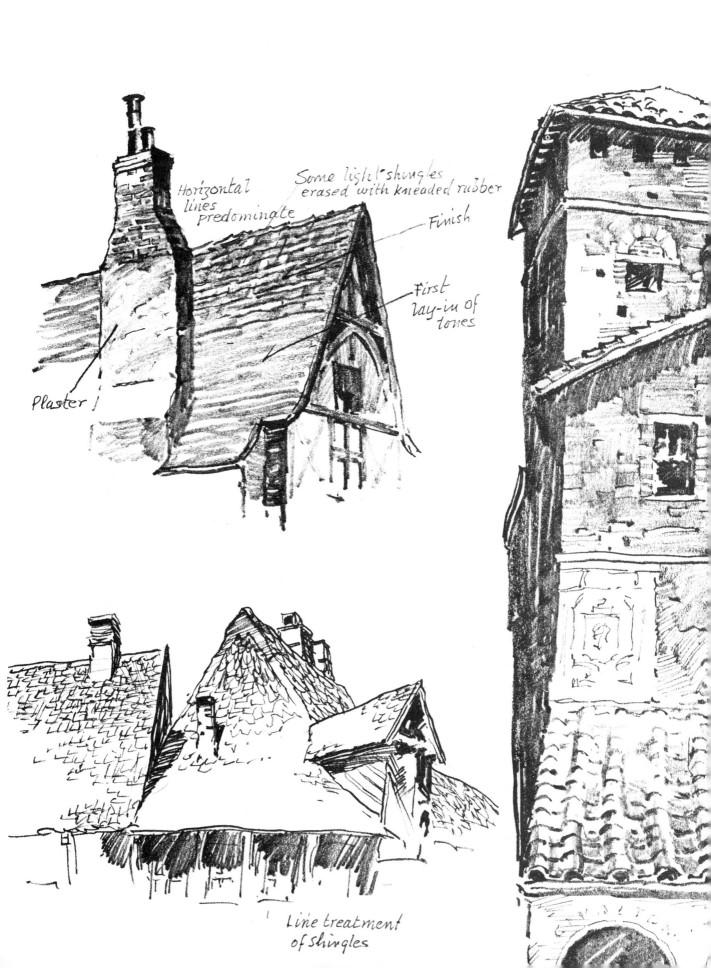

Horizontal lines predominate

Some light shingles erased with kneaded rubber

Finish

First lay-in of tones

Plaster

Line treatment of shingles

MASONRY

The problem in rendering brick is to give its true appearance without undue labor and without making the drawing look mechanical. It is not necessary, or desirable, to draw every brick; certainly it is necessary to draw some of the bricks meticulously, but it is easy to overdo this. Note how we begin, as in A, the tone of the shaded side massed-in as an undertone. Some areas (B) are left untouched for filling in with individual bricks against a light background. When the pencil is sharpened so that it makes broad strokes, as in C, each brick can be made with a single stroke provided it is in scale with the subject.

Now it will be found that the brick indication superimposed on the tone (A) does not have to be exact; the brick strokes rendered with a softer pencil can be quickly indicated without laying the bricks carefully as in the few areas, such as B, reserved for this meticulous procedure.

In D a sharp thin line gives a shadow line to a *few* of the bricks. See how this is done in the finished drawing.

At E is shown that area of the chimney before the bricks have been indicated.

The light side of the chimney can be rendered sparsely and some of it can be left altogether untouched.

On page 54 note how the brick face of the building has been treated. Much of it has been left white and the scale of the drawing, reproduced at exact size, is so small that rendering of individual bricks was unpractical. However, here and there brick-like strokes do provide all the impression needed to give the wall its character.

Broad strokes

some vertical

Some horizontal

Underline some stones

In a large wall area avoid picking out too many stones

Avoid too much accenting of stone joints

Leave some white areas

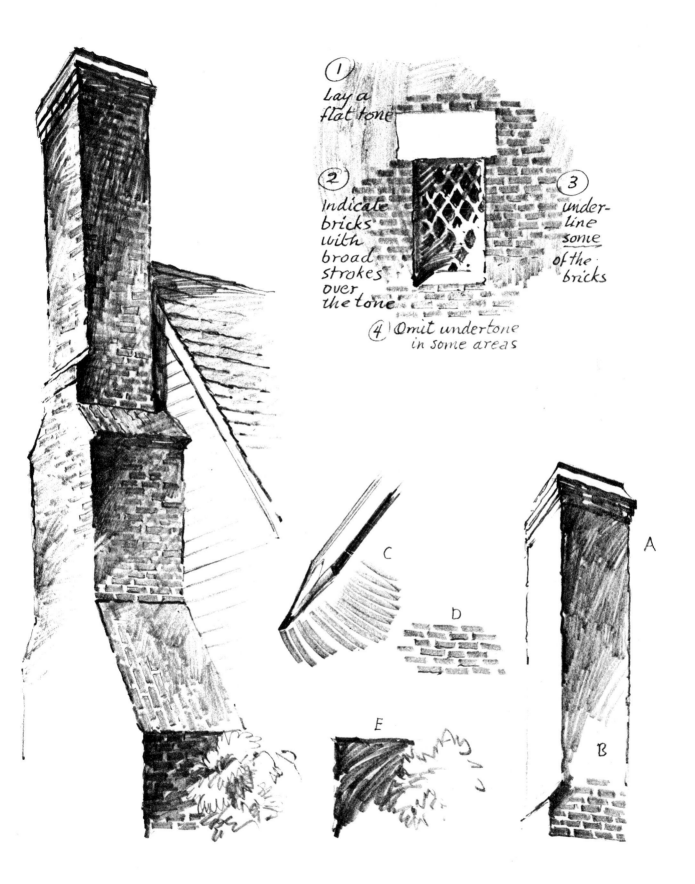

① Lay a flat tone

② Indicate bricks with broad strokes over the tone

③ under-line some of the bricks

④ Omit undertone in some areas

C

D

E

A

B

SHADOWS

It might truthfully be said that the success of a sketch depends more upon the rendering of its shadows than upon any other factor. Shadows define form. And shadows make the patterns of light and dark—another factor of vital importance.

The tonal value of cast shadows depends upon the value of the surfaces upon which they fall. Thus, in the *Zermatt* sketch opposite, the shadows upon the white clothes hung on the balcony are very light; those under the balcony quite dark, in spite of the fact that in my sketch the wall is white. Actually that wall was gray; I left it white for the sake of better pattern interest.

If the edges of shadows where they meet the light are made a little darker, the effect of strong light is intensified and the sketch is more likely to sparkle.

Shadows under eaves seem to me to be most effective when the pencil strokes are made in a downward direction—rather than horizontal, following the gutter line. This gives a less mechanical and more atmospheric effect.

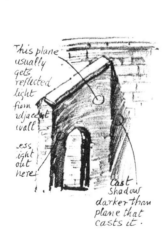

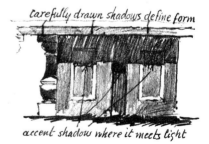

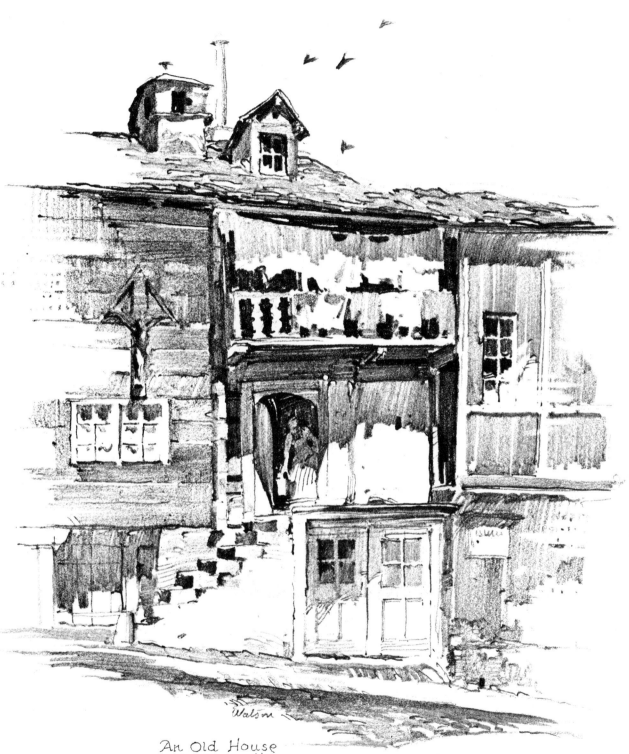

An Old House
at Zermatt
SWITZERLAND

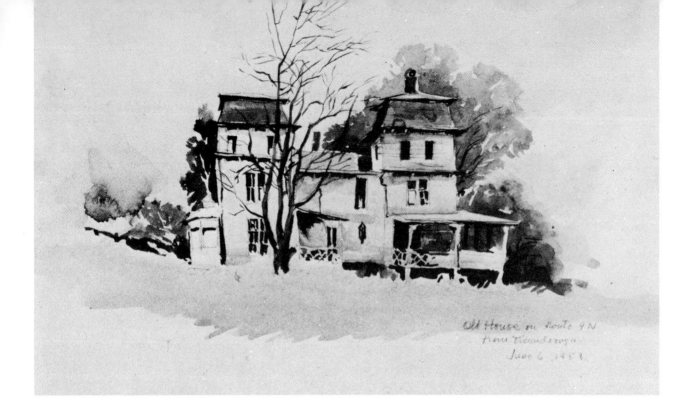

Old House on Route 9 N near Ticonderoga. June 6, 1952

ASSIGNMENT 11

COMPOSITION

Composition—the arrangement of a drawing's shape, form, tonal treatment and setting—is the artist's first problem, unless he undertakes to make a facsimile reproduction of the scene before him, copying exactly all literal facts and transient effects. There are times, to be sure, when this is a logical procedure, for example, when the subject is an historical building sitting for its portrait. But it is the creative aspect of sketching that interests us now, so we shall feel free to use our imagination and our dramatic sense, intent only upon the result.

The above picture is a photograph of a watercolor sketch I made of an old house near Ticonderoga, New York. It is offered as a subject for the student's pencil practice. On the page opposite are three very rough sketches. These do not presume to give more than suggestions of different ways the subject may be composed. And of course there are many ways.

The watercolor, greatly reduced, does not tell that this is a clapboard house, which it is. And in your larger drawing—perhaps twice the size of the photograph—this should be indicated.

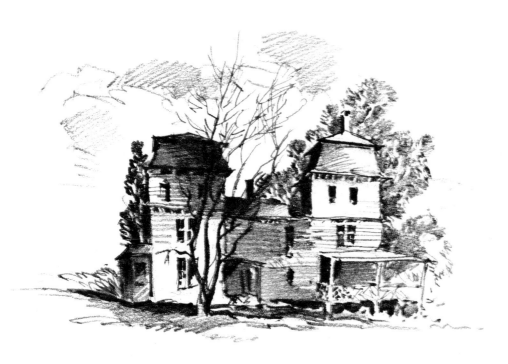

In my thumbnail sketches I have covered parts of the old house with tone without regard to what you see in the watercolor. There can always be an excuse for such invention—paint discolorations, dirt, or the shadow of a cloud. In two of the exercises I have omitted the foreground tree, which you may do or not, as desired. And of course the tree can be moved about at will. It can be a different kind of tree. The one in my picture is dead; you can substitute a live tree of any species. The trees behind the house serve a useful purpose; they can be used to silhouette light patches of the house, and they provide a natural setting for the house.

The sagging lines of this old mansion were not exaggerated in my watercolor; the structure was almost ready to tumble down. This, of course, gives the artist license in his drawing. A little more or less sag here and there, cannot be criticized.

In studying composition, thumbnail sketches like these are very helpful. Study your subject in this way, trying to visualize its many possibilities. This will actually save time, too, because having experimented on a small scale and made a decision, you can proceed confidently with your large sketch.

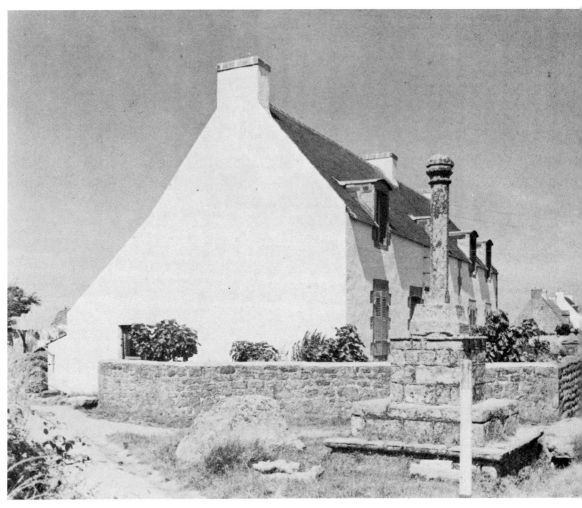

Samuel Chamberlain

Brittany, France

This interesting house presents the difficulty of a large blank, white wall. The two small sketches on the opposite page suggest different ways of handling the drawing. If the light wall is given a textured treatment it can be made more pleasing. But why not a tree or a vine? Perhaps a reversal of the light direction may be the better solution. This would not necessarily alter the light and shade effect of the monument which seems more interesting with the shadow on the right side. Try both ways of rendering this subject. The attractiveness of the sketch might be enhanced if the landscape setting is made more extensive.

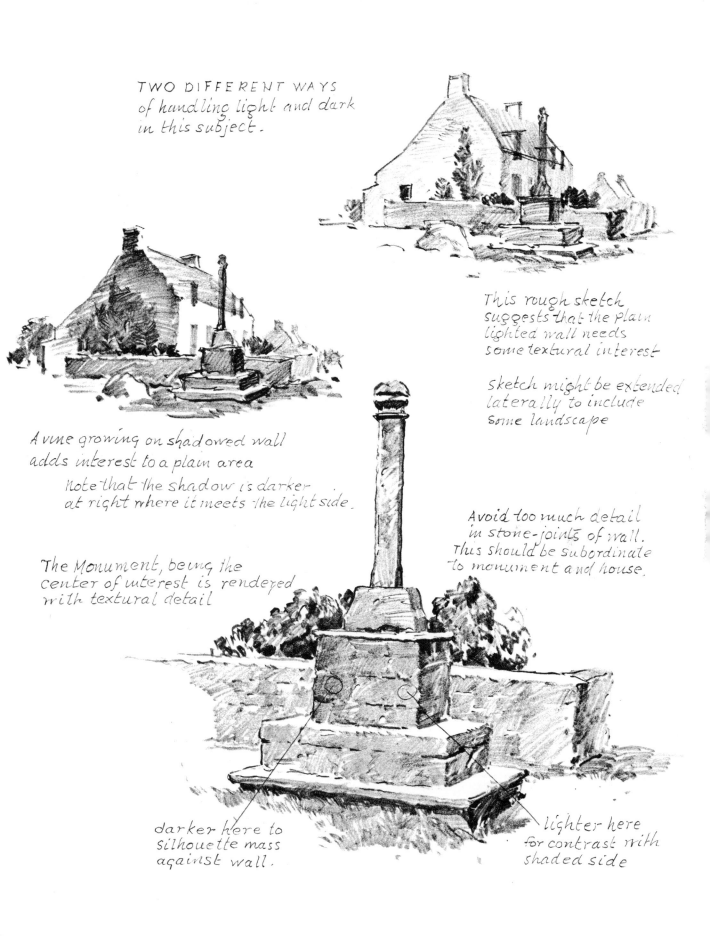

TWO DIFFERENT WAYS
of handling light and dark
in this subject.

This rough sketch
suggests that the plain
lighted wall needs
some textural interest

sketch might be extended
laterally to include
some landscape

A vine growing on shadowed wall
adds interest to a plain area

Note that the shadow is darker
at right where it meets the light side.

The Monument, being the
center of interest is rendered
with textural detail

Avoid too much detail
in stone-joints of wall.
This should be subordinate
to monument and house.

darker here to
silhouette mass
against wall.

lighter here
for contrast with
shaded side

ASSIGNMENT 13

This old house is an exciting subject, whether you make a sketch of the entire picture or of details. I have drawn one of the doorways in an architectural rendering type of treatment, but it would perhaps be livelier if handled in a looser manner. The student is invited to take the other doorway for his subject, treating it meticulously as I have done, or in a more sketchy manner, or both. The drawing should be somewhat larger than the doorway in the photograph. It may be desirable to improvise in order to get out of the picture gracefully at the right side.

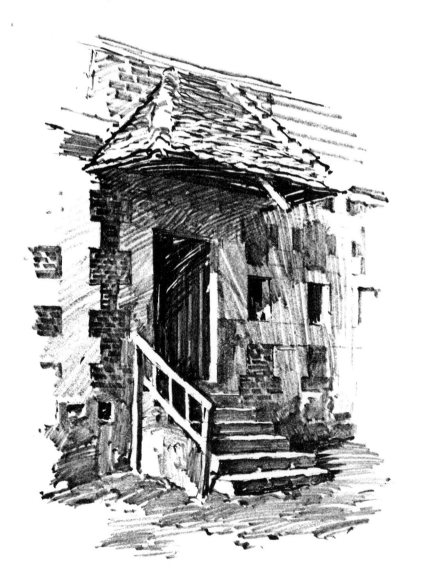

Normandy, France

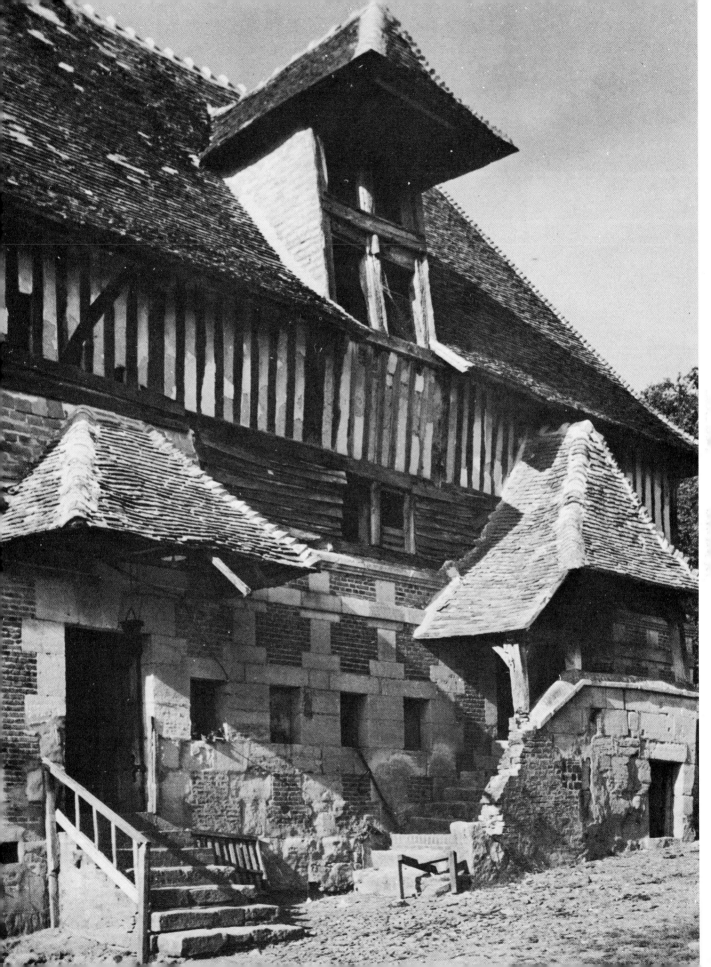

ASSIGNMENT 14

This view of the farm offers subjects for a detail of the barn and for a more extensive sketch including the arch of the wall and all that is seen through it.

Although, in the photograph, the shadow tones on the arch are as dark as those beyond, it would seem best to keep them lighter; the arch serves as a frame for the principal interest which is the subject, and it is best kept subordinate. This does not mean that it should be slighted in rendering; the stonework is very interesting and if treated with textural and tonal effect it will be most attractive. The wall can, and probably should, be extended somewhat on either side. Consult the various drawings in this book that will suggest stone treatment. Make your sketch about the same size as the photograph.

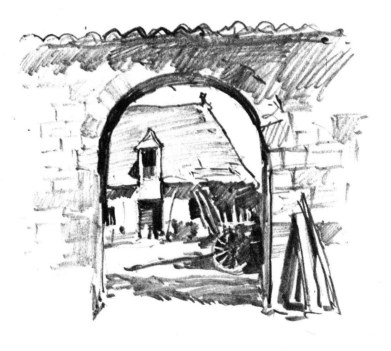

Peyrillac, France

Samuel Chamberlain

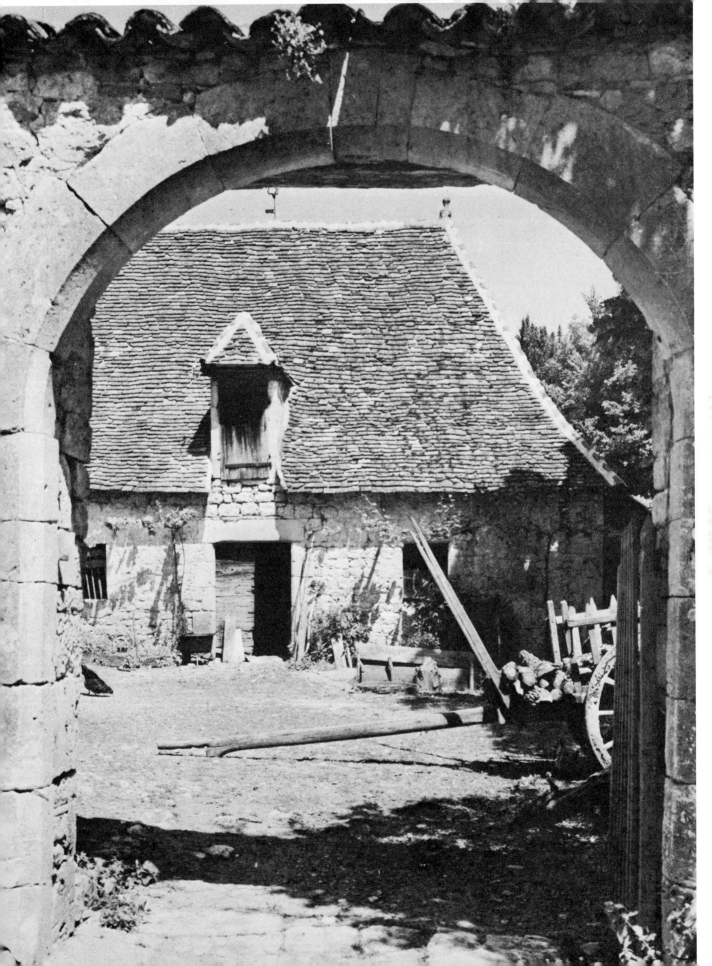

PATTERN

The part played by pattern, or design, in a sketch is here effectively demonstrated. The analysis at the right represents areas covered by *all* tone in the drawing. The diagram at the left isolates the *darkest* values. Of course the pencil tones cannot be quite that definitely classified; within the areas indicated by flat tone there is considerable tonal variation. But important as these variations and details are in the finished sketch, in the initial planning they must be conceived as flowing into cohesive masses that bind all parts together in dramatic patterns. As the artist studies his subject before beginning to draw, he determines the broad over-all design within which the incidents will fall. And if he does not keep his design in mind as he works he will be in danger of having a spotty sketch. The good sketch, like any other creative work, is an organized effort; it begins with a design, rather than with the assembling of details. And as each detail is added, its place in the design is considered.

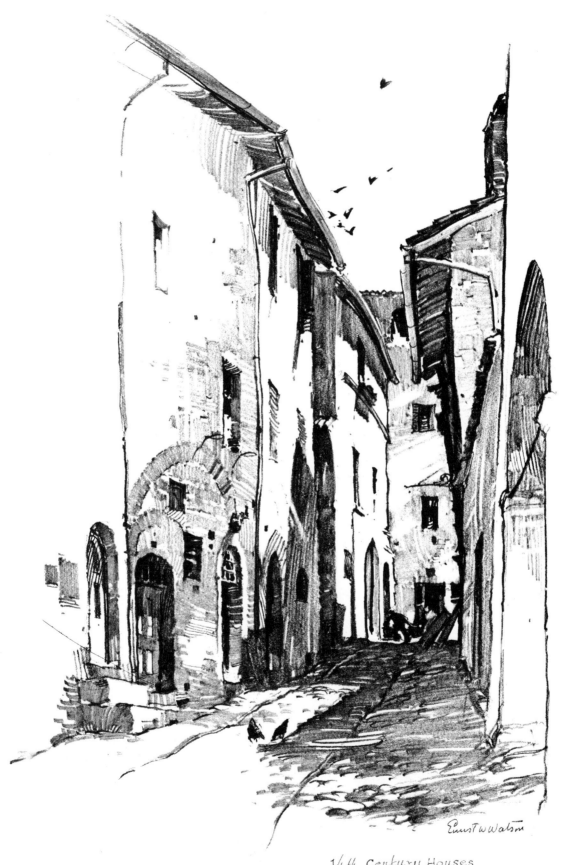

14th Century Houses
at ASSISI.

43

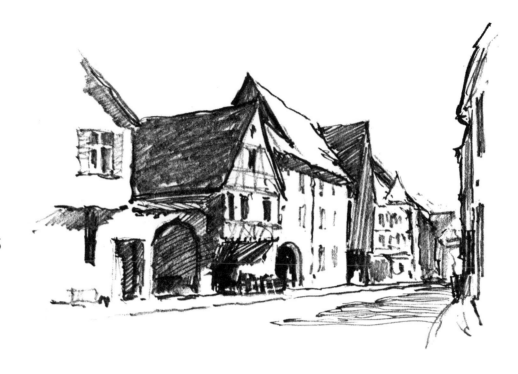

ASSIGNMENT 15

Here is a picturesque subject that lends itself to a variety of compositional treatments. The "roughs" which are reproduced at the same size as the originals, are shown only as hints for the student who should make his drawings at least as large as the photograph.

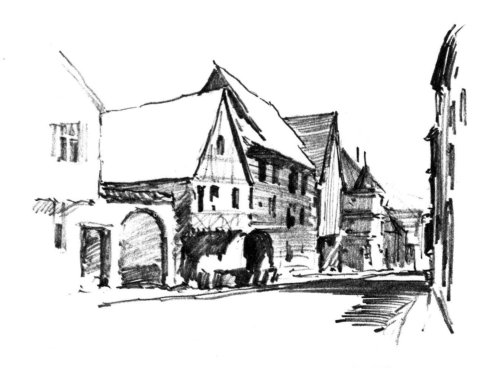

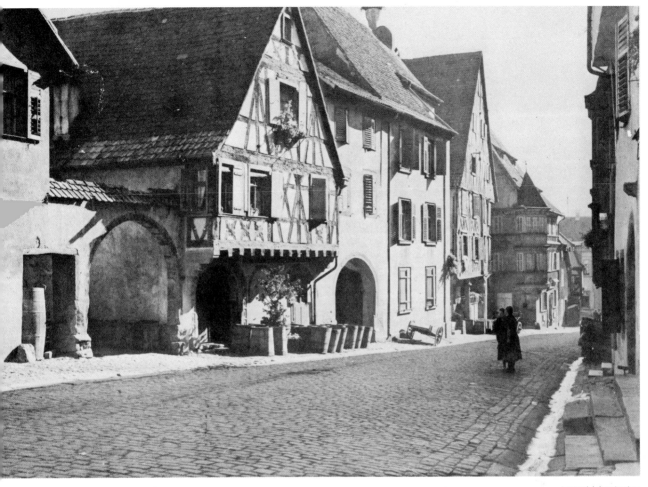

Samuel Chamberlain

Riquewihr, France

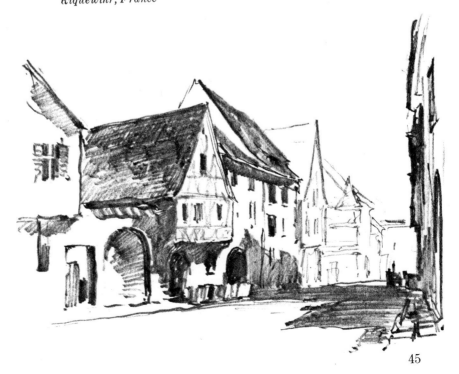

45

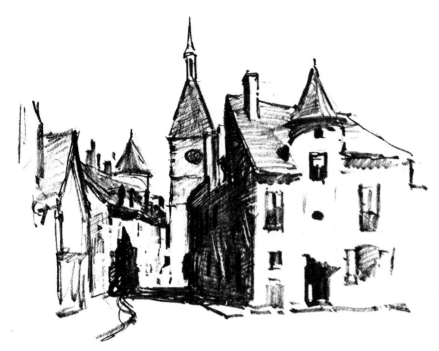

Avallon, France

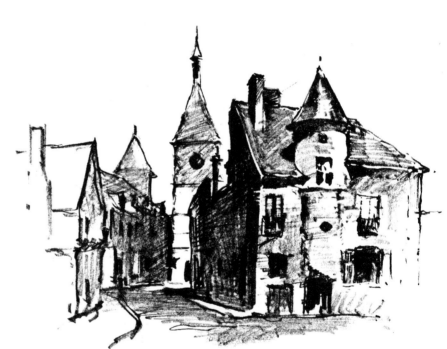

ASSIGNMENT 16

These rough sketches of a street scene in Burgundy, France, illustrate how light and dark patterns control the aspect of a drawing. In the upper sketch the interest is thrown principally in the street. In the lower one, more attention has been focused upon the facade of this fascinating building. Try both composition plans. Note the improvisation of buildings on the left; these are needed to give a balanced design.

46

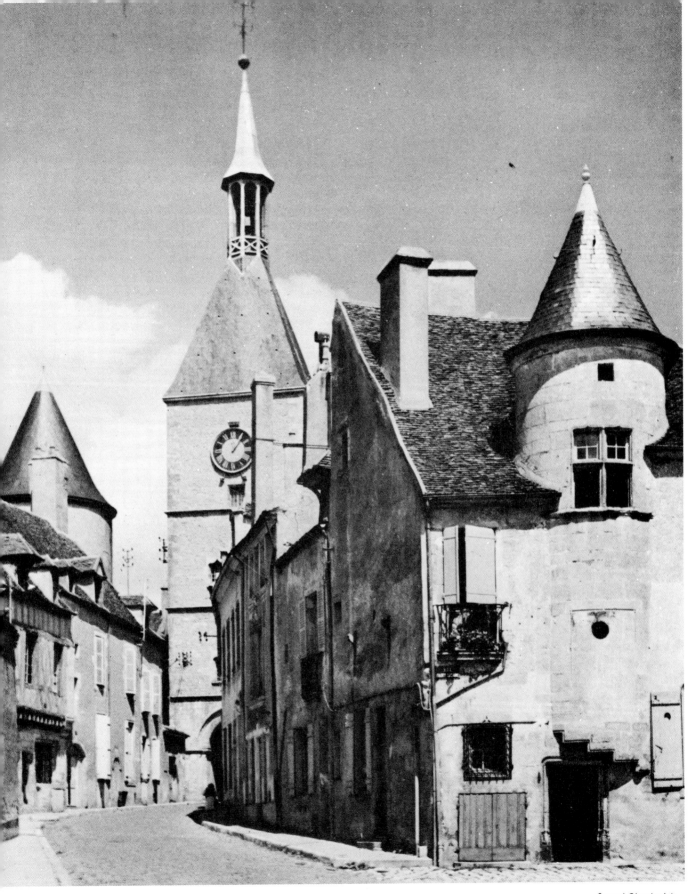

47

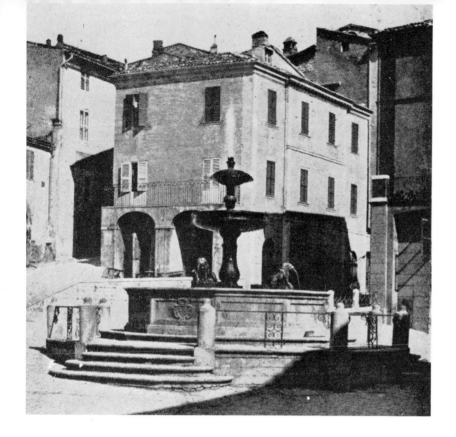

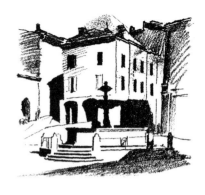

Assisi, Italy

LEGIBILITY

The Italian street scene pictured in the snapshot, *Piazza Granda Fontana, Assisi,* presents a problem in composition that is familiar to all artists who make a practice of sketching "on the spot."

If the shadow shapes and values in this subject are copied literally, the sketch will be as confusing as the photograph. Shadows on the fountain and those on buildings beyond are of approximately the same value. They create a confusing pattern in which the form and character of the fountain are lost (fig. 1).

The fountain obviously is the center of interest; and its environment, though important, is of quite secondary interest. By making a dark silhouette of the fountain (fig. 2) we realize its structural unity. By lightening the shadows of the background we isolate the fountain from its background setting, but so much so that it is not united with its environment. Fig. 3 represents an experiment designed to restore unity to the composition. In fig. 4 we see another trial which is more promising. This is the plan followed in the final pencil drawing.

Note that the roofs in the drawing have been made darker than in the photograph, and the shadow on the right side of the building is quite dark near the roof, although it fades to a very light tone below to favor the silhouette of the fountain mass. The modified shape of this shadow serves to tie together the fountain mass and the roofs; these are disconnected in the snapshot. The artist can take great liberties with cast shadows when their authenticity is not needed to define recognized form.

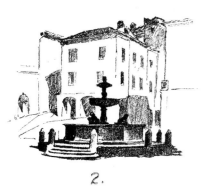

2.

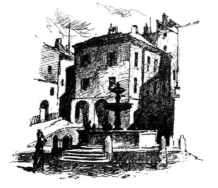

3

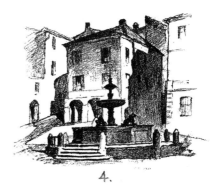

4.

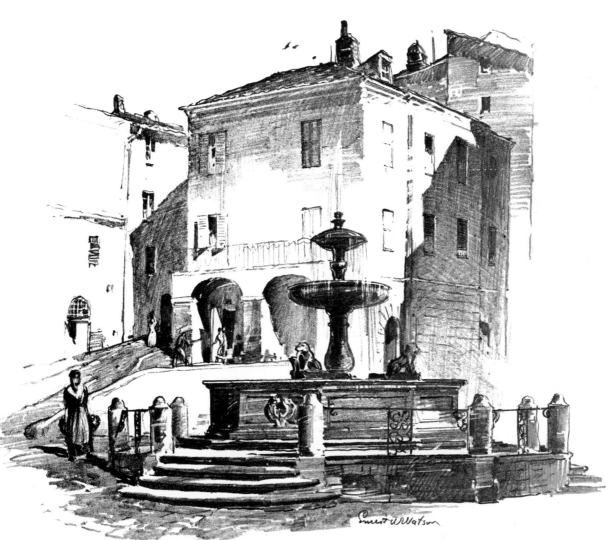

PIAZZA GRANDA FONTANA
assisi Italy

49

ASSIGNMENT 17

The problem here is similar to that of the Assisi fountain scene, although the subject is far less confusing because the fountain is clearly silhouetted on the left against a very light background. All one need do, in this French scene, is to make the dark building at the right considerably lighter so that it takes its place perspectively in the middle distance.

If you were there, on the spot, you might move your sketching stool somewhat to the right. This would completely silhouette the fountain against the light buildings in the background. Even so, the dark building ought to be made lighter, if only for the sake of a balanced composition. As it is, the right side of the picture is wholly dark and the left side light.

Probably you will want to show more of the building on the right than is seen in the photograph, improvising what is outside the picture.

Against the wall of the house is something that looks like a long box. Since this is exactly the same value as the fountain in shadow, it almost appears to be attached to it. Cover it with a scrap of paper; do you not see how that little detail interferes with the legibility of the picture?

Note how the cloud mass enhances the design of the subject.

Would it help the composition if the cast shadow of the fountain were longer, extending over the sidewalk?

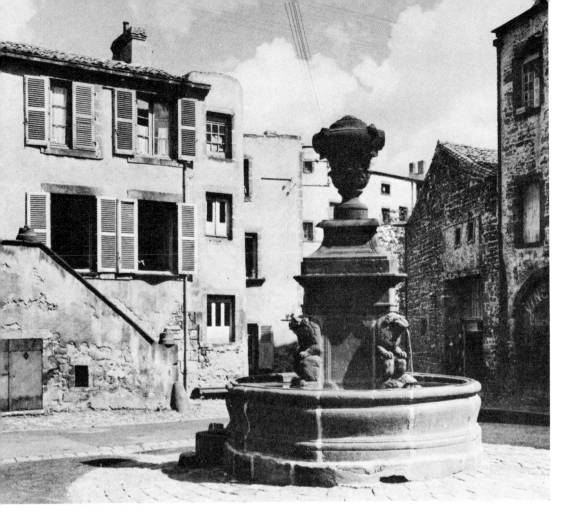

Samuel Chamberlain

Riom, France

*You might like to draw the ox
at the fountain in your sketch. Try
keeping him lighter in tone, even in
semi-outline if it seems better
for the composition.*

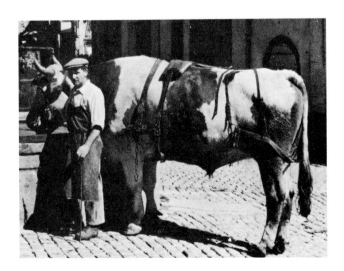

Riquewihr, France

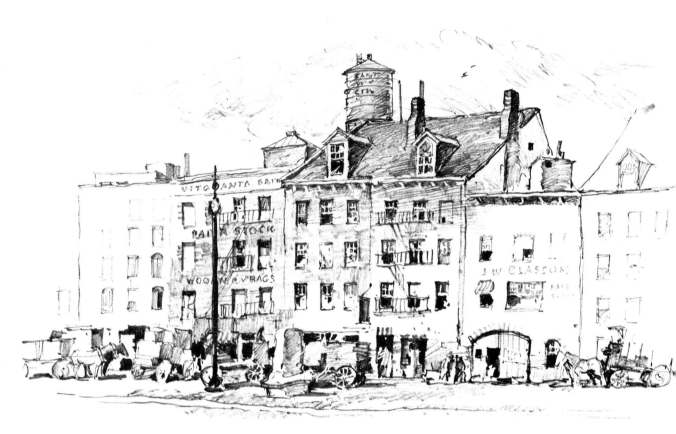

SOUTH STREET, NEW YORK

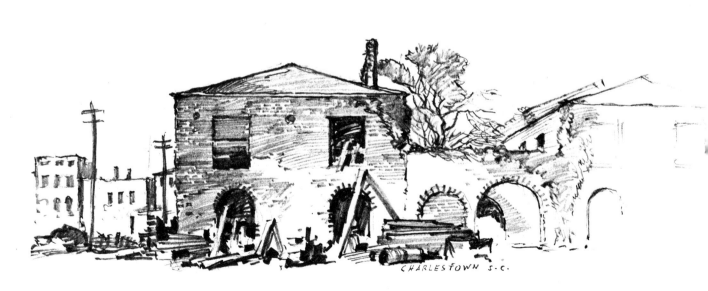

CHARLESTOWN S.C.

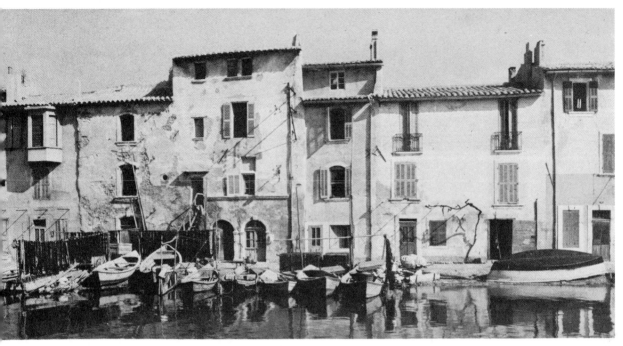

Martiques, France

ASSIGNMENT 18

When we are confronted with a long stretch of building like the above subject, it is necessary to devise a tonal pattern on the walls which will give both design and textural interest. The problem here is similar to that in the sketch of South Street, New York, where the different buildings were of uniform color and tone. The placing of the tone that makes a dark and light pattern on them is purely arbitrary; it might have been designed otherwise. In the old market buildings at Charleston, South Carolina, the situation is somewhat simpler but, in my desire to avoid carrying a monotonous brick treatment over the entire facade, I had a pattern problem here, too. This little sketch, by the way, shows rather nicely how to ease gently out of the picture, indicating lightly, on the edges, a continuation of the scene.

In the photograph assigned for your work, you may be troubled by the boats. If you do not wish to struggle with them, merely substitute a street for the water. In order to make the skyline more exciting, I would not hesitate to put a steeper roof on one or two of the buildings. This would provide opportunity for more dark roof masses, which would help the sketch greatly.

ASSIGNMENT 19

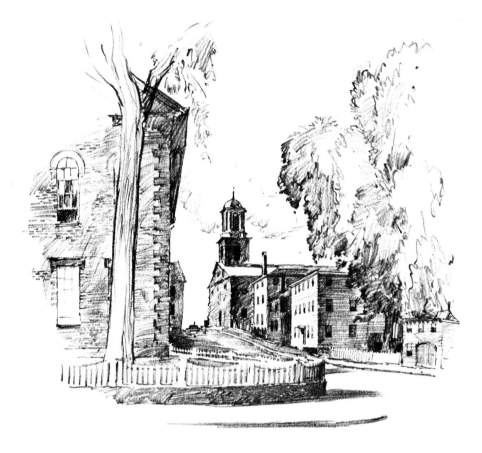

Portsmouth, New Hampshire

This beautiful New England street scene is an excellent subject for the pencil artist. My small rough sketch is offered to suggest compositional treatment rather than technical handling, which is left to the reader who may be drawing it.

I particularly wanted to suggest how the edges of the sketch might be rendered, the brick building on the left and the tree on the right. It seems to me that the tree ought not to be given too much emphasis; it really serves as a frame for what is seen beyond. Similarly, there would be no point in showing more of the building on the left; to do so would detract from the vista that is dominated by the beautiful church. This, indeed, is like a jewel in the setting made by the tree and the brick building.

If the drawing is made at least half again the size of the photograph it will be large enough for convenient rendering of the details, which are very interesting.

Samuel Chamberlain

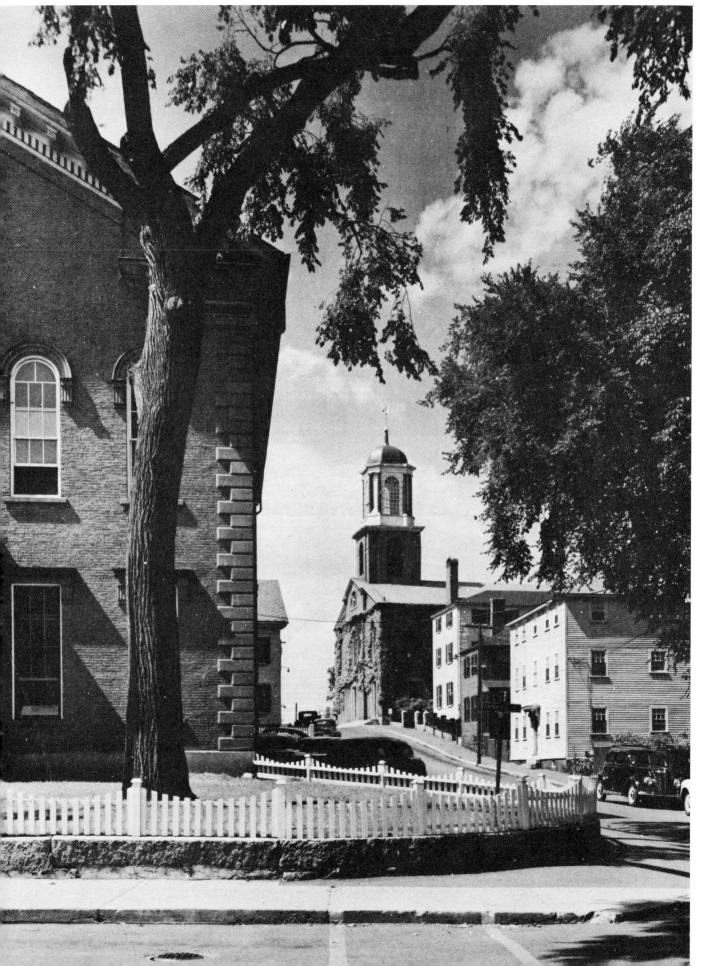

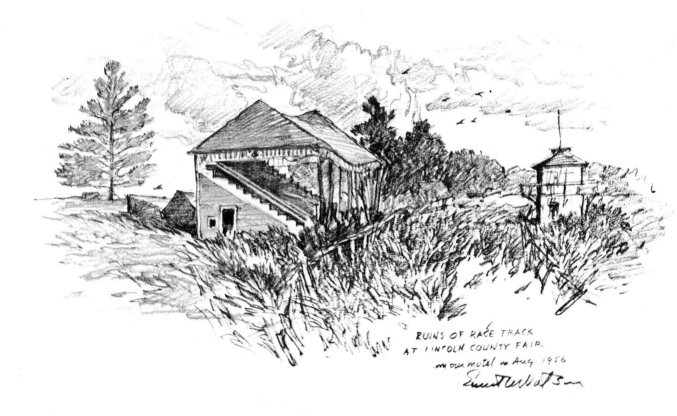

RUINS OF RACE TRACK
AT LINCOLN COUNTY FAIR
..m our motel in Aug. 1956

RUINS OF A COUNTRY FAIR

This little sketch from my window at the County Fair Motel, near Damarascotta, Maine, was made one bright August morning when dew glistened on the grass and the old ruin assumed—to me—a romantic and poetic air. It is reproduced at exact size of the drawing in my pictorial diary. I tried to express the sentiment which the scene inspired, and rendered it with a delicacy that contrasts with the drawing on the opposite page.

I want to call particular attention to the treatment of the grass and weeds that have grown up in the abandoned race track. This treatment demonstrated below, is, I think, a rather successful one.

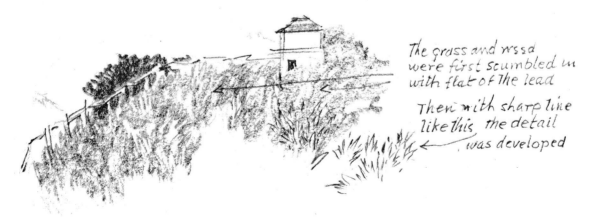

The grass and weed were first scumbled in with flat of the lead

Then with sharp line like this, the detail ← was developed

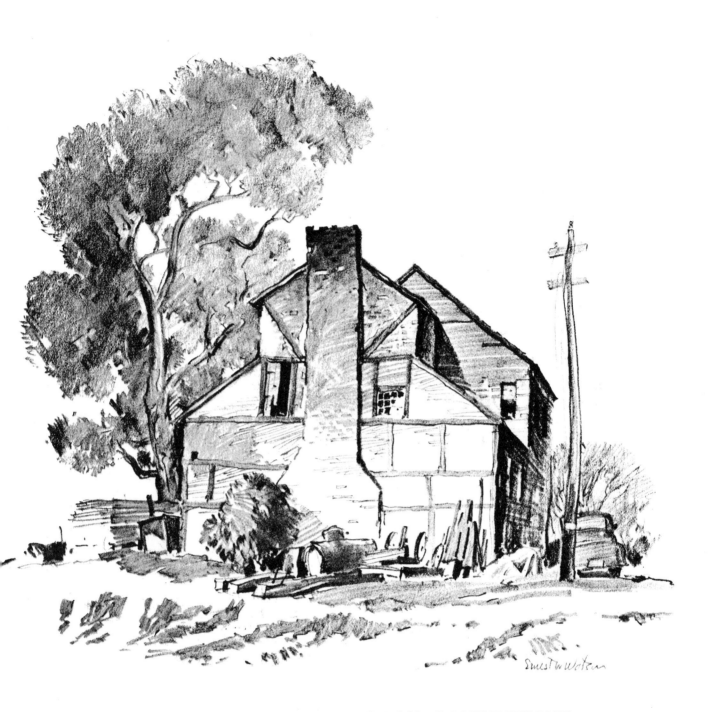

OLD MILL AT LIME ROCK, CONNECTICUT

I point out here the very definite pattern of the foreground which, I feel, gives the building good support. Note in this drawing the use of thin sharp line on the end of the building to give variety and textural interest. See how the building has been made dark at the top to give a strong silhouette against the sky. The tortillon stump was used at the top of the chimney to produce a smoky effect. Observe treatment of brick rendering, a few outlined bricks within flat tone sufficing to indicate the material.

ASSIGNMENT 20

This is an unusually interesting subject but can be made more so by the exercise of a little resourcefulness. The sunlit side of the shed is so nearly the same value as the shaded side that there is a monotony of dark gray tone. Why not make the sunny side much lighter? Then that tarpaper roof is extremely uninteresting. Substitute weathered shingles such as the old shed undoubtedly had originally.

The house with dormer windows, just behind the shed, while affording background interest, ought of course to be lighter in tone so as to avoid the confusion it now gives the picture. It might be treated mostly in line with casual shading indication. The large house at the left does not belong in the picture, but the lobster pots and the automobile will be interesting details.

The foreground near the shed is extremely interesting. The rocks are nicely disposed in design. If the rowboat is included, it might be moved nearer the shed to advantage.

What to do in right foreground may be puzzling, since in the photograph the boat is only partly seen. Perhaps the sketch will be better without it. The rocky foreground just in front of and behind its prow would be appropriate. The posts and stones in the immediate right foreground are not particularly interesting; they might be eliminated.

If you want to develop the sketch beyond what is seen at the right—and this would seem to be indicated—the other building, cut off at the right side of the photograph, can be completed and brought into the picture.

That dark shadow under the shed should be made about as dark as a 6B pencil can make it. A dark opening in the left wall would help; the door might be swung from the left side and opened part way, or a small window might be added.

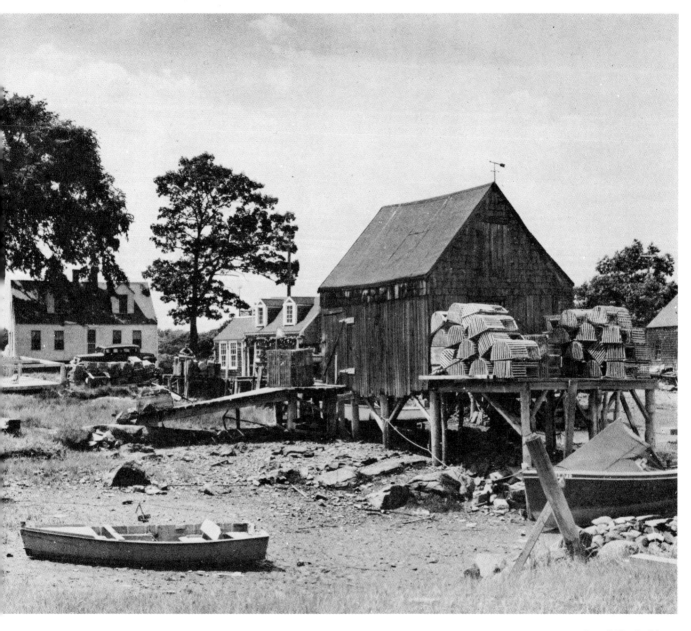

Samuel Chamberlain

Cape Porpoise, Maine

Samuel Chamberlain

Novillé-Maupertuis, France

This French village scene presents a similar problem to the group of houses on Lake Lugano in Italy, which I sketched some years ago. In place of the mountain, there is the church; and in place of the lake a corresponding area of garden. I think I would eliminate the trees in the background; they present a monotonous, horizontal mass of dark. Or if you wish, indicate them pretty much in outline and break up the uniformity of their contour. The silhouette of the distant buildings is so interesting that it should be dominant in the background.

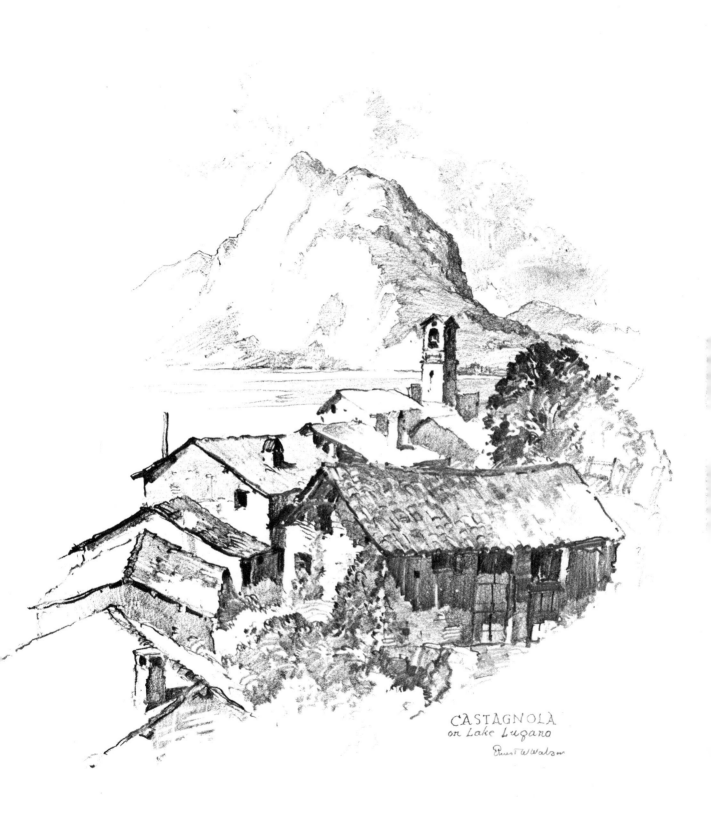

CASTAGNOLA
on Lake Lugano

Ernest W Watson

I have put this drawing in the book to demonstrate the power of the pencil in bold dramatic effects produced with the 6B pencil which gives slashing, inky-black strokes when applied with vigor. The same 6B pencil was used throughout this drawing which I made in the garden of the *Chapel of the Tercer Order de San Francisco* in Cuernavaca, Mexico.

The technique on the building is of a rather scumbled sort, notably on the dome, which shows a bit of scraping with the point of a sharp razor blade. The mullions of some of the windows were scraped out in this way. This was possible because the drawing is on a clay-coat paper.

Again, on the last pages of this book, I want to emphasize the decisive part the paper plays in pencil drawing. You must have a sympathetic paper and you must have several sheets of paper underneath your drawing; a hard, unyielding surface will simply prevent the kind of effects you are striving for.

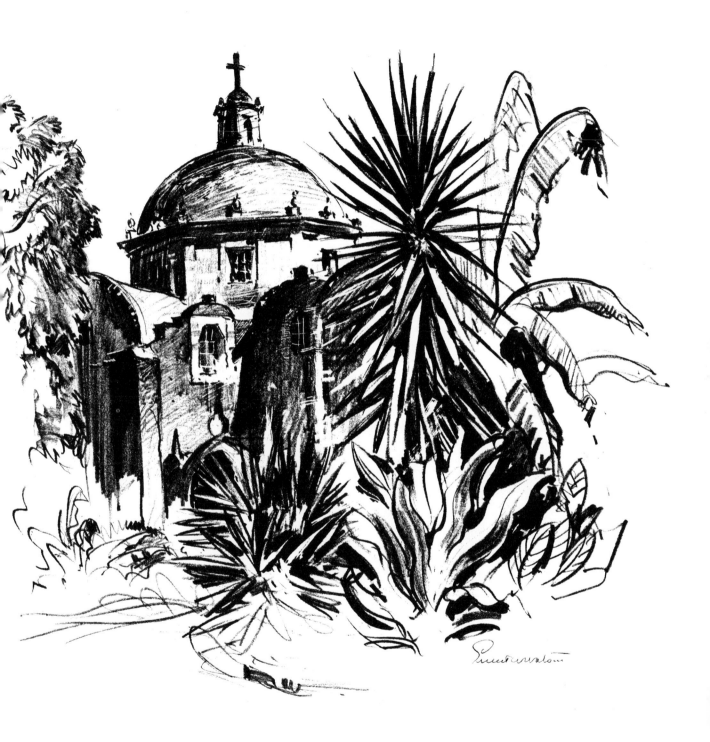

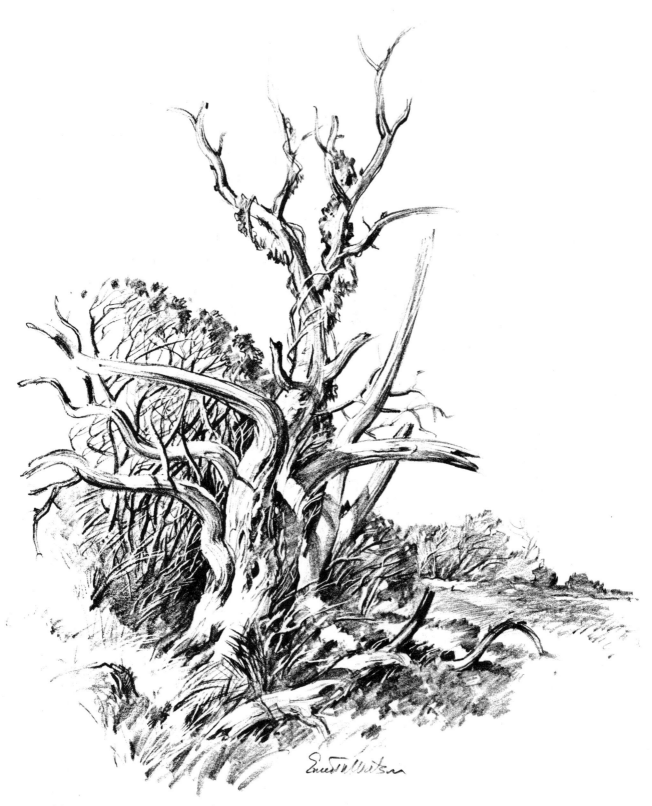

Contents

66 *Scumbled technique*
68 *How to look at trees*
69 *And draw them*
71 *Analysis of form and structure*
73 *Light and shade*
74 *An old oak in South Carolina*
76 *Some technical details*
78 *A dramatic live oak*
80 *How to develop a landscape sketch*
82 *Studies of rocks*
84 *Dead white pine and white spruce, Maine*
85 *A test of your skill*
86 *A giant scrub pine in Maine*
89 *Study of a willow*
91 *Study of a fallen tree*

92 *Palm trees*
94 *An elm in springtime*
96 *Light and shadow on branches*
98 *An elm in summer garb*
100 *Wood interior and brook*
101 *Ruins in a jungle*
102 *A rock in the forest*
104 *Moss-draped trees*
104 *An unusual landscape*
107 *Stone wall and barns*
109 *Road at edge of lake*
111 *Autumn corn field*

Opposite: Dead Chestnut Tree

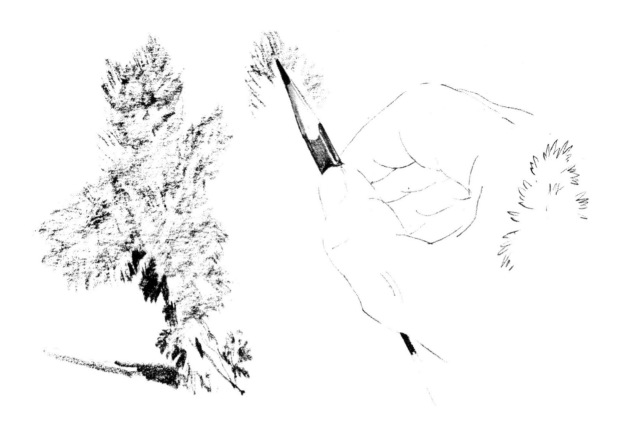

SCUMBLED TECHNIQUE

This is a practical technique for quick sketching. With the pencil held between the thumb and forefinger the pencil almost lies on the paper, and the *length* of the lead, rather than its point, does the work. It is obvious that in this way tones are rapidly made. The page opposite, a reproduction from my Mexican sketchbook, shows how this technique looks in application. The drawings were made from my Pullman car window during a fifteen or twenty minute stop in a primitive village.

In the above demonstration I've shown how the tree was massed-in with the flat of the lead. The sharp, thin lines at the right were added afterward to give detail and finish. The result is seen in my sketch of the same tree on the opposite page. In the bottom sketch on that page I left the tree mass mainly in the scumbled stage, largely confining the use of the sharp line to the buildings.

Referring to the scumbled tree above, note that the pencil almost automatically leaves little light areas that suggest branch construction. So often accidents lead to interesting effects.

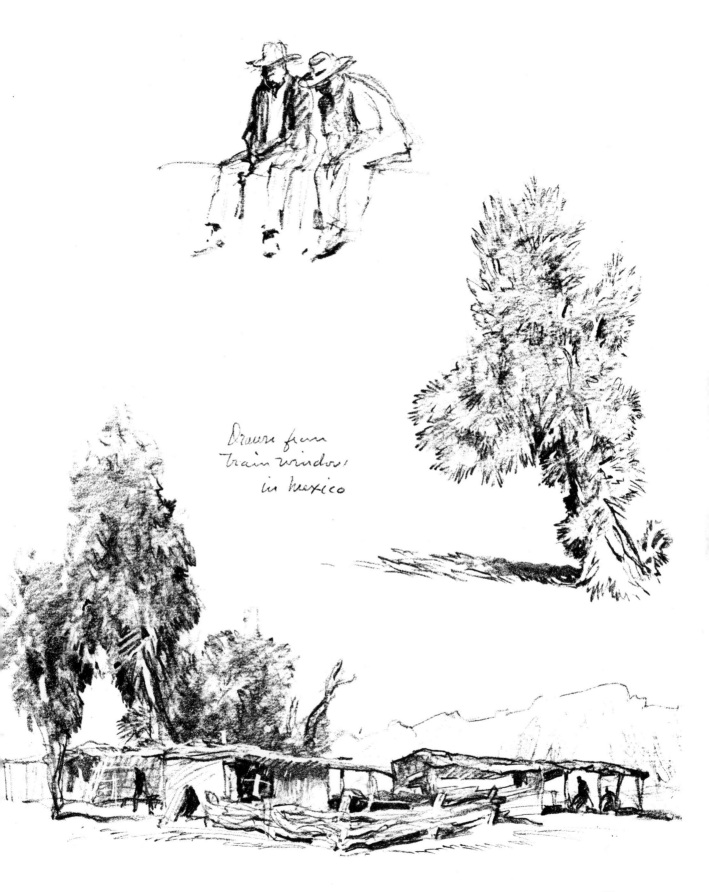

Drawn from
Train windows
in Mexico

HOW TO LOOK AT TREES

In drawing anything whatsoever, the artist's first objective is to establish its character. Every human figure, for example, has its individuality of proportion, shape, structure and carriage, or stance. These are the basic characteristics that must be recognized and recorded before there can be any consideration of detail or of technique.

What is true of people, is as true of trees. Each has its own personality. It stands in a certain way; it has its own peculiar structure; its mass assumes an individual and distinguishing shape. This is true of individual specimens within each variety; no two oak trees, for example, are alike; each because of its separate life experience differs, often radically, from others of its family. The vicissitudes of life are as potent in shaping tree character as human character.

As we drive through the countryside we occasionally notice a tree which is so dramatic that we just have to stop to admire it. There is something peculiarly beautiful about it which makes it stand out from its many neighbors.

What is it that gives the tree such distinction? Is it not first of all its design? Is it not the unusual formation of its foliage masses? Is it not an ordered beauty in the arrangement of its branches? Yes it is design; for some reason its structure has seen fit to develop in such a way as to catch the eye of the artist and, if he is drawing trees, make him get out his pencils and capture its individual beauty.

To do this the artist requires some orderly thinking. He needs to analyze his tree critically to discover the secret of that beauty. On pages 70, 71, and 72 I have demonstrated the kind of analysis to which I refer. It is a simple procedure but an essential one. First establish the tree's stance. Does it stand erect or does it lean one way or another, and if it leans—in which direction, and how much? This is important: if the stance is not correctly realized, the design of the foliage masses as you see them will not be right because their development in the tree has been in reference to its stance. The whole tree grows and expresses itself as a unit.

Such an analysis is the first step. I usually make small analytical drawings quite meticulously, because I have learned by experience that, otherwise, it is easy to fail in portraying the grandeur or the dignity or the charm of a particular tree.

In drawing trees we have to consider both their silhouette (the shape of their mass against the sky) and such light and shade as is produced by the forms of their foliage masses. Sometimes, as with the locust on page 72 and the maple on page 73, we are more impressed by light-and-shade effects than by silhouette. However, that does not make us less concerned with the over-all shape of the tree's mass. Some trees, like the birch, do not have sufficiently compact leaf masses to suggest any light and shade treatment whatsoever. For instance the form of the South Carolina oak on page 74 is broken by light and dark masses, but its silhouette, shown in the small diagram, is what attracted me to it at first. Similarly the oak on page 70 is principally attractive because of the design of its masses.

AND DRAW THEM

Learning about tree structure, the way trunk and branches grow, is a study in itself and I suggest much drawing of trees when they are bare of leaves. Naturally, every species has its own growth characteristics and the student should draw as many different species as possible. This matter of structure is a fascinating thing; the strange ways of trees gives us many surprises. The convolutions of branches in some tropical specimens is a matter of wonder.

The textures of tree trunks are of great importance in tree sketching. I advise making many large-scale drawings of trunks alone, getting acquainted with the infinite variety of bark textures, some of which are ingeniously contorted and so attractive. Compare the rough bark of the locust with the smooth skin of the beech. Being acquainted with these characteristics is important, even when your tree drawings are quite small and you can do no more than sketchily suggest the trunk textures.

In this connection, refer to the drawing of the elm on page 95. I made this sketch from the photograph opposite to give readers a hint of how one can render such a scene. Now in the photograph, the tree trunk is very dark; it does not reveal its texture or the accidents of its growth. Yet in my tree you will see that these have been supplied. Having drawn all manner of trees for years, I am well aware of the way in which their trunks so often are made up of folds of bark and twisted sinews.

Note also the treatment of trunks in the group on page 103. You will see here the suggestion of bark having been stripped from the trunk at places, a rather common occurence. Observe the trunk of the dead tree on page 64. It is such accidents of structure and texture that will give your tree drawings authority and interest. So make a thorough study of this important aspect of the subject. It might be interesting to devote one entire sketchbook to this. I assure you the effort will be as rewarding as it is fascinating. It will give you a valuable intimacy with all trees.

Just what kind of strokes to make to indicate various kinds of foliage is something each has to develop for himself; that indeed is the technique which will be his signature. I am sure that anyone familiar with my drawings, for example, can readily identify them.

While your drawings will seldom be large enough to show actual leaf details, you can, by the way you handle your pencil strokes, indicate leaf character. Thus in the locust tree on page 72 the pencil strokes have a character that could not be mistaken for willow or pine; and the spring foliage of the willow on page 88 indicates the delicacy of foliage in which individual leaves merge in delicate masses.

It has been impossible in this book to illustrate more than a few of our native trees, but I deem the omission of others unimportant because anyone who has assimilated the instruction on these pages will have enough resourcefulness to adapt it to trees of all kinds.

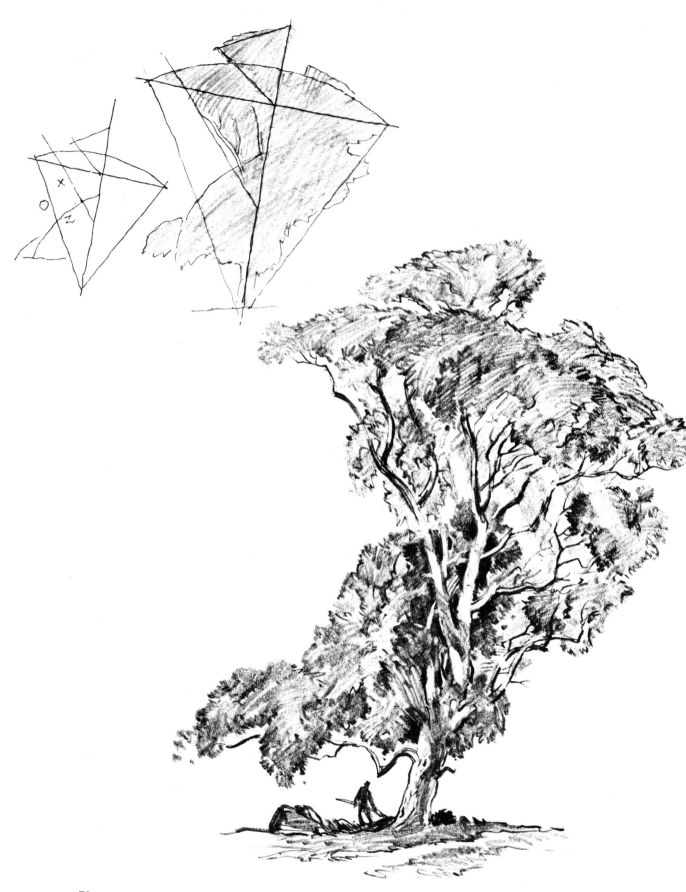

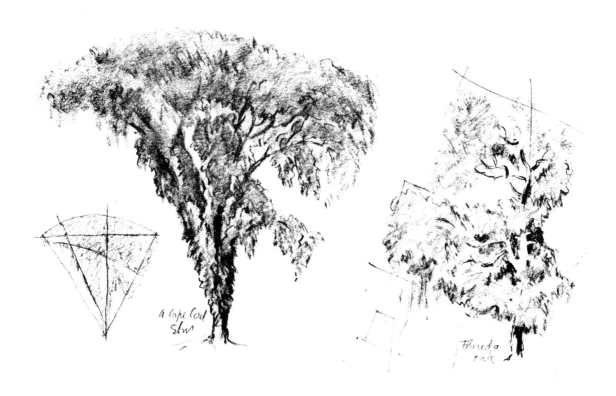

A Cape Cod elm

Florida oak

ANALYSIS OF FORM AND STRUCTURE

On pages 68 and 69 I mentioned the importance of analyzing foliage forms and the structure of trees before attempting to render them. Here we have a graphic demonstration of the procedure.

Consider the oak on the opposite page. Note first its stance, its pronounced lean to the right. Then, as our diagrams illustrate, the analysis gives us an almost perfect geometric figure, the trunk line nearly bisecting the triangle.

Interestingly enough the Cape Cod elm has a somewhat similar geometric basis. The design of the Florida oak really surprised me— two rectangles, balanced off center on its vertical trunk. Both of these sketches are exact size of quick sketches made from my car. I make many such sketches of trees that have especially interesting formation. From these I can at any time make larger, more complete drawings.

Note how the elm was "brushed-in" with the flat of the lead, as demonstrated on page 66, and the lower and right portions given more finish with line treatment. I just didn't have time to complete the entire drawing in that way.

Referring again to the large oak drawing, on page 70, note that while the silhouette of the tree foliage masses is the most important aspect of its character, the lower leaf mass is dense enough to give light and shade. The variation of tones in the upper masses is due to thickness of foliage, although the leafage is not sufficiently dense for noticeable light and shadow.

The diagonal light rays were added after the drawing was otherwise completed. They were taken out with the kneaded eraser.

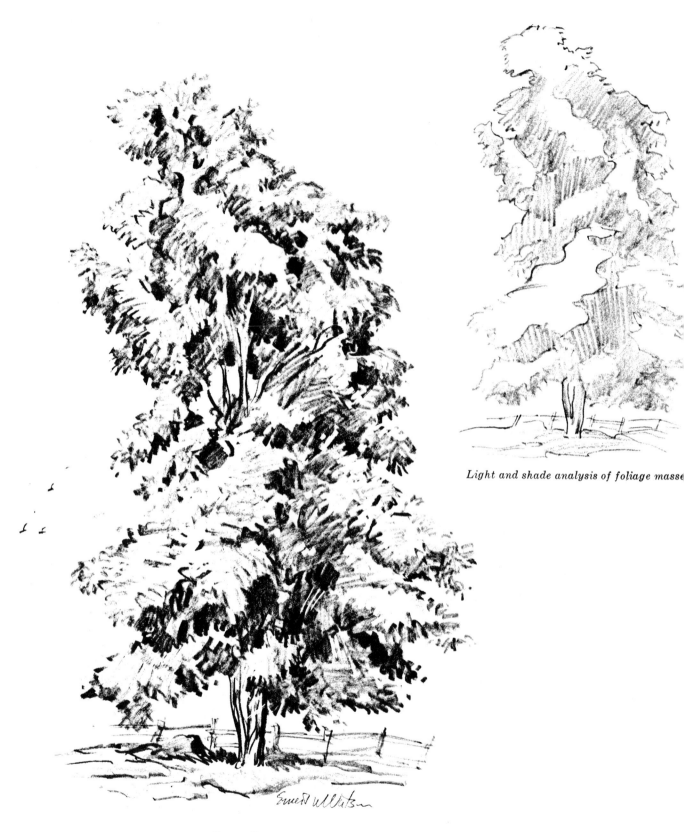

Light and shade analysis of foliage masses

Locust Tree

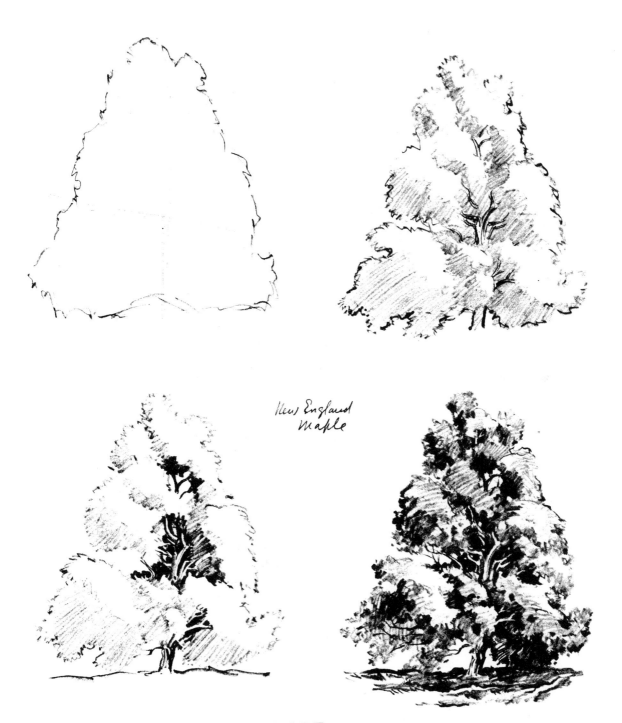

New England
Maple

LIGHT AND SHADE

When a tree is in full leaf, its entire foliage mass naturally breaks up into separate elements that must be rendered in light and shadow. These foliage masses do not always make a pleasant design and it is, therefore, necessary to redesign them. At any rate, a quick analytical sketch like that of the locust on page 72 is helpful before actually starting tree rendering. After indicating the foliage masses and the main branches that can be seen (as in the upper right sketch of the maple) I usually lay-in the darkest tones (lower left drawing), and then finish with the lighter tones.

73

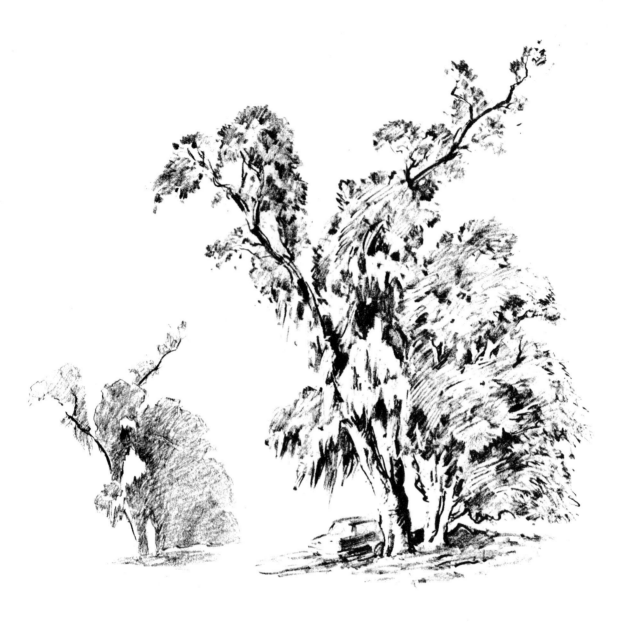

AN OLD OAK IN SOUTH CAROLINA

I was first attracted to this tree in South Carolina by its interesting silhouette. But within that, the disposition of light and dark interested me as much. Those pendant light shapes on the big tree are Spanish moss which drapes so many southern trees with lacy green-gray adornments. This tree is very old and, evidently, has suffered many accidents which have resulted in its bizarre shape.

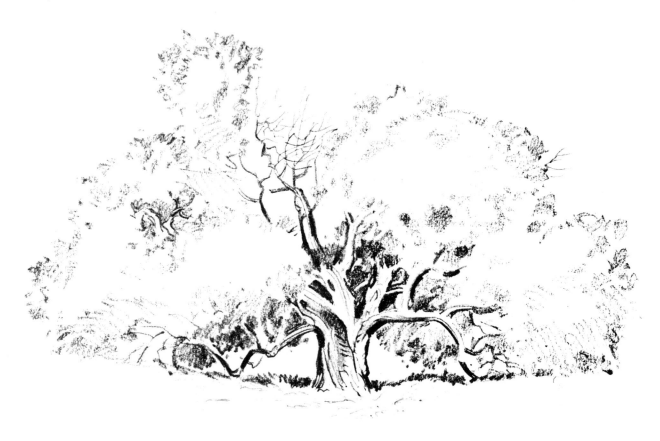

These two sketches of an old apple tree, exact size as the originals, were made at my Berkshire, Massachusetts, home. In the upper one I used very little tone, more in the lower one; in both I avoided using large pencil masses.

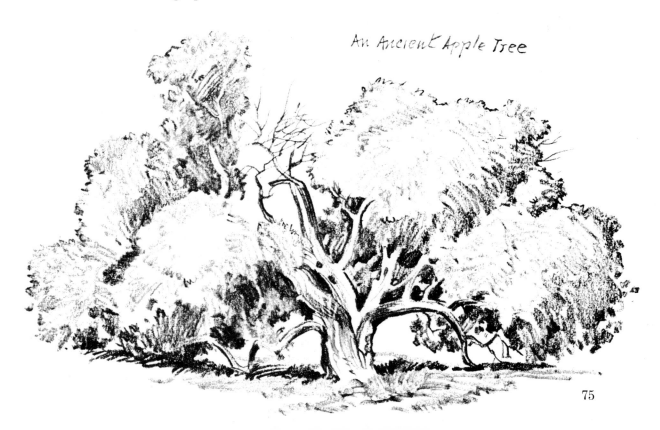

An Ancient Apple Tree

SOME TECHNICAL DETAILS

In this plate I want to point out a number of technical points as demonstrated in the details under the larger drawing.

Now refer to the tree trunk. I have made two sketches of this to show devices which, absent in the one on the left, are so important in giving life and sparkle to that on the right.

First observe the reflected light (B) just inside the contour line of the right outline. You will never see a pure white reflected light like that in a tree trunk, but, as I have said before, we are dealing not in literal representation but in suggestion. And unless you take notice of reflected light in rounded objects they will not look round. Study the tree trunks in other drawings in the book in this connection.

Next, note the accenting of shadows at A, giving sharp contrast with the adjoining white areas; and at C, the addition of small but important textural accents such as you will see in any tree trunk. Look for similar treatments in the sketches of the fallen branch, comparing the upper with the lower detail.

In rendering the distance (see lower sketches) I point out the difference between the lifeless detail at the left and the one at the right wherein small white touches (A) and line accents (C) break up an otherwise monotonous gray mass of distant trees. The areas marked B indicate streaks of light breaking into the gray ground areas.

Some of these details are very delicate but they are important in giving vitality to the drawing. My drawing may perhaps look somewhat brittle, due to emphasis of these points for instruction.

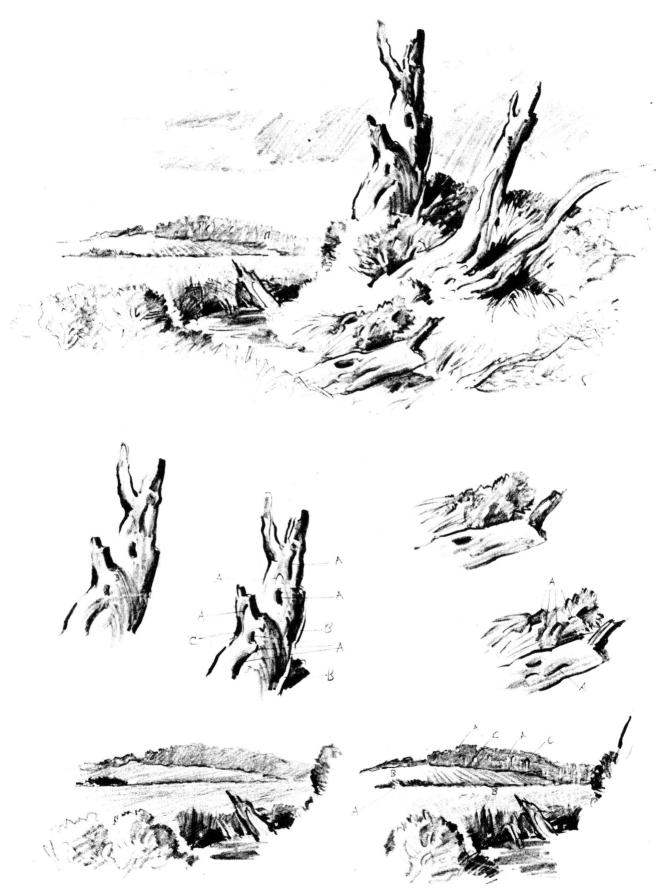

A DRAMATIC LIVE OAK

I drove perhaps a mile past this tree in Georgia then, unable to get it out of my mind, I turned back and made the drawing which pleased me more than any other tree sketch that I did on my southern trip. It is an old, weather-beaten tree that has taken on a unique character which is enhanced by the Spanish moss draped from its upper branches, and by the vines that creep up its trunk. To point up the handsome design of all these elements I have made an analysis in one flat tone, shown above. The detail at the right, the same size as my original (the reproduction of the entire tree is slightly smaller) shows how beautifully even this small foliage mass composes itself.

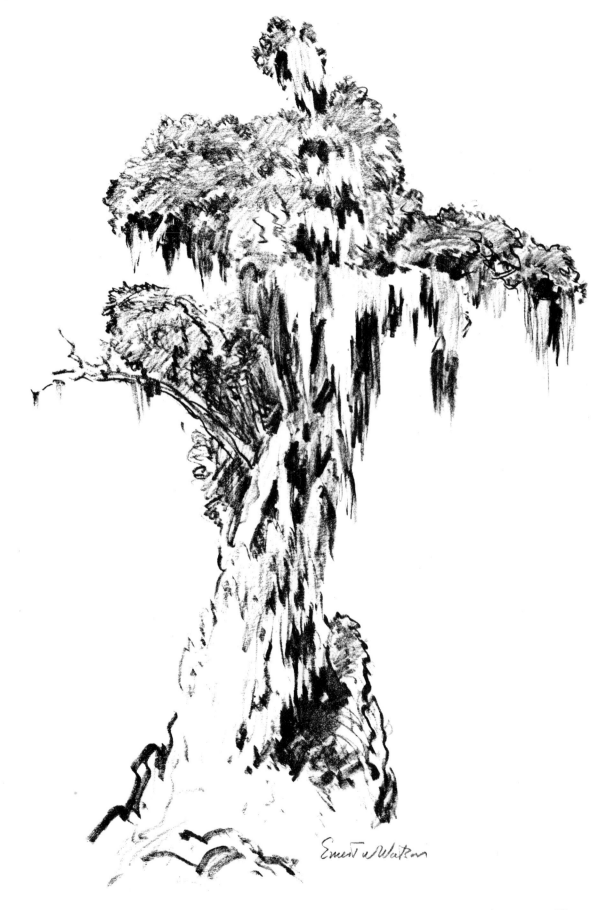

Ernest W Watson

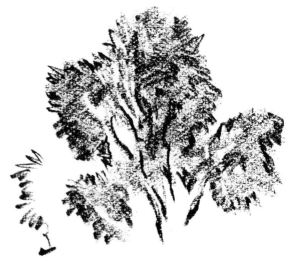

*First rough-out tree mass; then develop
leaf indications with line*

HOW TO DEVELOP A LANDSCAPE SKETCH

The two landscape sketches on the page opposite show its beginning and its completion.

First I massed the tree forms with a 4B on *Aquabee Satin Finish* paper, thinking mainly of the shape of the foliage masses silhouetted against the sky and mindful also of the structure of that large tree, the trunk and branches of which show light, here and there, against the dark leafage.

In the first stage, composition was my chief aim. I altered the tree arrangement from the nature subject, changing the tree forms somewhat and adding the smallest group at the right. The foreground tree was added at the last to give a more balanced composition; and the cloud in the sky serves a similar purpose.

Now if we mass-in foliage even in a casual manner, like the upper sketch, we discover that accidental shapes of light and dark are useful in our finished sketch. You will see that this is so in this instance.

Bringing the sketch to completion is a matter of developing light-and-shade foliage masses and, with sharper pencil, indicating leaf character throughout, much as is demonstrated on page 66. These line indications run all through the mass as well as along the contours. They sharpen up the drawing and put life into it.

Note, also, that sharp dark shadow lines under white branches play an important part in emphasizing structure.

Observe that the foreground indication of the grasses and the middle distant dark line of the marsh's further edge make a rather definite pattern. In connection with this turn to pages 112 and 113 where I have called especial attention to the importance of giving foreground masses rather well-defined pattern value.

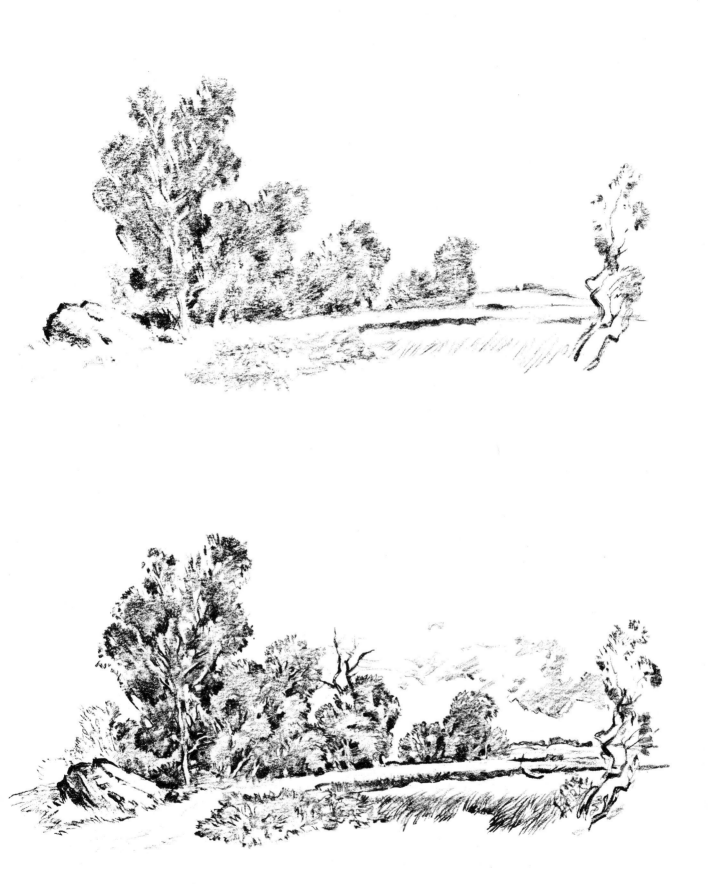

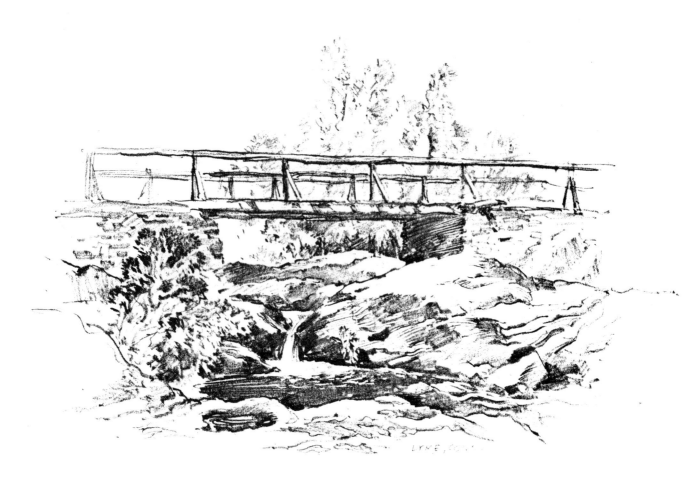

STUDIES OF ROCKS

Rocks can be difficult or relatively easy to render depending upon the character of their forms and how they are lighted. Rounded, smoothly worn rocks are harder to draw than rocks that are more angular, as they do not have definite light-and-shade patterns.

The rocks in the above sketch are at the head of a waterfall in the hills near Lyme, Connecticut. They have been worn smooth by waters that have tumbled over them for centuries; their convolutions are subtle. To render such rocks, particularly on a gray day, taxes an artist's resourcefulness. He has to organize his own light-and-shadow effects to give the sketch interest and legibility.

By contrast, the rocks on the opposite page, sketched on the New York shoreline of Long Island Sound, supply a ready-made composition of light and shadow, as is evident in the first stage of the drawing at the top of the page. A brilliant sun picked out the formation in a sharply defined pattern which was easy to follow. These rocks also have been subjected to the wearing action of the waters which, however, have broken them up into some very sharp-edged elements that provide an interesting contrast with the smoother forms above.

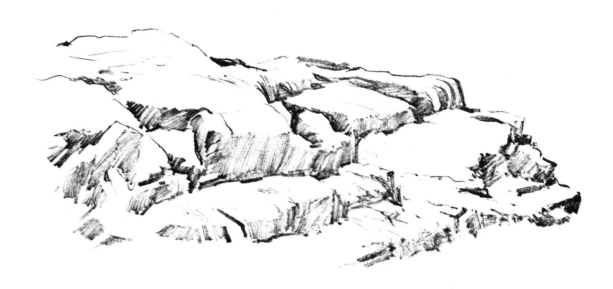

After laying-in the basic form pattern in the upper sketch, the textures were developed within lighted areas and in the shaded parts. In applying tone to the lighted planes I was careful not to camouflage the basic form pattern too much, so I left many of the light planes white.

I spent quite a bit of time meticulously drawing these rocks in order to make them authentic. One might think it would be easy to fake such a study but I assure the student that it is not; you just have to study rocks as conscientiously as you study the human figure. They do surprising and beautiful things.

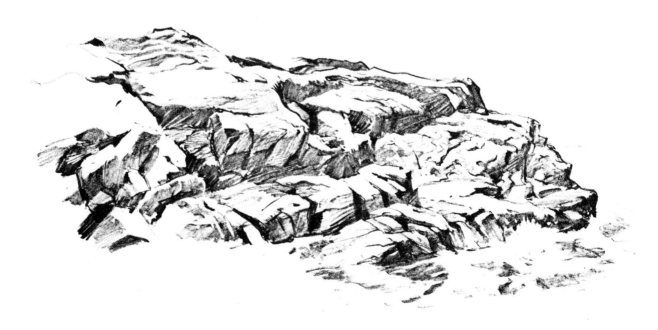

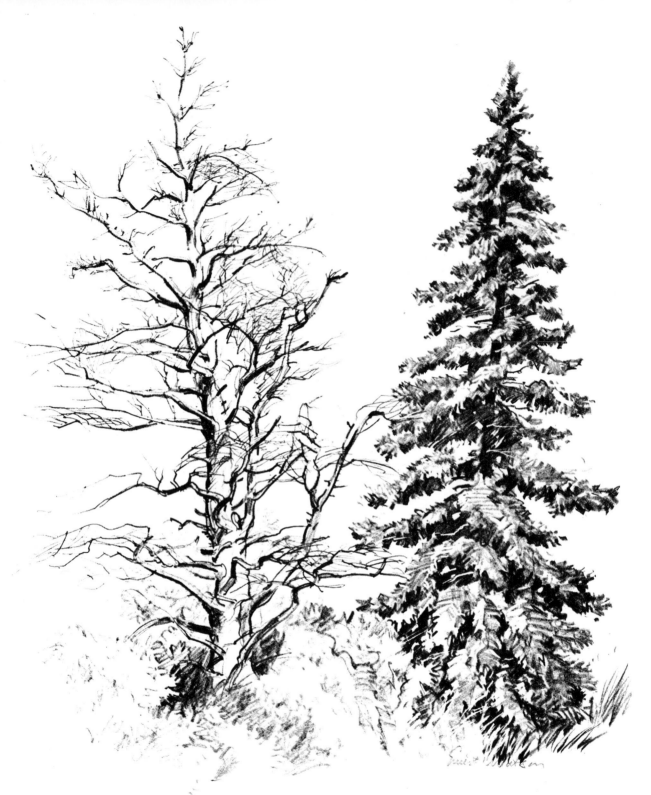

DEAD WHITE PINE AND WHITE SPRUCE, MAINE

These dramatic trees are characteristic of the Maine Coast. The dead pine is always fascinating. Even in death it will not surrender its vigor. You have to draw it with a nervous, spontaneous touch.

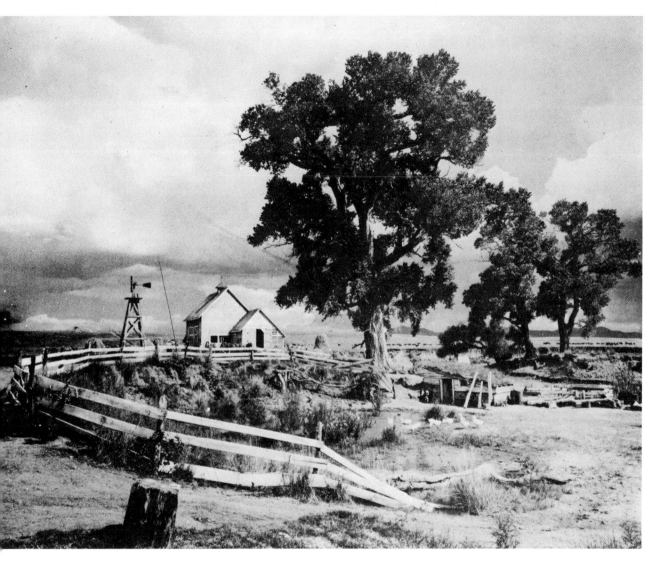

Photograph of "Oklahoma!" motion picture set

Photograph from Sinclair Refining Company through the courtesy of Magna ("Oklahoma!")

A TEST OF YOUR SKILL

This scene, from the motion picture set for *Oklahoma!* is an excellent subject for your own creative sketch. Refer to all tree demonstrations and to those drawings in which foreground has been carefully designed in definite pattern. The sky will be important here. Refer to sky studies in various sketches. Do not hesitate to cover the building with a tone to silhouette it against the sky if that seems indicated. Extend the landscape to right or left if you wish. Of course the big tree is the *pièce de résistance* here. Analyze it carefully to be sure you capture its dramatic character.

A GIANT SCRUB PINE IN MAINE

Along the road to Christmas Cove, a fascinating Maine Coast Harbor, is a row of giant scrub pine trees. They are called "scrub" because they are not suitable for lumber. When a "scrub" was very young an insect, boring into the bud at the tip of the main stem, destroyed the possibility of that sapling becoming a straight growing tree from which boards and timbers could be cut. Thus, almost from birth, the tree expanded laterally and its side branches sprung out in the most astonishing ways to produce a beautiful and riotous creation.

These trees, well over one hundred years old, are challenging to the pencil artist. They are challenging because it is always difficult to convey the impression of their immensity in a relativley small pencil sketch. I made several drawings of these trees. The one reproduced here is the best of the lot, but upon fininshing it I felt somewhat frustrated because it didn't project the great size of this monster tree, even after I put in the fence to give it scale. When that did not suffice, I brought in the horses, standing head to tail as horses are wont to do in pasture, the tail of one serving to protect the head of the other from pestering flies. But even then I felt disappointed; somehow that tree doesn't look big to me.

The difficulty of suggesting the size of a tree in small-scale drawings has always baffled me. That willow on page 88, for example it is really a big old tree and it ought to be more convincing than it is in my drawing. All artists have the same complaint and we just have to recognize the limitations of small-scale drawings. There is no point in making bigger drawings when they are to be reproduced at small-scale. The more one can focus upon the detail of the trunk the more likely one is to succeed in portraying size because the marks of age are usually recorded there.

Now when you go to Maine, as you should, remember to look for these trees on the road from Damariscotta to Christmas Cove. I think their gray, pre-historic looking trunks and erratic growth will entrance you as they did me.

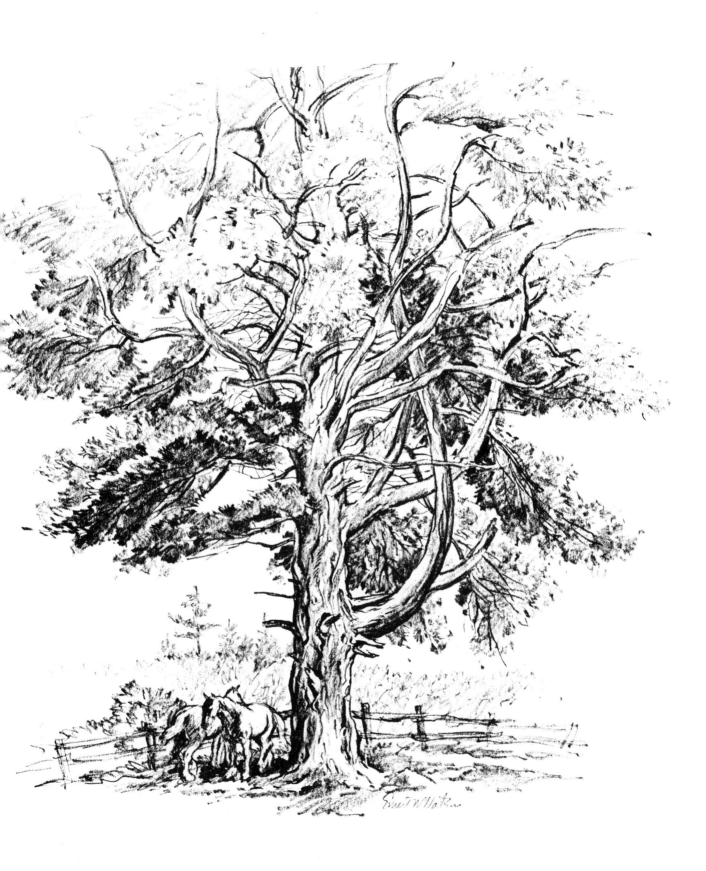

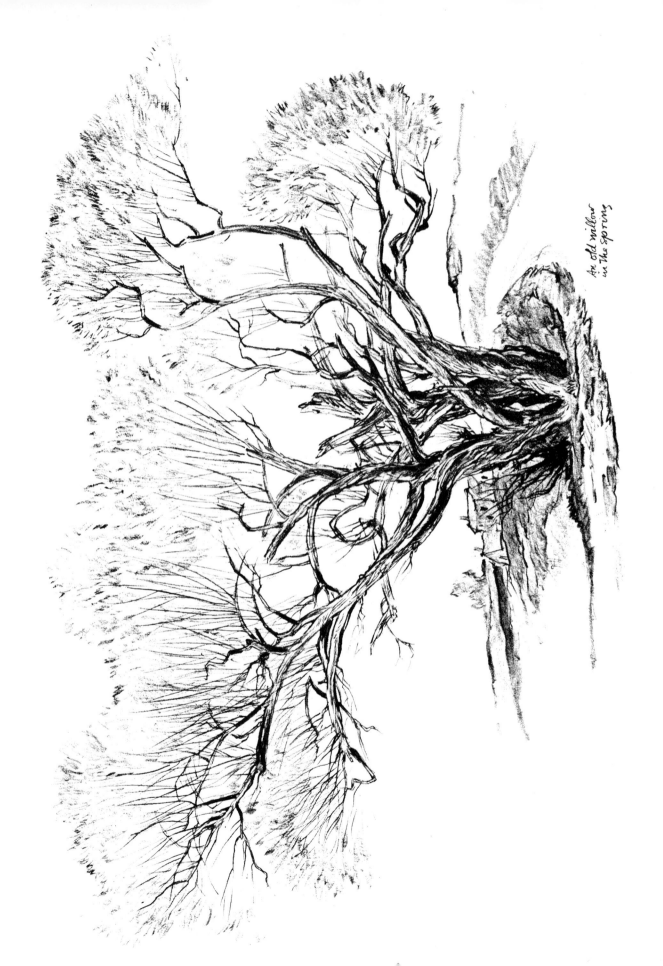

An old willow
in the spring

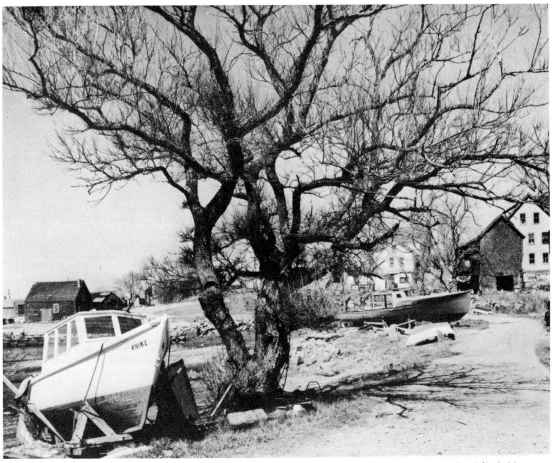

STUDY OF A WILLOW

The above photograph of a willow tree is offered as a subject for the reader's pencil. The problem is similar to that of my own drawing on the page opposite, but there is much background interest in the photograph that can be effectively exploited.

The boat in left foreground, in my opinion, is awkward in the picture. I would leave it out, drawing a small dory up under the tree if desired, or putting some interesting rocks there.

The branches of the willow are all quite black in the photograph but we need only to look at the tree photograph on page 43 to get some ideas for light and shade on them. References to the elm on page 41 and to the tree study on page 49 will be helpful.

Organize those masses of small branches and twigs into a fairly definite pattern which already is suggested by their disposition in the picture. Keep your darkest tones in the tree and its shadow on the ground.

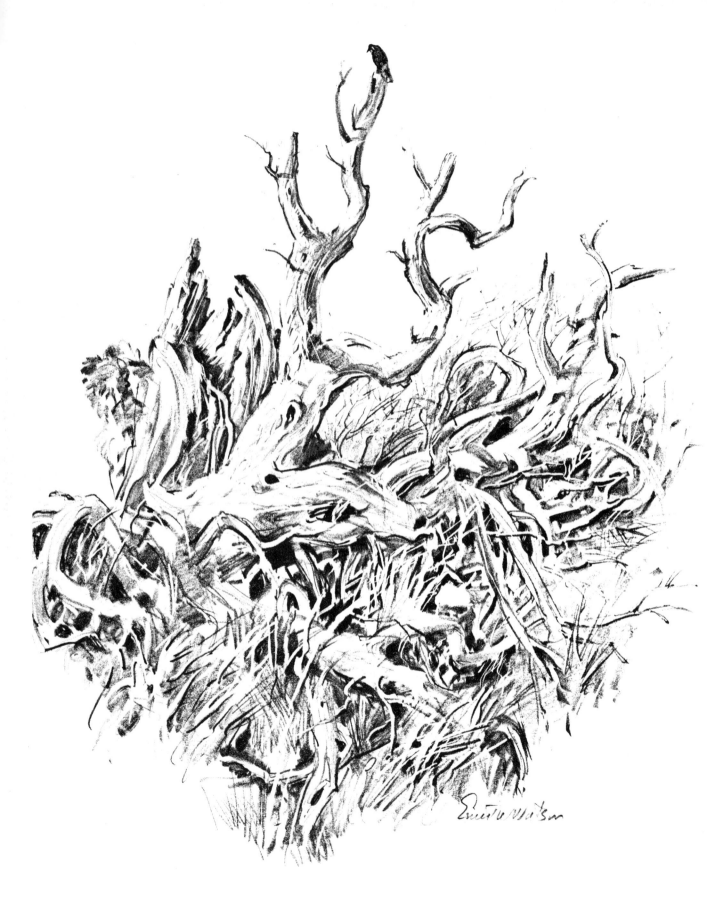

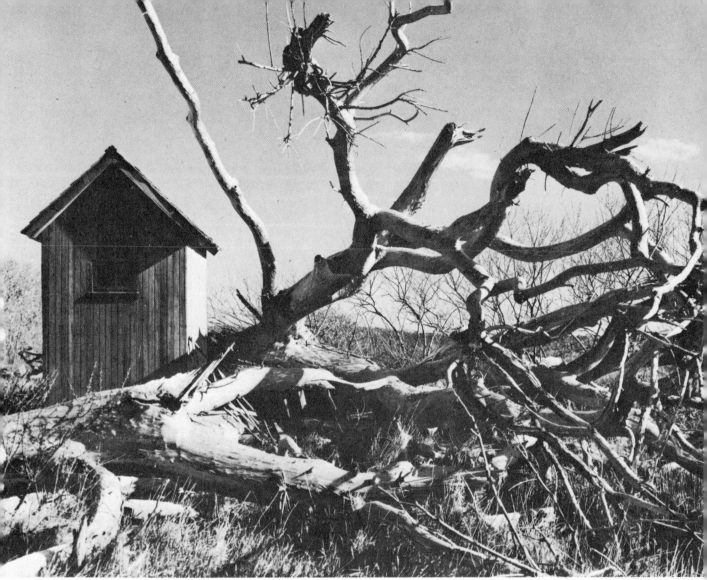

STUDY OF A FALLEN TREE

This ought to be fun. It should be drawn on clay-coated paper to make possible the interesting silhouetting of light branches against the dark shadow by scraping them out with the razor blade.

Make a meticulous drawing of the main branches in light line so that you can render with assurance and vigor later with your soft leads, their dramatic play of light and shadow.

Perhaps instead of the shed in the background you may wish to develop a background of bushes similar to that on page 64.

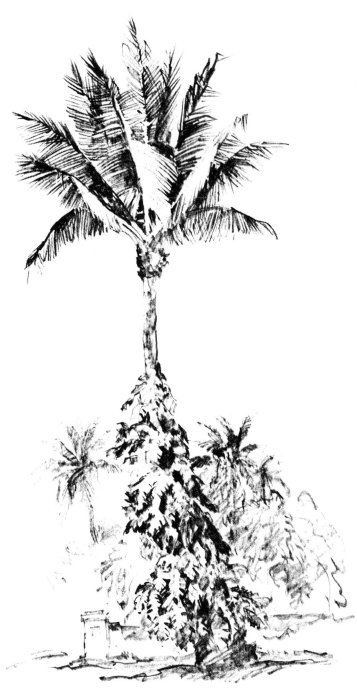

Florida Palm with Climbing Vine

PALM TREES

When I first drew palm trees in Florida, I was surprised at the difficulty they presented in a pencil study. The trouble, evidently, was my failure to realize how much solid dark mass there is in those graceful waving fronds. When I recognized *that*, I had the problem at least partly licked. I say "partly" because I still find palms among the most difficult of all trees to draw. In the lower branches of that palm on the opposite page, notice how many of the leaves are partly broken or bent and therefore interrupt the regularity of growth of the branch. You have to draw those broken leaves quite meticulously. They are very characteristic and if you ignore them you just don't have a convincing palm tree. They have to be carefully outlined and then silhouetted by penciling-in the dark behind them.

Also you have to silhouette some of the branches white or very light against dark mass, bringing them toward you. This, too, involves careful delineation. I recall spending considerable time capturing the graceful sweep of those curving branches before I attempted any rendering. After that, I brushed-in the black masses with a soft lead worn to a point like #6 on page 11, and from them worked out to the leaf detail, using a pointed lead to indicate the sharply pointed, slender character of the leaves.

The vine that climbs up so many of the trees is *pothos aurea* (of the Philodendron family) a lush, brilliant, deeply serrated leaf. It adds its peculiar beauty on an already lovely tree.

Both of these drawings were done on *Aquabee Kid Finish* with a 6B pencil.

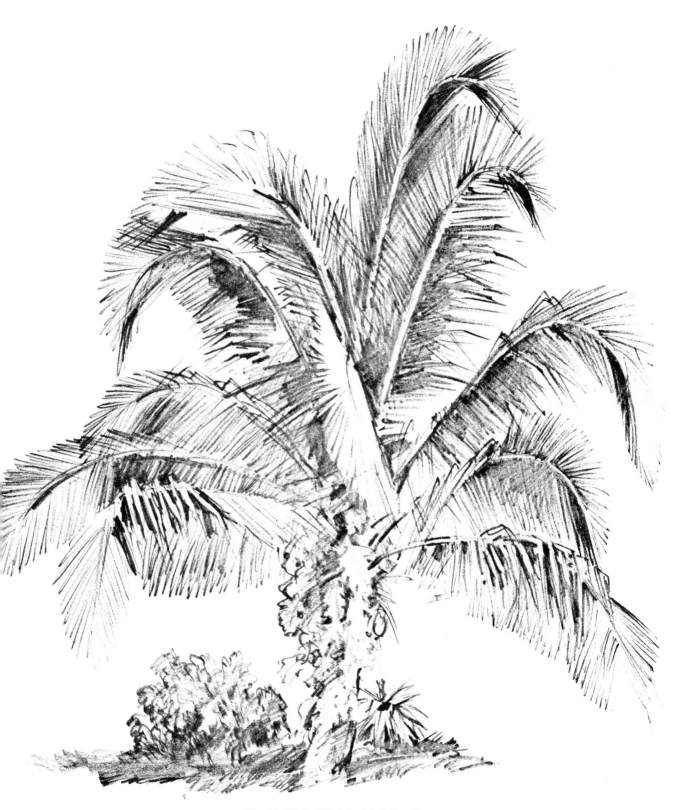

Florida Palm Sketched in Miami

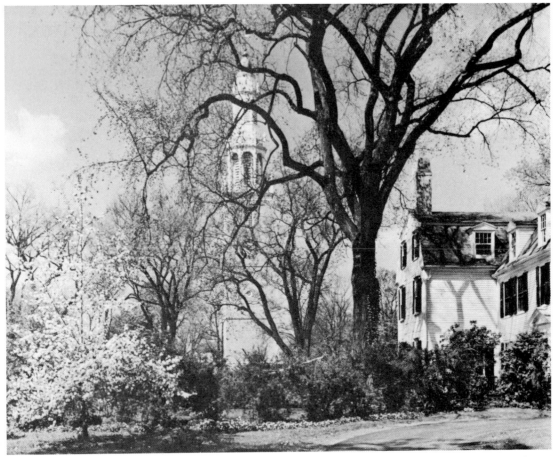

On Campus of Phillips Andover Academy, Andover, Mass. Samuel Chamberlain

AN ELM IN SPRINGTIME

I have made a rendering of this subject to illustrate several points. On page 68 mention has already been made of the rendering of the trunk and branches of this elm, calling attention to the treatment of bark growth and texture which had to come out of my memory of such things through observation of countless trees, because these details are not revealed in the photograph. Notice here the indications of reflected light and refer to instruction on this phenomenon on pages 76 and 77.

In my drawing, the church tower is rendered with great delicacy in light tone in order not to have it impinge upon the foreground. The tree foliage is kept filmy through avoidance of such vigorous strokes, for instance, as those in the foliage on page 101. It is springtime and the leafage at this time is tender rather than assertive.

Note the way in which the foreground bushes gradually lose their tone at the sides and gracefully melt into the white paper.

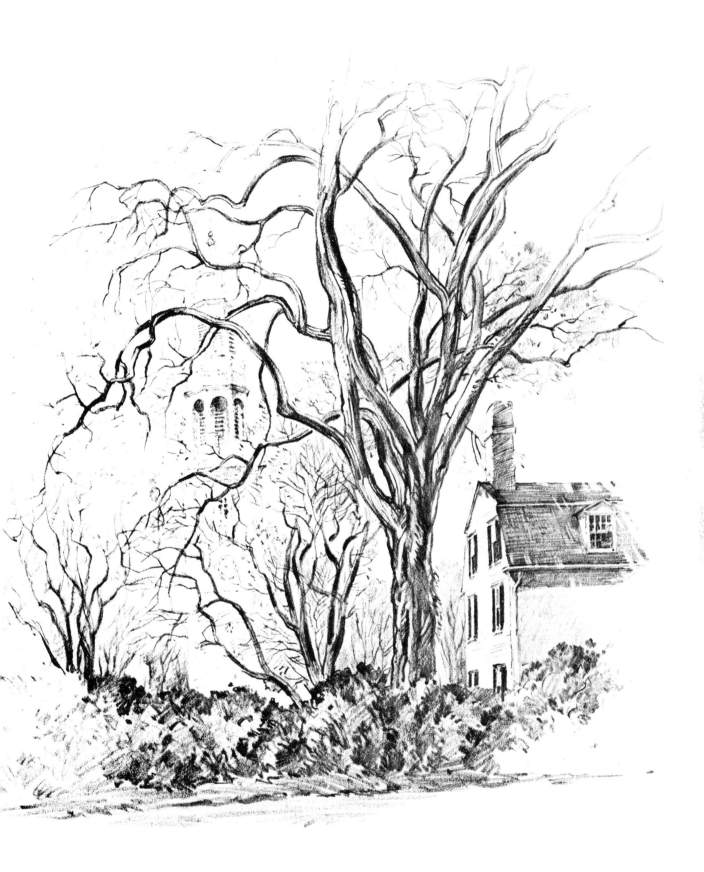

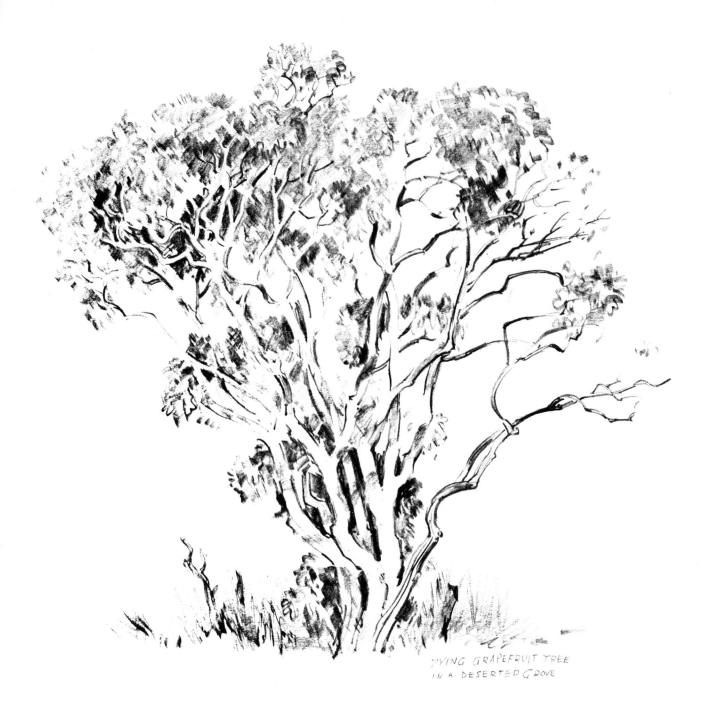

DYING GRAPEFRUIT TREE
IN A DESERTED GROVE

LIGHT AND SHADOW ON BRANCHES

The light-and-shade treatment of the branches of this old grape-fruit tree is similar to the effect seen in the photograph on the opposite page. The photograph is offered here as a subject for the student's pencil in the study of this light-and-shade effect. Your drawing might be made the same size as the photograph.

96

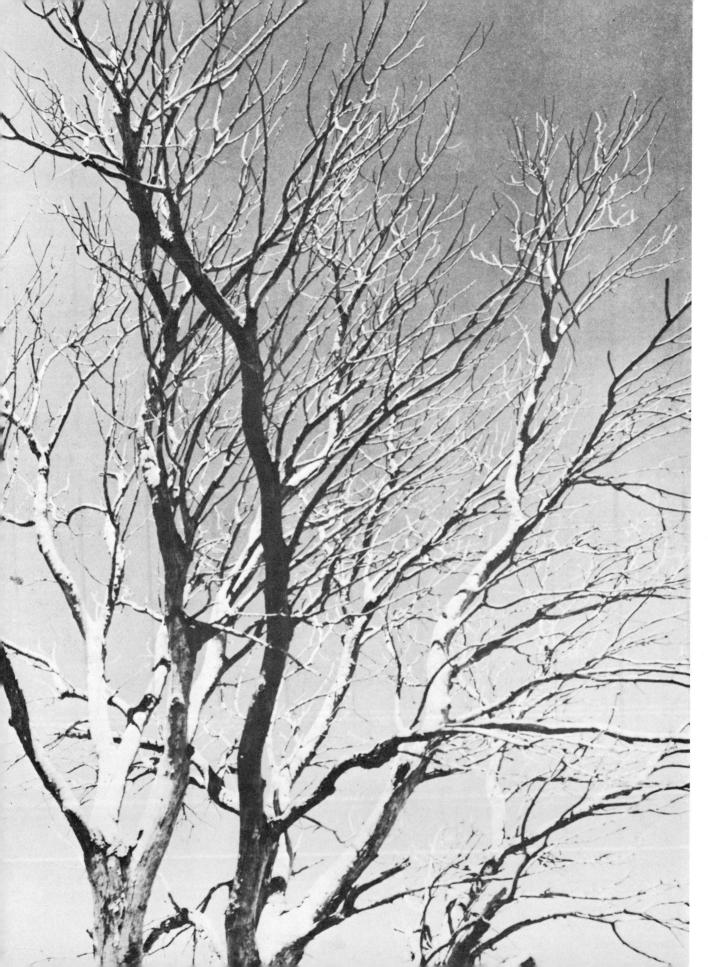

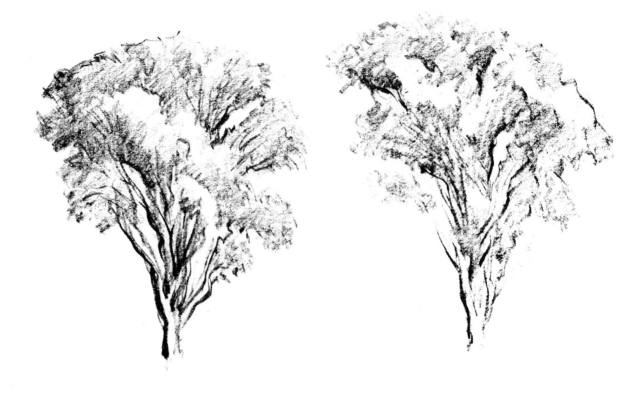

AN ELM IN SUMMER GARB

This is a magnificent specimen of one of New England's famous elms. Yet we have to do some creative designing in drawing it because as it stands, its foliage disposition lacks interest. We often encounter this problem in drawing trees and we have to use our ingenuity in rearranging their leaf masses.

At the top of this page are two suggestions for the massing of the foliage in an effort to give interesting light and shadow effects. Notice that I have opened up space between some of the branches to give greater variety in their structure. Thus, you will say, we have not drawn the tree of the photograph but have created entirely different trees. Well, the one on the left strays from the original only slightly so far as its over-all form is concerned; its contour is similar even though the disposition of foliage masses is different. The one on the right does indeed look like another tree, but it is likely that I might draw it that way if I were sketching on the spot. So long as the elm character is preserved it is unimportant that we make a facsimile— provided we can improve upon it.

The point I want to make here is that we have to be creative when drawing from nature. This means, of course, that we must have a background of knowledge of trees, acquired through much observation.

Suppose you make a drawing from the photograph of this elm, adapting in your own way, its form and structure first in small studies then in a larger drawing, perhaps a little larger than the photograph.

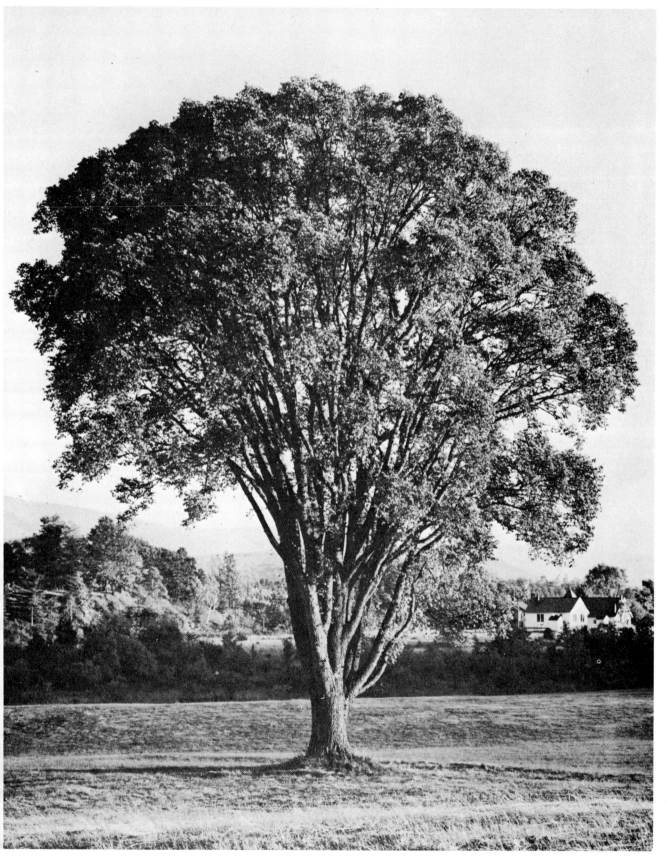

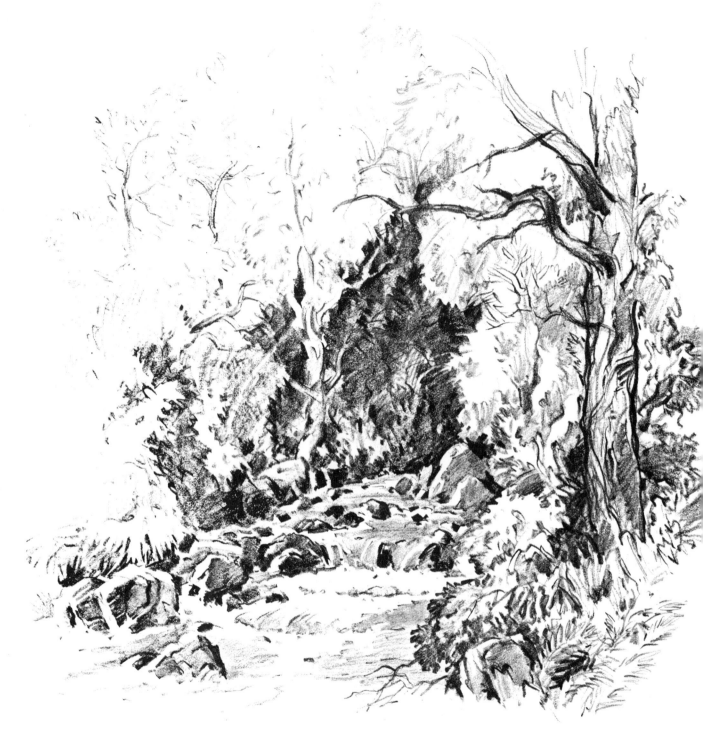

WOOD INTERIOR AND BROOK

In the drawings on these two pages we consider the problem of rendering dark wood interiors. In the brook subject I tried to create the effect of peering into the darkness through an opening in sunlit trees which serve as a frame. This obviated the necessity of covering large areas with dark tone, a procedure that is difficult with the pencil.

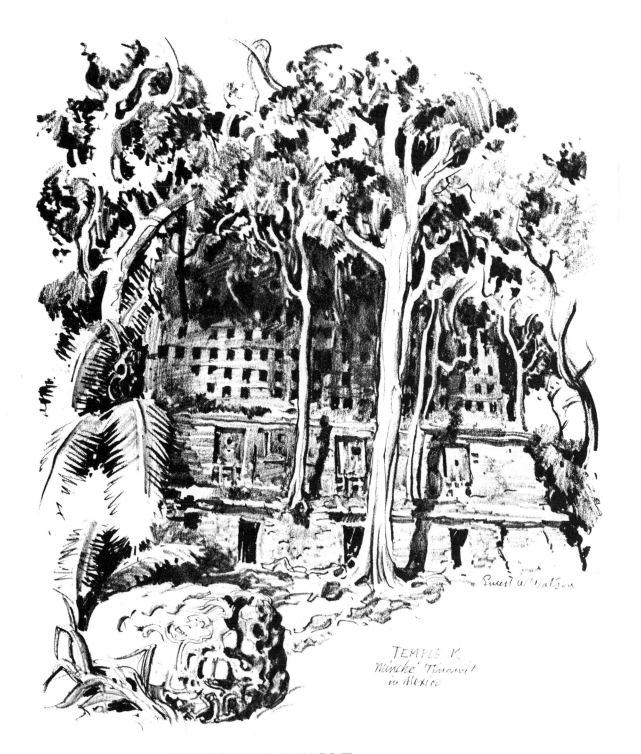

TEMPLE K
Minche Tinamit
in Mexico

RUINS IN A JUNGLE

In this drawing I felt forced to cover a large area with dark tone in order to give the dramatic effect of the ancient ruin shadowed in the gloom of the giant trees. The drawing, considerably reduced in this reproduction, is on a kid-finished paper. The blacks were rendered with a 6B pencil, lighter tones with 4B, 3B and B.

Scumbled tones on a rough surfaced paper with a soft pencil - or on a clay-coated paper gives accidental suggestions for the rendering of stone texture

A ROCK IN THE FOREST

This dramatic composition of trees and rock in upper New York State, was sketched on *Video* clay-coated paper with a single pencil, 3B. The tortuous growth of the trees makes a spirited design and the great rock seen against dark hemlocks provides a striking contrast of shape and texture.

Note how the foliage has been vigorously and rapidly "brushed-in" with a broad-edged point, without much attention to detail of leafage except in a few places, notably in the lower left branch where a few light shapes suggesting leaves are important. The emphasis here is on the writhing trunks and branches and on the rock which has been rather meticulously rendered. Note the play of sunlight and shadows on the trunks, also the indications of bark textures.

The tone on the rock was laid-in with the side of the pencil, held as demonstrated above. Then the point picked out details and added line interest. The delicate trees in the right background, bare of leaves, add a note of contrast to the sturdiness of the rest.

There was no scraping out with razor blade in this drawing; all the whites are untouched paper.

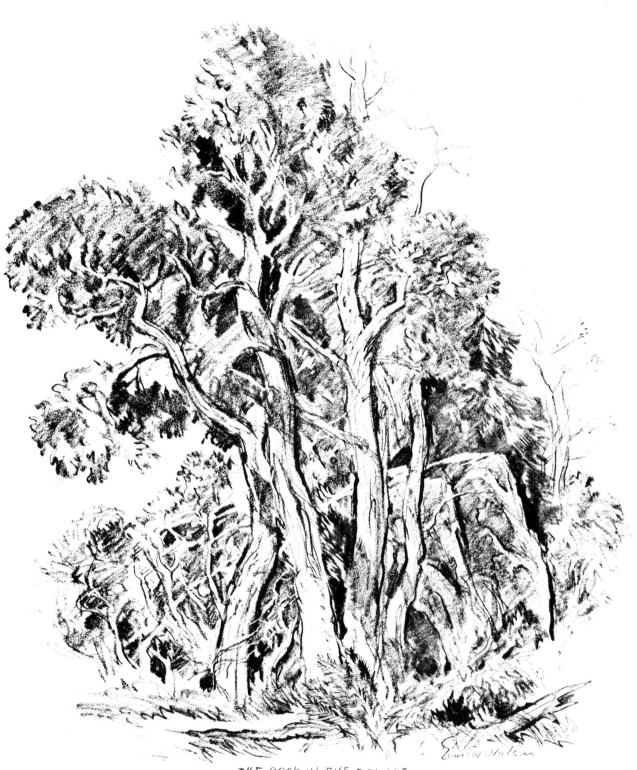

THE ROCK IN THE FOREST

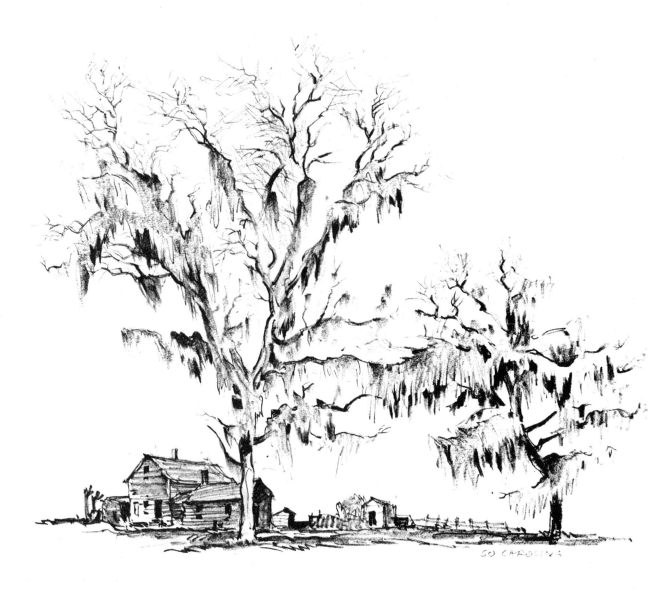

MOSS-DRAPED TREES

Spanish moss gives these bare winter trees a ghostly aspect. I was particularly attracted to the way in which the two trees appear to have clasped hands in a graceful gesture.

AN UNUSUAL LANDSCAPE

This landscape, photographed by Samuel Chamberlain near Carnac, France, is a fascinating subject which I invite readers to render in their own way, perhaps creating quite a different foreground pattern than I have in my sketch. The sky treatment is not one that I often choose, but it is sometimes useful so I wanted to include it in the book.

Samuel Chamberlain

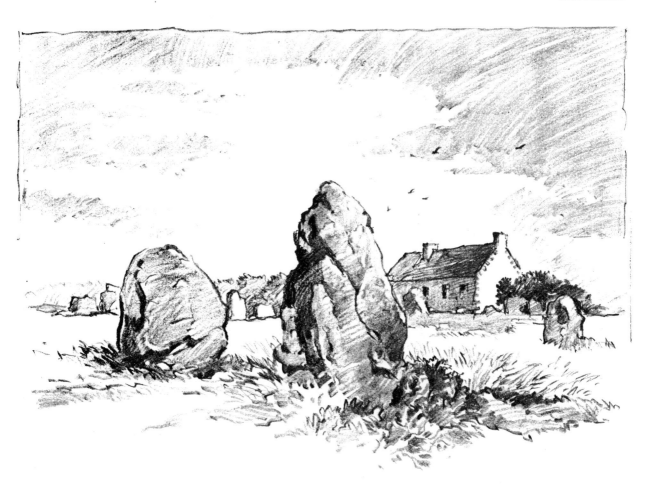

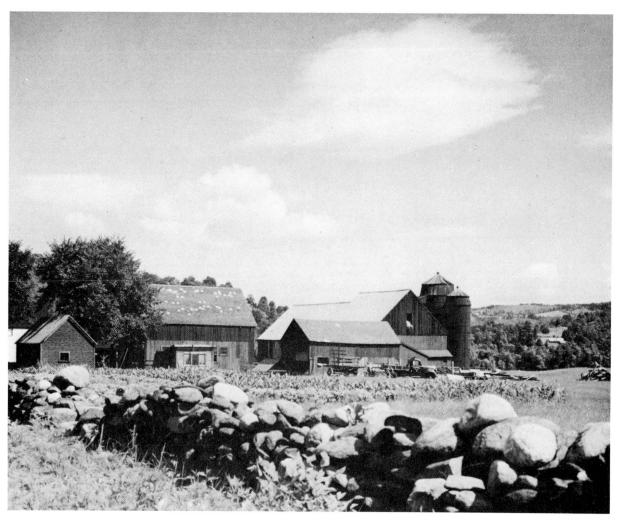

Samuel Chamberlain

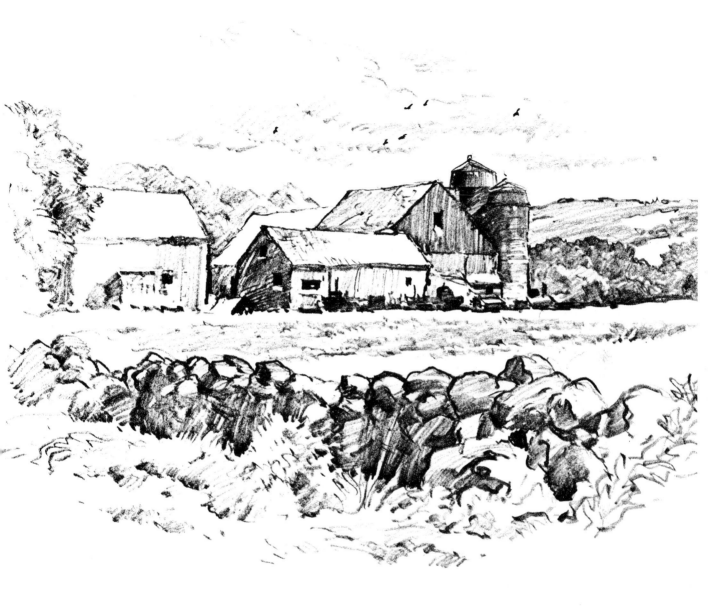

STONE WALL AND BARNS

A stone wall is not the easiest subject to draw in pencil. If we render too many of the stones individually, the wall structure as a whole loses its unity. We have to pick out a few, then treat the rest in mass.

We have taken considerable liberty with the farm buildings, putting the pencil tones where they are most effective in our sketch, rather than trying to reproduce those of the photograph. The clouds are an important element here, but, as always, they have to be rendered with considerable delicacy.

This drawing, on the reverse side of *Video* paper, was done with 5B, 3B, B and HB, each pencil being selected for the tone which it would best render with direct, firm pressure.

Samuel Chamberlain

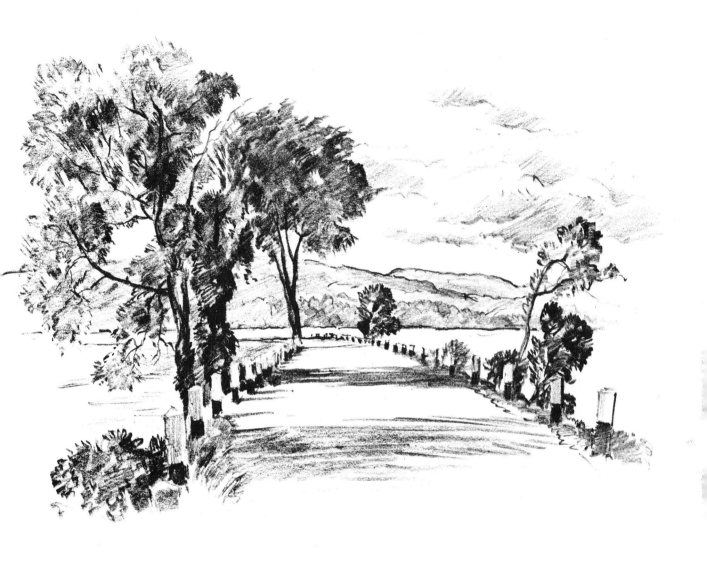

ROAD AT EDGE OF LAKE

I selected this subject for demonstration because it presents interesting tonal problems. We realize at once that, with the pencil, it is impossible to simulate the subtle tonal variations of road, water and hills. In a situation of this kind we have to decide what areas should receive tone and what should be untouched paper. It seems obvious that the hills rather than the water should be toned. Then, of course, the water has to be white; a tone on its surface would merge with the hills and be ineffective. It is possible that a light tone might look well on the road, especially in the distance, but I preferred to leave it white too. Leaving out the figures, which in the photograph give a balance of interest at the right, I substituted the small trees.

AUTUMN CORN FIELD

The particular problem here is the designing of the ground pattern to give an interesting arrangement of light and dark. This is purely arbitrary since in the scene from which the sketch was made the ground was uniform in tone except for the shadows of the corn shocks. With the pencil we are always looking for pattern and when it is missing in our subject we have to create it.

I have made a rather heavy cloud formation in this sketch to hold together the many vertical shapes of corn shocks and trees. Black birds against the sky help to keep clouds back where they belong.

This drawing, slightly larger than the reproduction, was done on the reverse side of *Video* clay-coated paper, which surface is quite a bit like *Aquabee Satin Finish*. The darkest tones were done with 6B, the lightest (clouds) with HB.

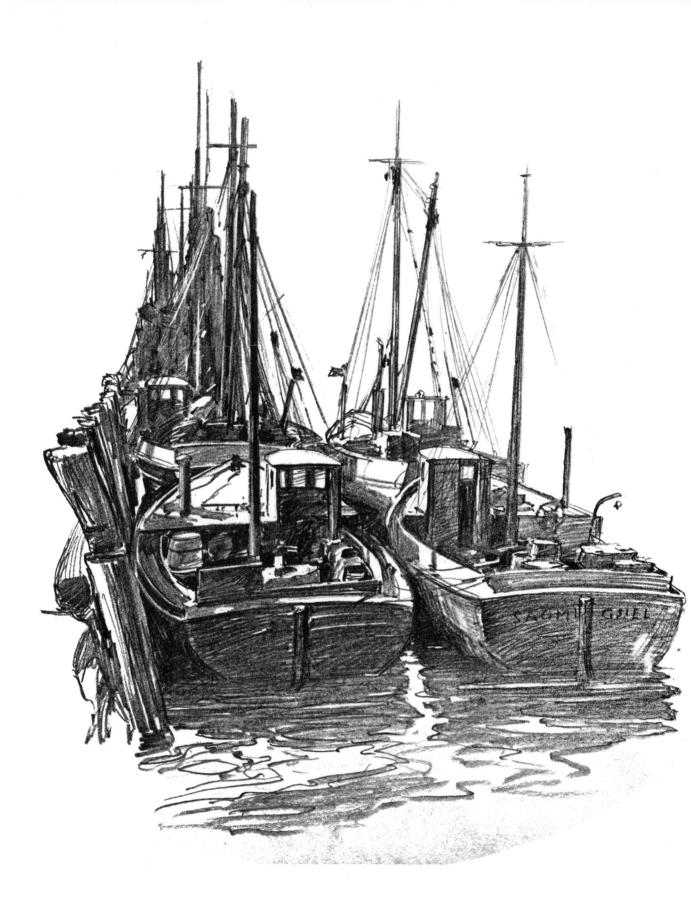

3

Contents

115 Outdoor sketching
117 Two contrasting subjects
118 Study of rocks
119 Fishing dock at Port Clyde, Maine
121 From St. Ives to Maine
122 Boats at New Harbor, Maine
123 Fish processing plant
124 Waterfront shack
125 Dragger for sale
126 A two-minute sketch
127 Subject finished in studio
128 Your sketching assignments

Opposite: Sketch in Camden, Maine

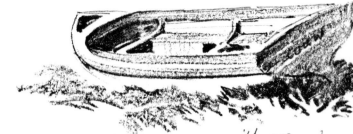

Drawn with 6B only
on a rough surface

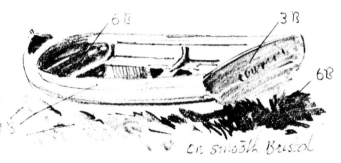

6B

3B

6B

3B

on smooth Bristol

B

3B

3B

HB

Drawn on
"Alexis (Strathmore)

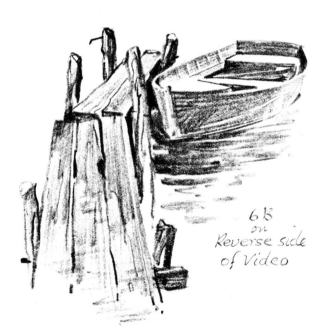

6B
on
Reverse side
of Video

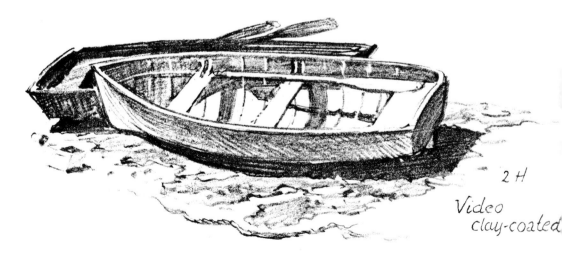

2H
Video
clay-coated

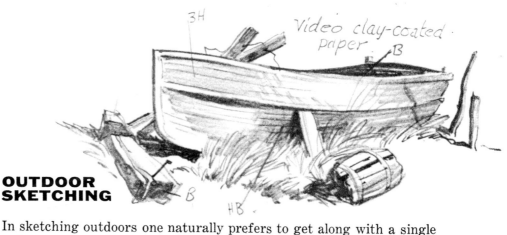

3H

Video clay-coated paper *B*

B

HB

OUTDOOR SKETCHING

In sketching outdoors one naturally prefers to get along with a single soft pencil. The student has enough difficulty at first in on-the-spot drawing, without having to think of different grades of pencils. However, one does become accustomed to a handful of pencils with practice and it is advisable to do so because one cannot always have at hand the surface that is ideal for single pencil work. Indeed, most of my own sketching over many years has been on the rougher stock. I have a system of notching the ends of my pencils for ready identification. I will not make any suggestions as to notching because everyone will devise a system of his own. When you get used to handling several pencils in sketching, there is no awkwardness about it at all.

You will prefer to sketch on a sunny day because of the clear patterns of sunlight and shadow. However, there is likely to be difficulty in finding a place in the shade to draw. So often the best position from the standpoint of the picture is right out in the sun. The glare of sunlight on white paper is trying on the eyes and it interferes with values. But it is not impossible; by holding the board at an oblique angle to the sun, glare is avoided and one can work in relative comfort. The sketch of Camden Harbor, on page 112 was done under these conditions.

A small portfolio that carries your paper serves also as a drawing board — the paper being secured by two large rubber bands.

Curious spectators may sometimes be a nuisance; they make most artists uncomfortable as they stand at one's shoulder, perhaps asking questions. One way to avoid them is to turn the drawing face down as the spectator approaches and merely gaze at one's subject. That leaves nothing for him to do but pass on.

I first carefully lay-out the essential composition and the large outlines of forms with a very light line, thus leaving me free of drawing problems when I begin tonal work. In rendering I like to lay-in black tones first. This gives the drawing vitality to start with, and the lighter tones can be better related when this strongest note has been established.

To keep drawings from smearing until you get home, fasten another sheet of paper to them with paper clips or masking tape. Later, if desired, they can be "fixed" with one of the many plastic spray fixatifs on the market. I prefer not to use fixatif at all because in time it does alter, if only slightly, the pencil tones; despite all claims to the contrary it also turns yellow after a while. I find that matting drawings on a heavy board is good protection because the raised surface of the matt prevents smearing.

A piece of kneaded rubber pressed down on a pencil tone will lift and lighten it where desired

When pinched to an edge

it will cut light strokes into the tone

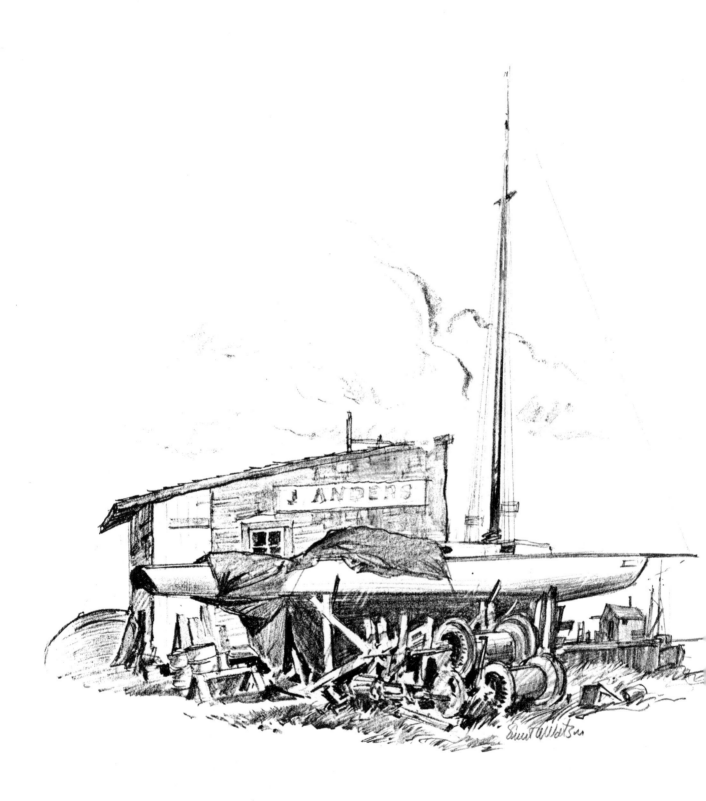

TWO CONTRASTING SUBJECTS

The sketch on the opposite page, made in Camden, Maine, started with only the catboat and rusting winches in the foreground. Behind was a modern, uninteresting shed and at the right was a hill. I substituted the weathered shack and the distant pier with the lobster boat to give a more exciting setting. The drawing was made on clay-coated *Video* paper, with a 2H and an HB pencil.

The drawing below, made in the Charleston, South Carolina, harbor, was drawn with a 6B pencil on *Aquabee Satin Finish*. The water below the ship and dock structure was dark with their reflections, an effect that would not be rendered easily with the pencil and would certainly not improve the composition. The thing to do here, I thought, was to suggest the reflections without actually massing them in.

The treatment of water is indeed one of the interesting problems you will have to solve in your assignments on the following pages, and when you sketch from nature. More often than not water is very dark in value, as it was in this subject. Since the relatively small point of a pencil, even at its broadest stroke, does not render large dark areas pleasantly, you have to find ways to handle water suggestively. I have indicated some of these methods in many of the drawings in this book.

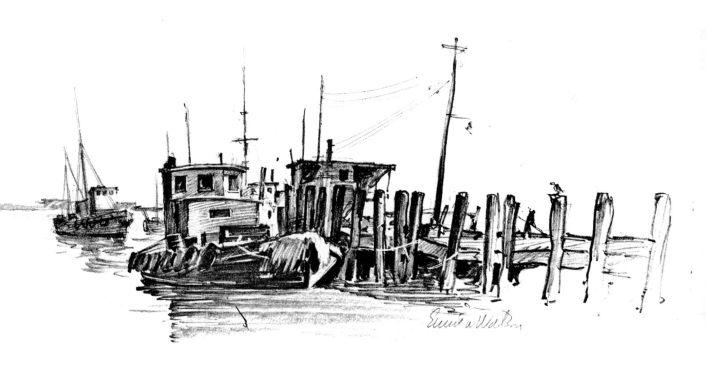

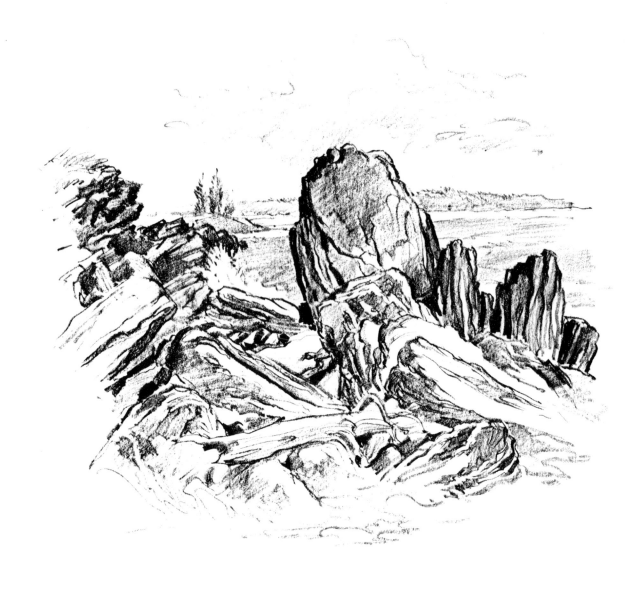

STUDY OF ROCKS

Rocks on the seacoast make fascinating subjects. Eroded into strange shapes and tossed about by stormy seas, they challenge the illustrative skill of the pencil artist. They have to be drawn carefully in order to portray their character.

This drawing was made on *Aquabee Satin Finish* with 6B and 5B pencils.

Rocks have to be rendered with considerable vigor and yet they present delicacies too. They combine the jagged character of split and broken forms with rounded shapes and surfaces worn smooth by the relentless motion of waves.

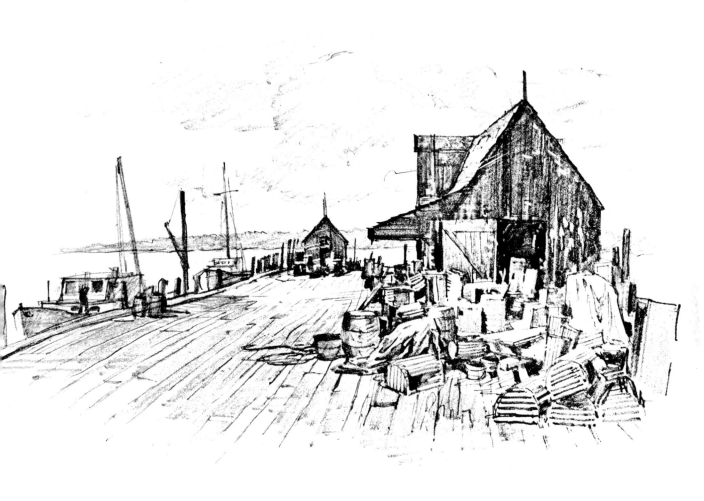

FISHING DOCK AT PORT CLYDE, MAINE

Fishing docks usually are ready-made subjects for the pencil artist. The litter of lobster traps, crates, barrels, lumber and miscellaneous junk piled in front of the dark fish house on this Port Clyde dock gives plenty of opportunity for an inviting play of light and shade, and detail interest. In sketching such stuff we do not need to understand exactly what it is we are drawing: a mysterious conglomeration of light-and-dark shapes is sufficiently illustrative when partly hidden by enough well-defined objects. For example, in this sketch we can distinguish only the lobster traps, two or three barrels and a bucket or two.

The wavy planks of the dock add rhythmic flowing lines to the composition. Note how I have let the light "eat-out" their detail in the background. The sharp lines indicating the planks give a pleasing technical contrast to the broad strokes of the tonal areas.

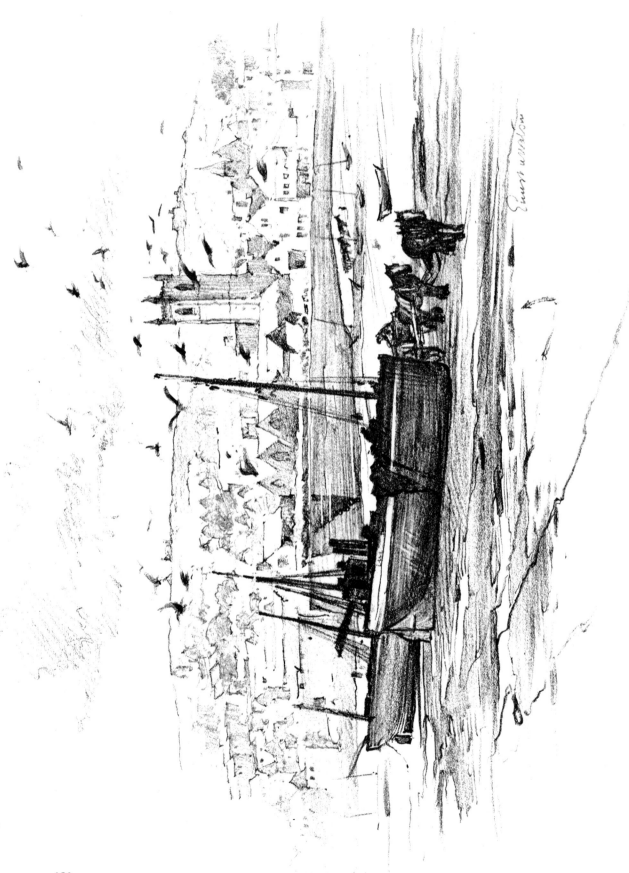

Tide Out, St. Ives, Cornwall, England

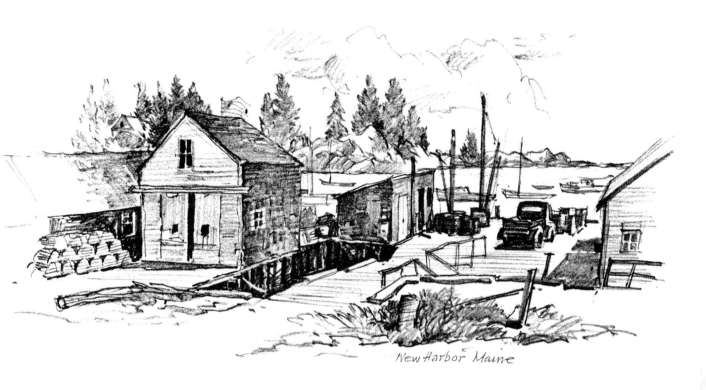

New Harbor Maine

FROM ST. IVES TO MAINE

Tide Out, St. Ives is the harbor of the famous St. Ives in Cornwall, England, which was the destination of the "man with seven wives" in the well-known nursery rhyme. When the tide is out, fishing boats are left stranded on the sands as in my sketch, which was made on the spot several years ago. I reproduce it here because I think it shows quite successfully how a distant village might be treated. Comparison with the Camden, Maine, sketch on page 112 is interesting; in the former, the buildings are barely suggested with delicate line, while here we see them indicated by light tone as well as line. This more tonal treatment is appropriate in the St. Ives subject because it supports the very dark massing of the foreground boats. Furthermore the buildings in strong sunlight offered definite shadow shapes that make a pleasing pattern. pleasing pattern.

The New Harbor, Maine, subject presented quite a different problem. The landscape across the bay was rather uninteresting so I substituted an entirely different bit of scenery that was simpler and made a more agreeable background for the fishing shacks and dock.

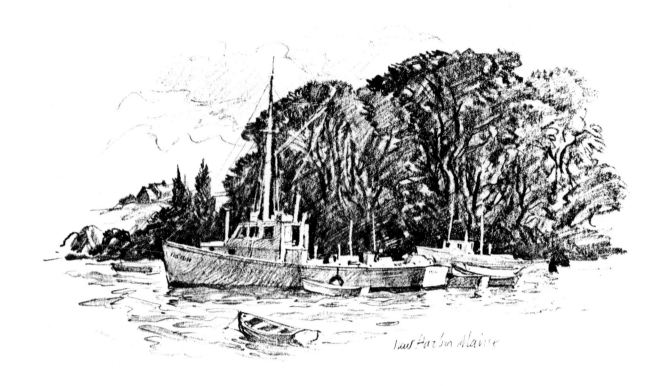

BOATS AT NEW HARBOR, MAINE

This small sketch done at New Harbor, Maine, is only slightly reduced from the original drawing. It is not the kind of treatment one would want for a large sketch; to render that dark tree mass in a large **area** would be laborious. First, the boats were carefully drawn with a sharp point, and then the dark, tree mass was brought down to their outlines. The masts and other light objects that project into the dark area of the foliage were scraped out with the corner of a sharp razor blade. This was possible because the drawing was on clay-coated paper.

I call special attention to the treatment of the water. Note that the reflections, rendered with a rather light tone, are given emphasis by outlining with a very sharp point; this I think enhances their pattern interest. Actually the reflections seemed much darker than I made them, but I felt that the lighter treatment more successfully suggested the gentle play of sunlight on the undulating water.

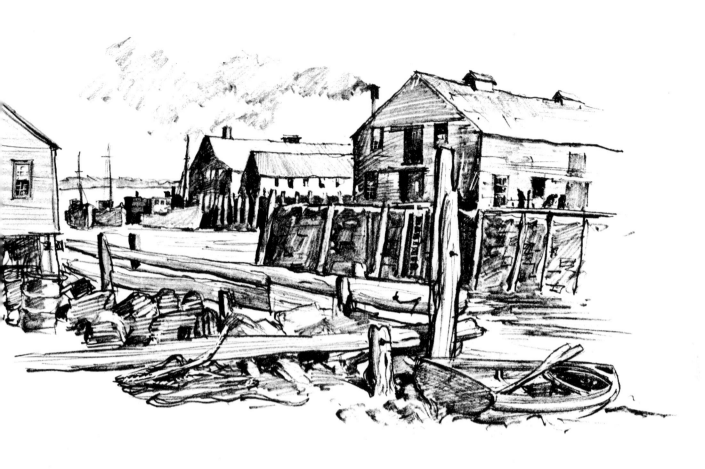

FISH PROCESSING PLANT

This sketch was made on *Aquabee Satin Finish* paper with a single soft lead (6B). First I drew the large shed with its stone pier — after outlining the posts in the foreground which break across its dark shadow mass. The sun from the right illuminated the top of the stone pier, an important effect I was careful to preserve. Note how small accents of white throughout all the dark areas are a factor in keeping the sketch alive. Actually those wood piles that lean against the stone were not light. Furthermore the long timbers that lie along the bank in the immediate foreground were quite dark. When working with the pencil — instead of with color — we have to make translations of this sort. The rowboat that lies in the foreground fills a space that was quite empty in the subject itself.

The lobster traps are casually suggested: I felt that if meticulously drawn they would command too much foreground attention.

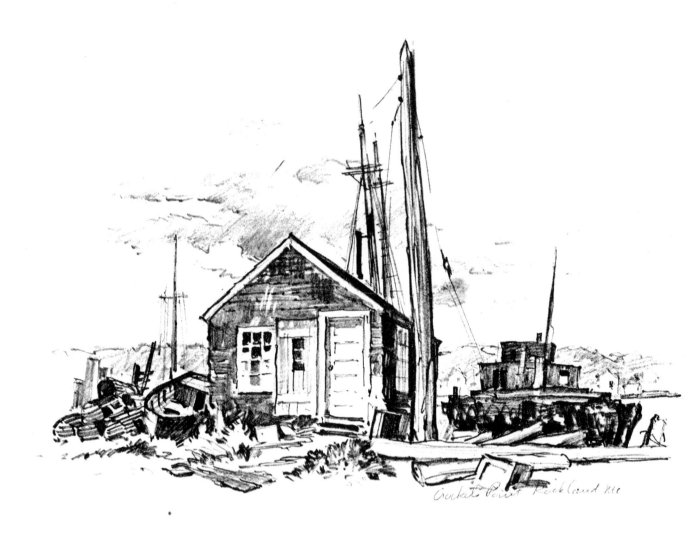

WATERFRONT SHACK

sharp lines for accent

When I saw this subject the sunlight came from the right instead of the left. Reversing the effect, I felt that the composition would be better and it would be possible to·make the front of that old shack more interesting. The barge rotting at the pier would be a dark mass in either event. The foreground was partly improvised; I added the logs and the broken crate. The clapboard shack was in a state of semi-decay. Note the variety of pencil strokes to simulate this effect, and the little white accents throughout. I am going to call your attention to what seems a very minor technical trick: it is the accenting, with sharp thin lines, of tonal passages around small white areas as pointed out in the sketch at the left. Of course this can be overdone but, judiciously used, the device sharpens the sketch and keeps it sparkling.

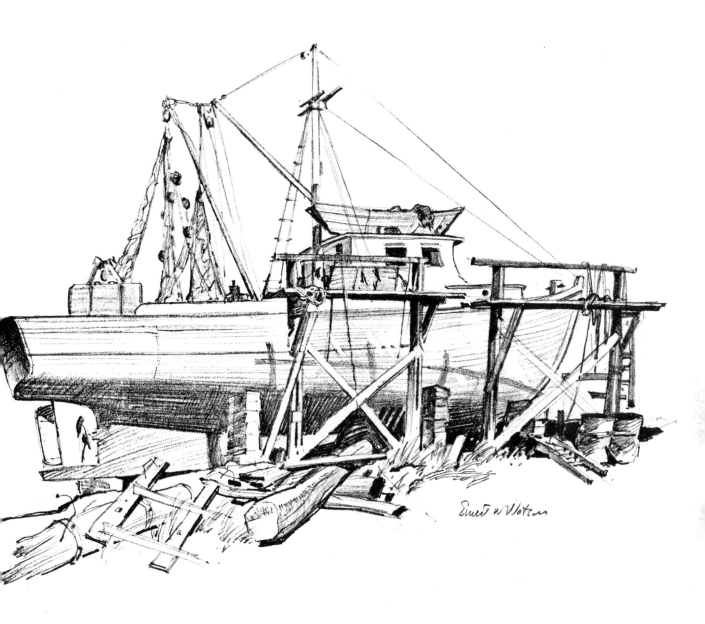

DRAGGER FOR SALE

A "dragger" is a craft that drags for fish with such nets as you see suspended from the boom in my sketch. I was told that this boat, fully equipped, was shored-up at the basin awaiting a purchaser — $15,000 asking price.

My drawing was made on a fine clear day when sunshine and shadow provided ideal sketching conditions. All there was to do here was to produce a literal transcript of what was before me. I worked on a smooth-surface bristol board with 6B, 3B and B pencils. The latter, sharpened to a point, was used for those plank lines on the lighted side of the hull and, of course, for the rigging. Needless to say, I made a meticulous line drawing of the entire structure before beginning to render it. The original, nine inches long, took two hours to complete.

A TWO-MINUTE SKETCH

There are times and occasions when it is not convenient, even impossible, to sit down to render a subject that you very much want to add to your portfolio of sketches. The ability to carry it home with you depends upon your skill in memorizing. The student soon discovers that a rapid sketch supplies the necessary framework for a more or less detailed memory of the object. The explanation is simple; even in such a rapid sketch, the searching eye encompasses nearly every detail and records it on the mental "film." This impression does not have the permanency of a camera film; it fades rather quickly, but is likely to remain clear for a day or two.

I suggest the rapid sketch as a discipline which will certainly pay off many times in future work.

My rapid sketch may seem to record little enough detail from which to make the detailed drawing. In this particular instance I was aided by a fairly good knowledge of tug boat construction, having drawn many such craft in New York harbor.

This boat is the wreck of an old ocean-going tug in a cove at South Bristol, Maine, where it had been towed to serve a useful purpose even in death. Warped into position across a neck of tidal water and sunk, it serves as a sort of dam, protecting a series of lobster pounds to the right of the pilings in my sketch.

The treatment of a wooded hillside, especially when it serves as a backdrop, calls for some artifice. Note that I tried to make it interesting by creating a pattern of white shapes to break up an otherwise monotonous foliage mass.

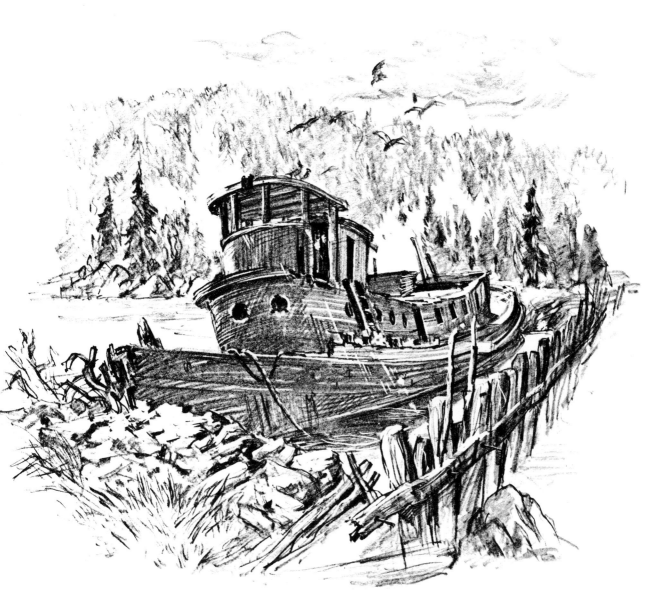

An Ocean-going Tugboat in its Last Anchorage

SUBJECT FINISHED IN STUDIO

The clay-coated paper used here made possible the white scraped-out details such as the lights on window frames and those diagonal white streaks across the boat under the pilothouse. Those are intended to give atmospheric effect, perhaps hinting at sun's rays. The reproduction is the same size as the original drawing.

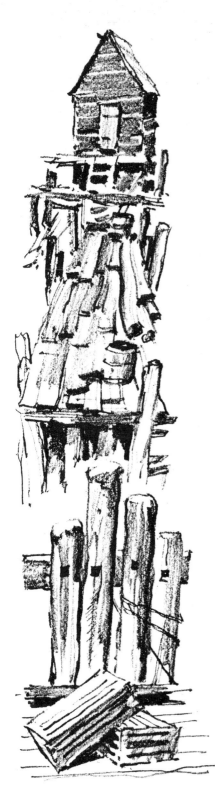

YOUR SKETCHING ASSIGNMENTS

The latter part of this book is devoted entirely to student assignments; photographs of stimulating subjects from which one can sketch as though on the spot where the pictures were taken. The pictures were carefully selected to present as many typical scenes and objects as possible and to involve a great variety of problems in composition and rendering.

On the pages opposite the photographs, I have made such suggestions with my own pencil as I consider helpful in the study of the particular subjects. Some of these are hints on composition, others are on rendering.

As I pointed out in my introductory remarks on pages 6 and 7, the student is expected to use these photographs creatively rather than to "copy" them. The pencil artist should be inventive and resourceful rather than slavishly imitative. Several different sketches might be made from each subject, experimenting with composition, light-and-shade effects and technique. It is not often that the subject is ready-made for the artist. Usually he has to do some scene shifting and improvising. Turn, for example, to the boats on page 160. The boats themselves compose satisfactorily, but the shed roof over the dock is awkward and distracting. I would remove the roof entirely to permit the pilothouse of the foremost boat to silhouette in an interesting way against a light background. I would also omit that black post, or pile, which sticks up at the side of the pilothouse—possibly bring it forward on the pier to clear the boat entirely. In such a position it may well be a valuable design feature.

Turn to page 146. That picture presents a problem. The *Leonard A* in the foreground is interesting in itself, but I think a sketch of the scene would be better without it. When it is removed, perhaps one of those rowboats should be pushed into the water for foreground interest. Or simply insert one or two rowboats taken from the photograph on page 140. I think that the composition of a sketch from the page 146 subject needs an extension of interest at the right of the shack. Complete the drawing of the boat that is only partly visible in the photograph, or add another from some other picture.

These comments, I hope, represent what I have in mind when I ask the student to be creative and resourceful in using the assignment pictures. So try to think of yourself as out of doors, unconfined by the edge of the photograph from which you are working. The other photographs supply objects and effects such as you might see if you were sketching from nature. Try to imagine what the scene would look like at another time of day when the shadows and light would be reversed. In other words *create* rather than *copy*.

All mediums have their limitations. The pencil student soon learns what his pencil will and will not do. He will discover, for example, that he cannot illustrate water tonally as in the photograph, and as a

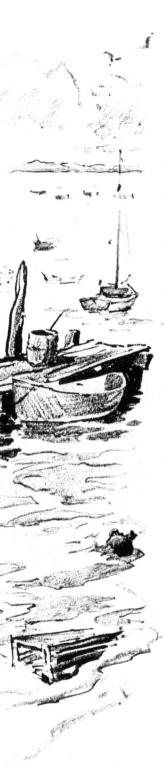

painter can do with color. The water in the picture on page 140 is very dark. To try to copy that effect in pencil tone would give a dismal effect. Here and there in the book I've given suggestions for solving that kind of problem. Turn, for example, to the drawing of the harbor at Camden, Maine, on page 112. In the subject itself the reflections of boat and dock darkened the entire area of water in the foreground. To simulate that effect would not only have been forcing the medium, it would have been poor composition.

This same Camden sketch points to another limitation. I refer to the distance which the painter would represent in tone and color. As a matter of fact it was quite dark. All the pencil can do with such a distant effect is to indicate it very lightly, usually in line but perhaps with some light tone. Compare the Camden sketch with "Tide Out, St. Ives" (page 120) in this connection.

You will discover that sky is just as impossible to illustrate tonally as is water. While some very light tone may successfully indicate cloud shadows, line often will be found to be more satisfactory as a means of indicating clouds.

The student will note that in none of my drawings have I worked within a rectangle as the painter would do. Each sketch is a vignette without a surrounding border. I do not condemn the practice of working to a border line, but I do think that the vignette is more interesting and that it suggests a continuation of the subject on all sides indefinitely. It invites the imagination to conceive of the entire setting of which the sketch is a part and it forces the artist to a more creative attitude toward the subject.

How to Use this Book

The assignment photographs are printed on the page so that the book has to be turned, in viewing them. There are two good reasons for this. First of all they can be larger when placed on the page this way; secondly, they are more convenient to draw from than if they were placed across the page's narrow dimension. The accompanying sketch demonstrates this, I think. These small books stay open quite readily but, if necessary, a rubber band will hold the desired page in position.

Rubber band to hold page open

Photograph to draw from

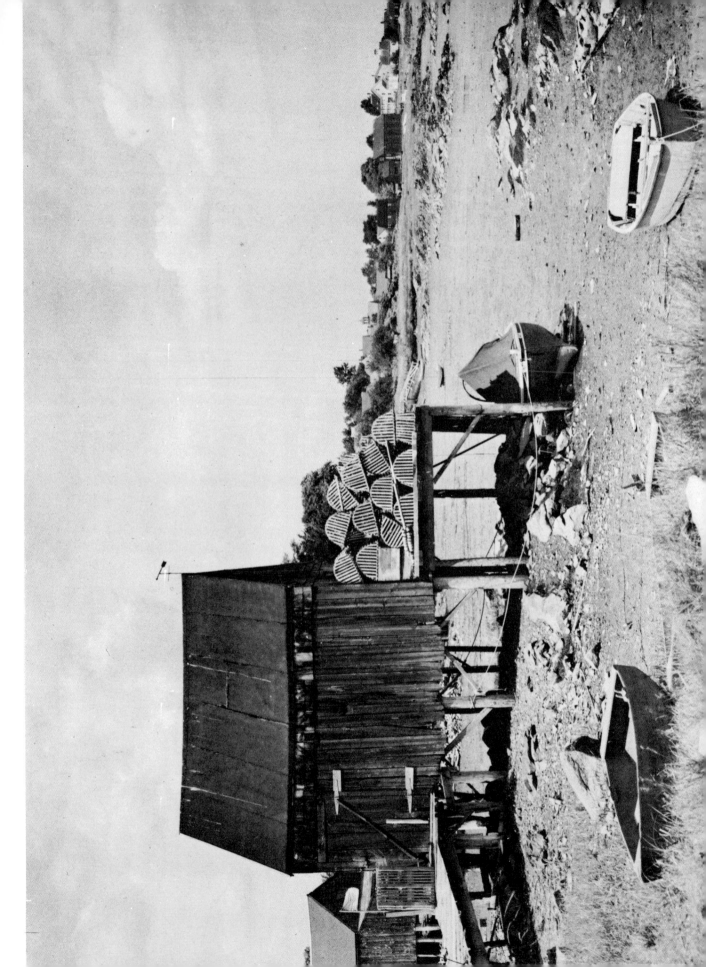

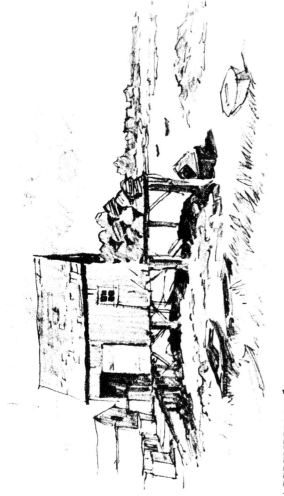

ASSIGNMENT 1

This is an almost ready-made subject. It composes naturally and needs only the artist's good selective judgment. The diagrams are made in wash, the better to encourage thinking of picture composition in terms of rather simple, flat tones. First we usually consider what shadow pattern alone will do for us. Brushing in the shadows with a solid dark gray, we find that we already have a good compositional basis. In sketch #2 we add an intermediate tone, opening the door in order to break up an otherwise monotonous rectangle of tone. In sketch #3 the roof is treated with a broken light tone to suggest old shingles, a more interesting roof than the tar paper — an artist's license. Thus we have altered the tonal scheme of the subject to suit a more agreeable arrangement for the pencil rendering. Now this is not the only way to treat this subject; indeed I suggest that the student try as many other devices as he can conceive. For instance, dark roof, lighter side wall — even try matching the values of the photograph. The pencil sketch is reproduced at exact size of the original. It is too small to do more than indicate in a general way how I would be likely to render this subject. Note that I have omitted the foliage that appears over the lobster traps; it is a confusing element. See other drawings in the book for suggestions for rendering details.

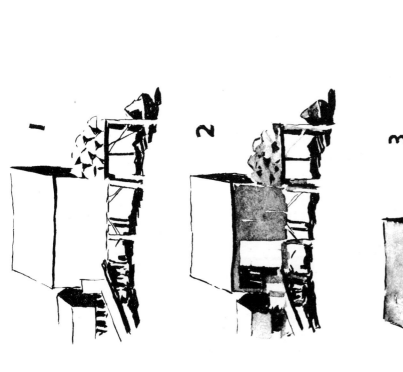

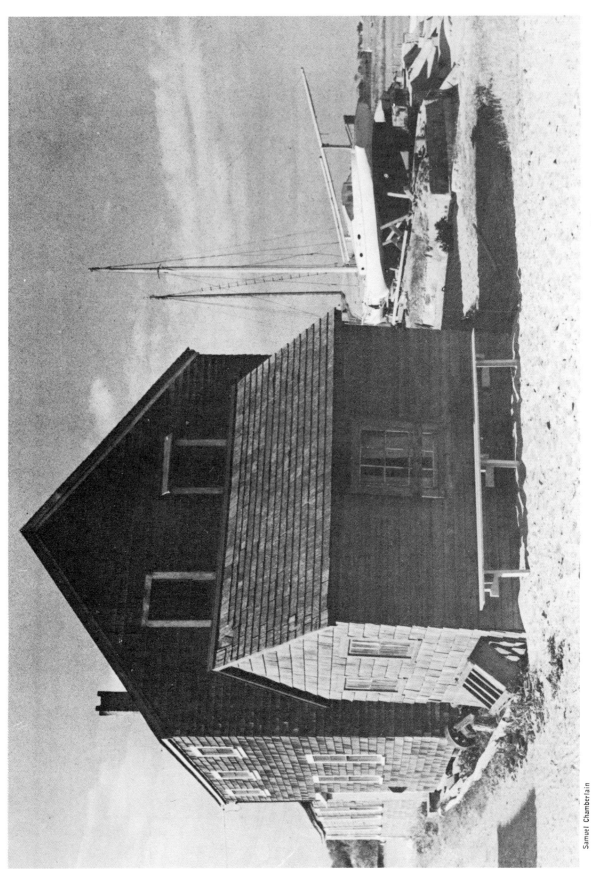

Samuel Chamberlain

View at Chatham, Massachusetts.

Although I believe the subject is best rendered with the sun at the left, as in the photograph, I have made a quick sketch (left) to "try out" a scheme with the sun coming from the opposite direction. After a subject has been selected it is a good idea to consider how it might look under other light conditions, then experiment in a rapid small sketch unless, being experienced, you can readily visualize other possible effects.

So much of the charm of this scene depends upon the white accents of that yacht, that I would do what I usually avoid — render the sky with tonal clouds, as in the lower drawing — to provide a gray background; or I would improvise some old buildings behind it as in the upper sketch. If the cloud shadow can be restricted to a small area, and you have a dark foreground mass in front of it, the result may be quite satisfactory.

Note that in my sketches I have enlarged the boat somewhat; also that I eliminated the second boat in order to give a better silhouette to the nearer one; but I have shown the mast of a second boat extending up from a dark mass merely suggesting another boat. The skyline has been lowered to permit the silhouetting of the boat's stern.

I erased the mast and boom out of the cloud, through two pieces of paper laid over the tone

Shadow strokes can be made in any direction — then other strokes over them to indicate shingles or clapboards

6 B for darkest tones
4 B for intermediates
B or H B for lightest tones

Keep pattern definite

133

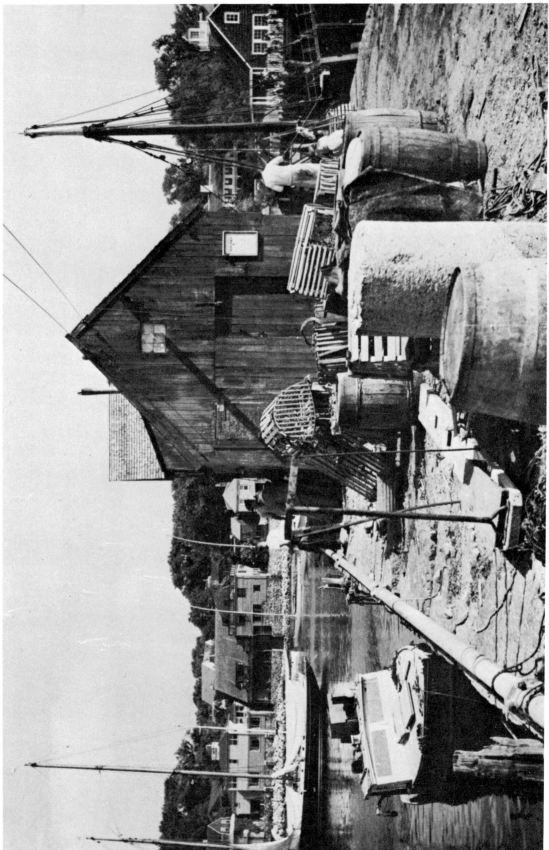

Fishing Pier, Rockport, Massachusetts

Samuel Chamberlain

134

ASSIGNMENT 3

In this subject the building is nearly in the center of the picture; your sketch ought to be developed so that interest is focused at one or the other side of the pier, rather than being divided as it is in the photograph. Since there is scarcely enough information on the right side to "get hold of," I suggest concentrating on the left side of the building. However, we could wish that a sizeable fishing boat, like that partially visable on the right side, were moored at the left in place of the small craft which has small compositional value. Try this: turn to page 158 and make a tracing of the SAOMI GUEL. Lay your tracing, reversed, that is, upside down, over the photograph alongside the pier. You will see that the SAOMI GUEL takes her place very pleasantly in the picture. The traced boat will be a trifle large in scale, but you can reduce it slightly in size, or you can bring her into the foreground so that the barrel on her deck is about level with the top of the pile. This will throw her stern out of the photograph, but you can extend your sketch to include as much of the harbor on that side as you wish.

If you moor the SAOMI GUEL close like this you may want to bring in the boat that lies just in front of her in the photograph. Note, also, that the photograph (page 158) provides fishing craft at a distant pier that will serve as models for lightly sketched boats at the right side of your pier.

The litter of lobster traps, barrels and other objects in the foreground provide ample interest, as do corresponding things in my sketch on page 119. Try rearranging them to suit your design better after you have your boats moored at the dock.

It is obvious that this subject is worth more than one sketch. Make as many interpretations of it as you have time for, and compare the sketches critically.

It seems to me that the dormer roof ought to be dark enough to silhouette against the sky which, by the way, might be treated somewhat like that in the Camden, Maine, sketch on page 112.

what like that in the Camden, Maine, sketch on page 2.

That shadow running along the end of the shed is cast by a projecting beam over the door, from which hoisting tackle is suspended. It will scarcely explain itself in the sketch unless it is given a different direction.

The planks of the pier in the photograph are obscured by litter: you may want to indicate them in your sketch although the litter itself is interesting.

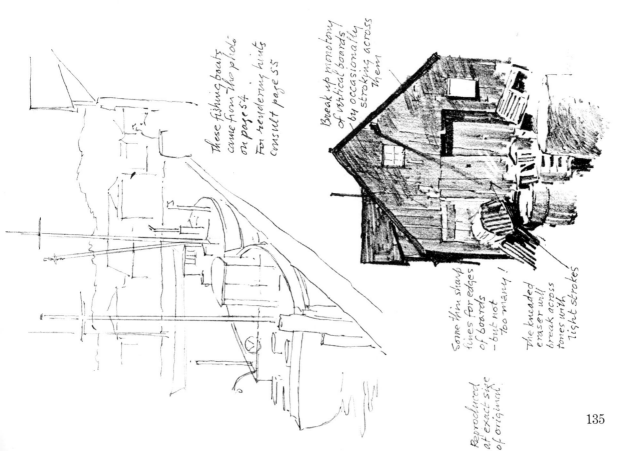

These fishing boats came from the photo on page 54.
For rendering hints consult page 55

Break up monotony of vertical boards by occasionally stroking across them

Some thin sharp lines for edges of boards — but not too many!

The kneaded eraser will break across tones with light strokes

Reproduced at exact size of original.

135

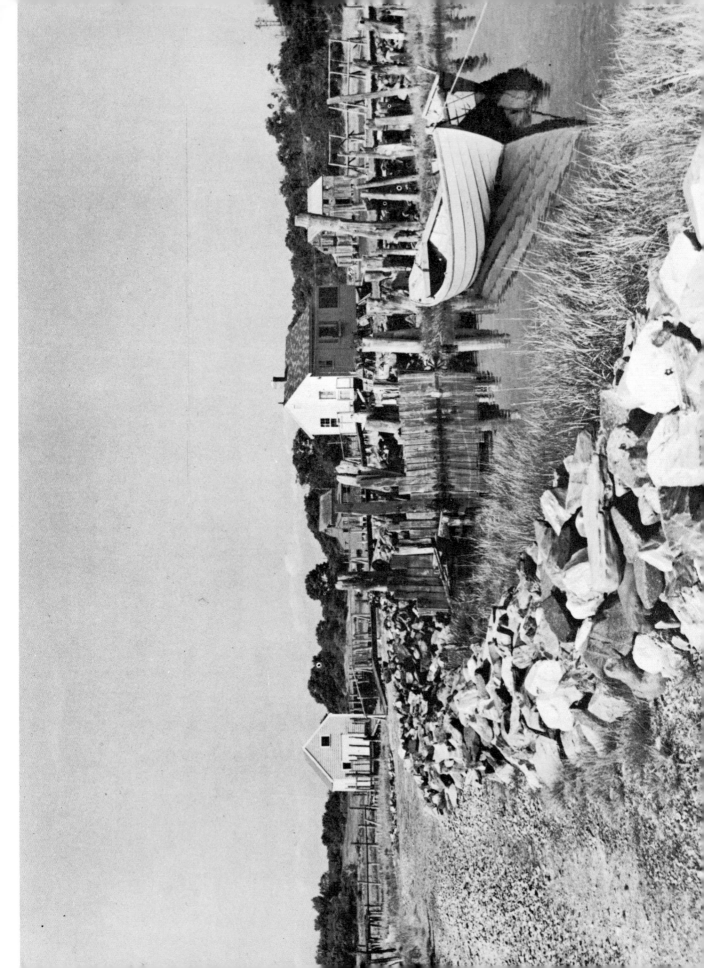

ASSIGNMENT 4

The sketches reproduced here at about half-size of the originals demonstrate how I would develop this subject. Always, or nearly always, I lay-in the very darkest tones as in sketch #1, because all of the other values are related to the darkest, which usually is as black as a soft pencil can make it.

The boat, being the most important item of interest, naturally gets next attention. If it is to look like a white boat there must be contrast with the dark water. Now with pencil it is possible to make a reasonable facsimile of that dark water mass, showing the reflections of the planks and piles, but it would be a laborious process and the drawing would certainly look labored. The pencil is not a medium for that kind of tonal effect, so we have to devise a method of indicating the appearance of water. We really are obliged to illustrate water in motion, because then we can break up its surface with reflected lights as I have done. The small amount of dark tone that I have put near the boat serves as a contrasting foil for it.

The light shading on the boat's side is improvised; there is nothing comparable in the photograph. I tried to apply it in such a way as to leave white accents that suggest light reflected up on the curving boards, an effect that is seen when the sun shines upon dancing waves.

Note, throughout, the function of thin, sharp lines used along with the broad strokes.

The background, obviously, is treated in a very casual way, no effort being made to be literally faithful to the subject. I have kept the background trees very light; to render them in dark tone, as in the photograph — or in nature itself — would destroy perspective effect.

The treatment of the rocky breakwater presents an interesting problem. If we attempted to render each of the innumerable stones we would find the result very fussy and the breakwater would become too important in the picture. While we do want to give it sufficient attention to look like what it is, this is not the center of the sketch's interest: it should not be so detailed as to prevent the eye from going over it readily to the boat and plank wall beyond. I started to draw the nearest rocks rather meticulously but, as soon as possible, to suggest rather than define those at a greater distance. Not over a dozen stones are drawn with verisimilitude. Note here the use of line, as well as of tone.

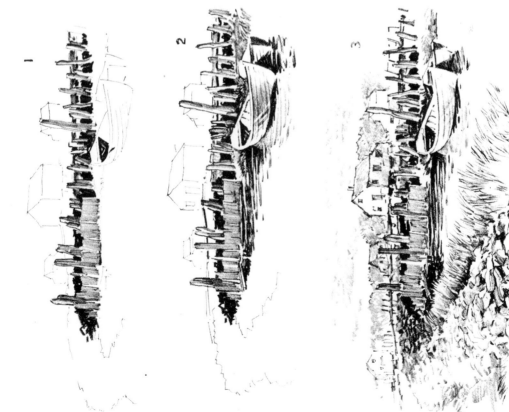

137

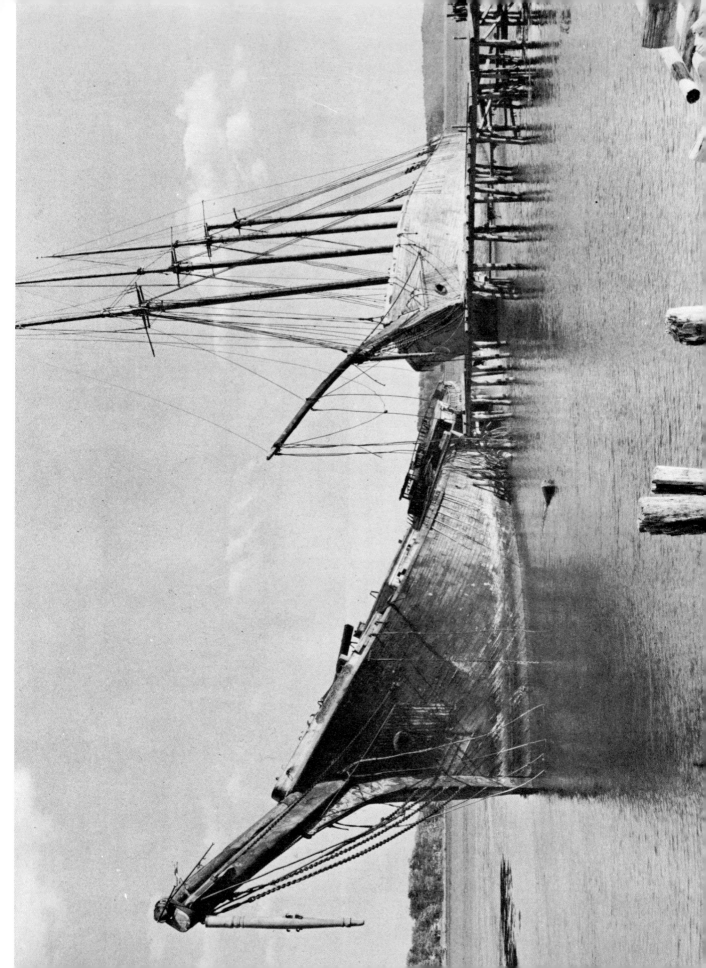

ASSIGNMENT 5

Here we have a subject with dividend interest. We find ourselves looking from one abandoned schooner to the other. Both are equally interesting and claim equal attention. This is nothing against the subject, we are glad of the dual attraction. But in a sketch we seek a focal point to give the picture stability. In the lower of these two rough sketches, reproduced at exact size of my drawings, I have indicated one way of doing this — concentrating our darks on the more distant schooner and the stern of the other. Now, because the eye will always be attracted by a dark area, we have established an orientation that overcomes the instability of competing points of interest.

This does not mean neglect of interest in the nearer hulk; although we keep it light in tone, we can give it as much illustrative content by making the most of all its details. Possibly we would be as successful if we reversed the picture plan, concentrating our dark tones on this boat and leaving the other one very light. In this event — and I suggest you give the scheme a tryout — I think the sketch should be extended further to the left of the prow, perhaps mooring a fishing boat (from page 117 or 158) out there, or a rotting tug boat (page 127). These should be small, in the distance.

You will note that I have raised the pier in the foreground so that it enters into the design, as it does not in the photograph. Doubtless the photographer could have produced nearly this effect if he had held his camera lower.

Thus, in almost every sketch we make, we have to be imaginative, inventive. And whether working from nature or photographs, we have to translate our subject from its full tonal expression to arrangements that make extensive use of white paper and line.

Again in this subject we have the problem of indicating water without recourse to tone. Anyone who has studied the nature of water, either of harbor or lake, is familiar with the many effects due to currents and winds that give the artist hints of simple ways to represent it in a pencil sketch.

In drawing from photographs, a fairly powerful reading glass is very useful; detail that might otherwise be overlooked may well be revealed by a magnifying glass.

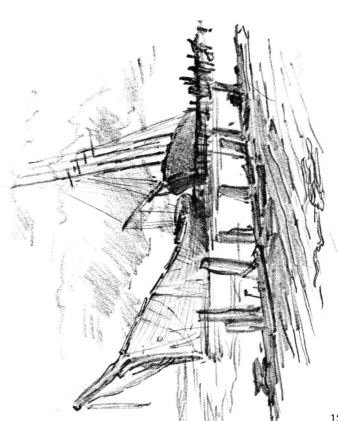

ASSIGNMENT 6

Since this is a tough assignment, I am taking considerable space to demonstrate the approach I would make to it.

A subject may attract us for a great variety of reasons, sometimes reasons that are not as valid for pencil rendering as for oil or water-color. If it is color that interests us we have to ask if it can be translated into black-and-white and in lines and patterns that are appropriate to the pencil medium. If it is values — that is, tonal relationships — we have a similar problem, because we have learned that the lead pencil is not adapted to literal tonal representation.

The subject in the above photograph certainly has great tonal appeal, but in our pencil sketch we cannot rely on that. However, it is an exciting group of boats in brilliant light and shade; we certainly ought to find it stimulating and suited to our medium.

At the beginning of our study we may not know how much of the scene we shall use; but we are certain that our sketch will include the boats and the dark building. I made a tracing from the photograph of these details which you see reduced in size, in fig. 1, thinking it would simplify things to have these isolated from the confusing background. Then I considered whether the design of the group would be better if boats 3 and 6 were eliminated. I particularly wanted to get rid of boat 3 because I was thinking of an arrangement which might be

expressed roughly by the diagram in fig. 3, which demonstrates a movement of interest, forming a sweeping curve from the building down through the boats to the vertical piles which serve to arrest the movement at the right. You can see that boat 3 would have no function in this movement; in fact it would serve to block it.

Having made this decision I began to render boat 1 (fig. 4) which certainly ought to be the focal point in the sketch. In the photograph the boat's shadow on the ground is nearly solid black. I wanted to take advantage of the black for the sake of value contrast with the shadow on the white boat which, naturally, had to be light; but, as you see, I confined the black to a relatively small area next to the hull, permitting us to see a suggestion of the shoring timbers.

The sketch in fig. 5 has been further developed as I felt my way in its tonal development. I was not quite certain at this point just how I would treat the foreground boats and the water, but, as is obvious, I had the basic pattern in mind which I mentioned in my reference to fig. 3. Note that the shadow, on the ground, of boat 2 is kept lighter than that cast by boat 1 which I chose for the focal point of the sketch.

In the completed rendering, reproduced at exact size below, you will be interested in the treatment of the water which, in small areas, can be comfortably rendered black.

That small white accent in the shadow under boat 1 — sunlight on a shoring timber — was erased through a rectangular "window" cut from a scrap of paper.

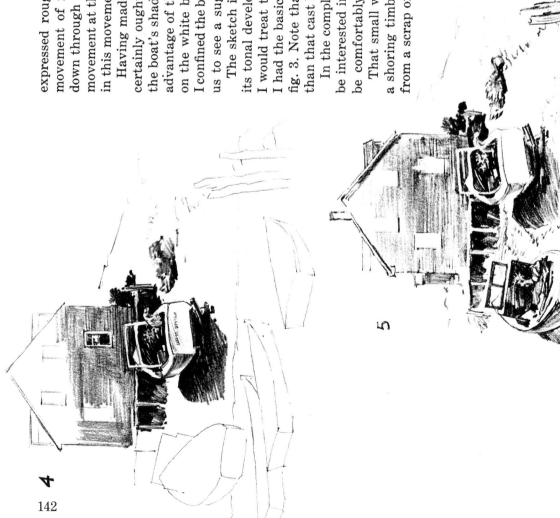

4

5

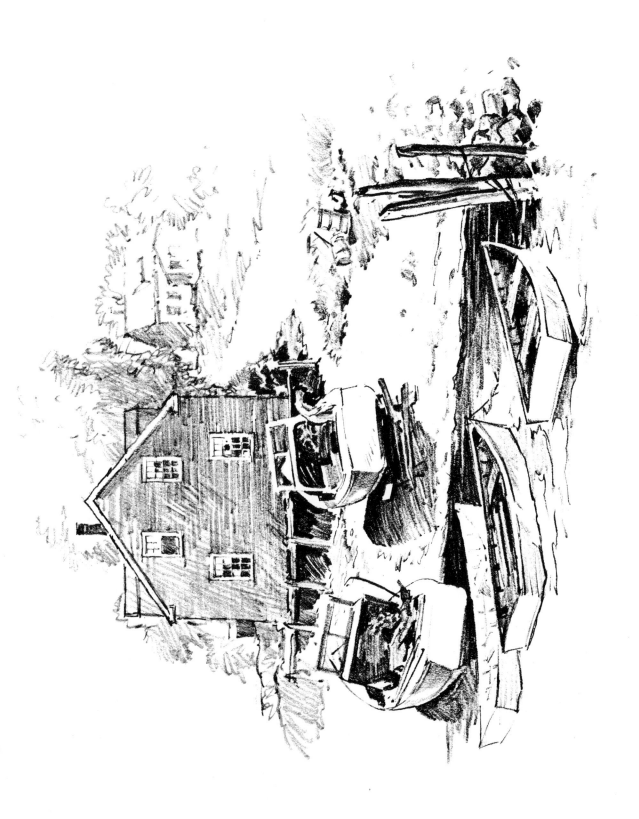

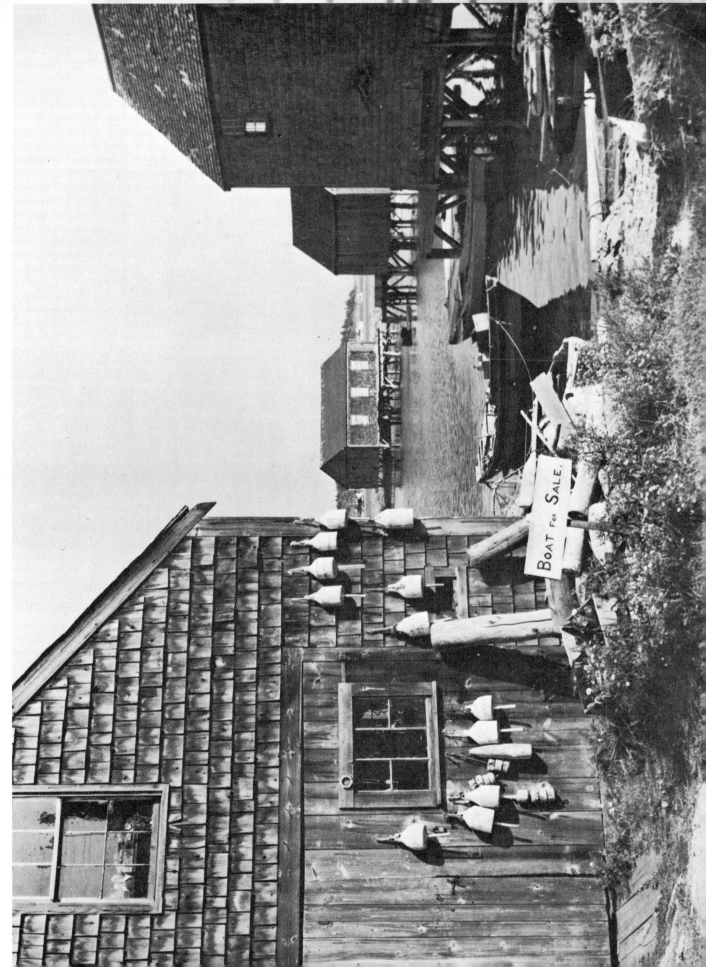

ASSIGNMENT 7

In this subject the interest seems to be concentrated in the fore-ground — the weathered lobster shack, the lobsterman's boat anchored nearby, the BOAT FOR SALE sign and the pile of junk. However we doubtless need the fairly complete setting such as I have indicated in the rough sketch above. You might not feel the necessity for including the entire front of the shack but I think you will, even though the left side of it is neglected as in the little rough. And it seems as if the larger building at the right would have to be more complete also, perhaps more complete than indicated. As you develop your drawing, these points can be determined. My sketch is on *Alexis* paper.

Begin by rendering the foreground as I have done below (repro-duced same size as original) and work out from there in all directions, stopping where it seems natural.

Here is a situation where the dark water reflections, being limited in area, can very easily be rendered in approximately their true value. You will note that I have even laid a light tone for the lighter water area, but I wouldn't carry it beyond the boat; I think you will want white paper there.

As you can see, I have taken considerable liberty with the fore-ground. Consult sketches on pages 123 and 125 for suggestion of logs and other detail. I have eliminated the boat that is moored close to the building because it is confusing.

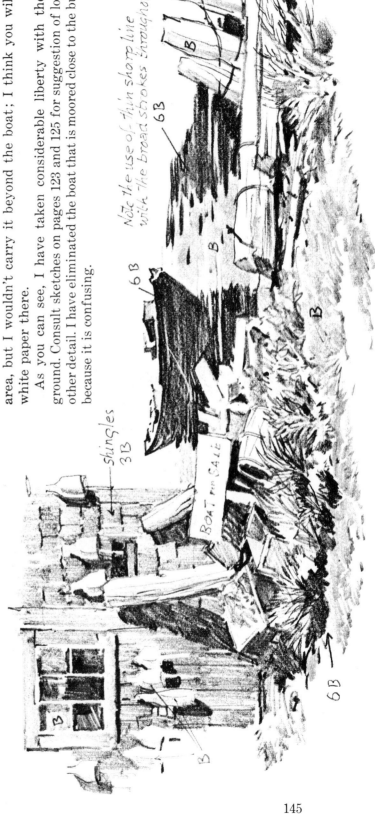

Note the use of thin sharp line with the broad strokes throughout

Shingles 3B

BOAT for SALE

6B

145

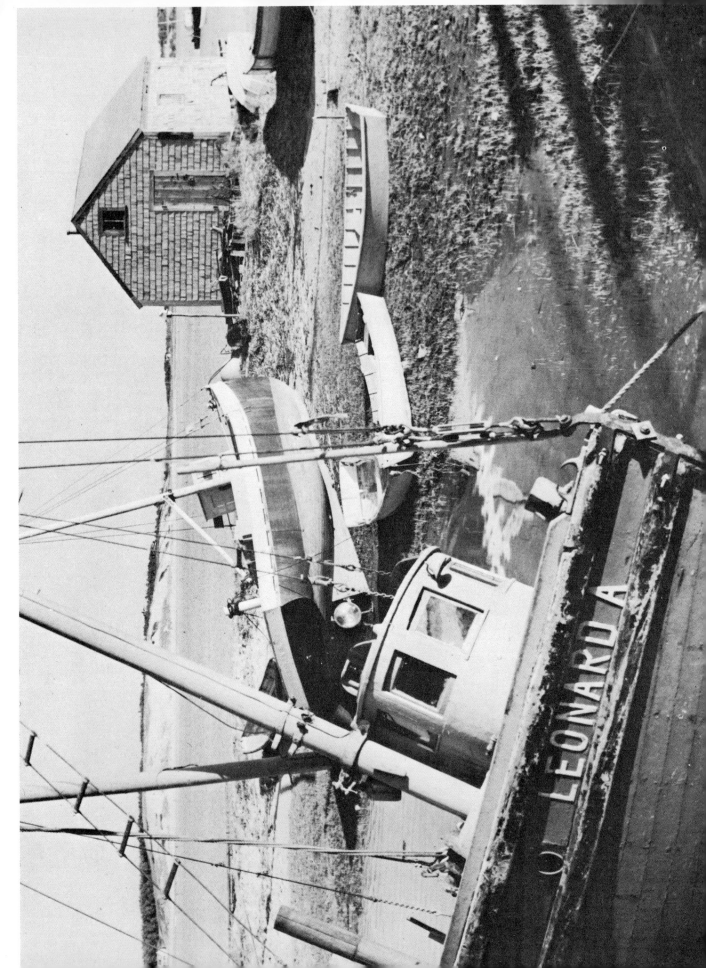

ASSIGNMENT 8

This subject appears confusing because of the LEONARD A which does not fit into a well-designed sketch. Forget the LEONARD A, eliminate it and you have an ideal subject, one that is practically self-composed except for some minor details.

When the LEONARD A has been removed you will have a foreground problem, though one that is readily solved. Moor a rowboat or two in the water, placing them where they will best adjust to the other boats.

Of course you will have to develop a pattern of gray and white on the ground, much as we did in assignment #6. The variation of tones in the photograph gives you a hint.

The most radical procedure which I have suggested below is the rendering of the water of the bay with black tone. Heretofore I have warned against large tonal areas in the water. However, this narrow strip of bay can be rendered comfortably in a very dark value with a soft lead. Note the whitecaps which keep the tone lively and atmospheric. How much more effective the sketch is, treated in this way. The dark water dramatically silhouettes the boat, shack and beach. How to render those white stay-lines against the black tone? With a sharp razor blade cut a mask as shown in the diagram and erase through the slit. This can be done upon your return to the studio.

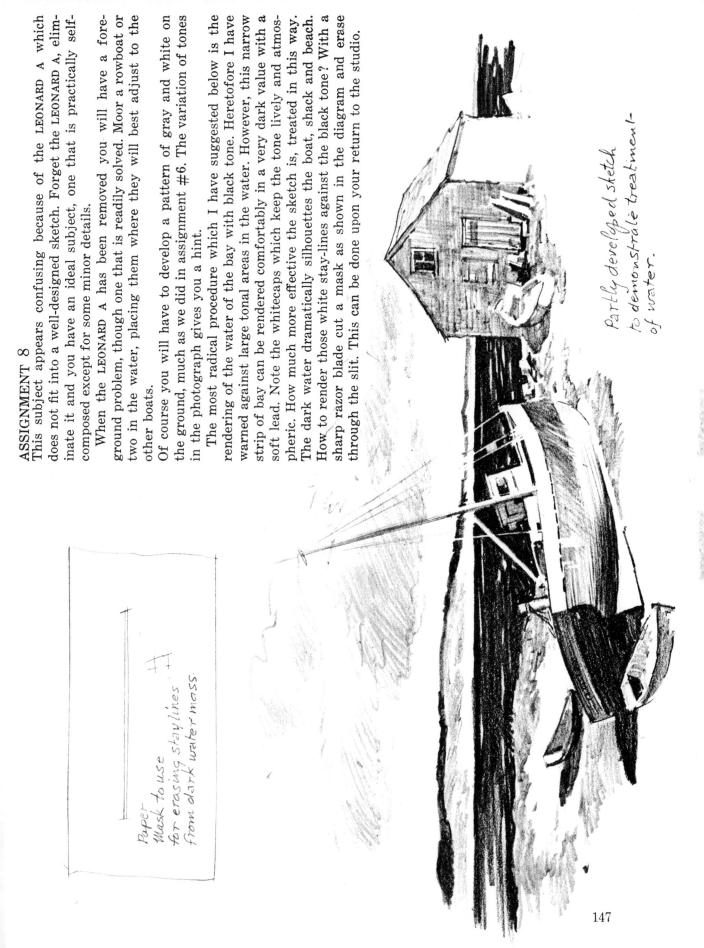

Paper
Mask to use
for erasing stay lines
from dark water mass.

Partly developed sketch
to demonstrate treatment
of water.

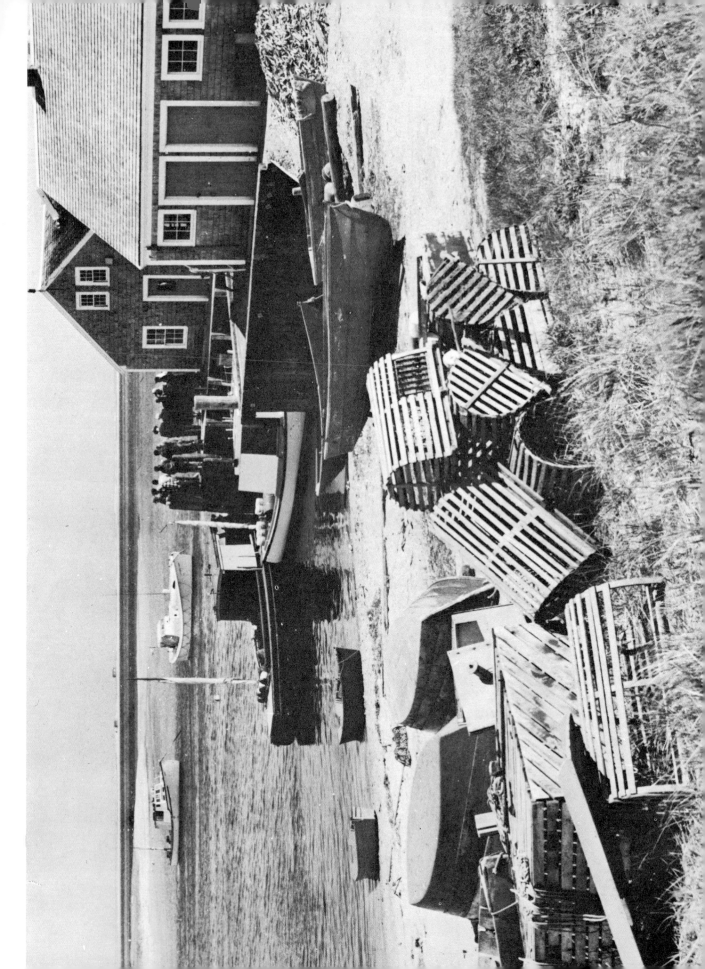

ASSIGNMENT 9

I will concentrate upon "still life" in this subject and leave the composition to you, without more than written suggestions. If you have followed me thus far you have learned a good deal about designing your sketch. You have become more or less expert in translating the tonal effects in the subject, be it a photograph or the scene itself.

If you focus interest on the foreground you certainly will make the middle distant buildings and boats lighter in value than if you looked over the lobster traps to center interest on the activity at the pier. In the latter event you may or may not want to represent the foreground objects quite as much in detail as I have done. You have to focus on one area or the other.

I have made that little wash drawing to point out the importance of keeping in mind the geometric formation of the objects as revealed in their simple light-and-shadow pattern. Unless this is realized, it is very easy to produce a confusing rendering. In studying the picture possibilities of any of these photographic assignments, that kind of analysis (with your brush and two flat tones) will often help to compose your sketch in the most dramatic way.

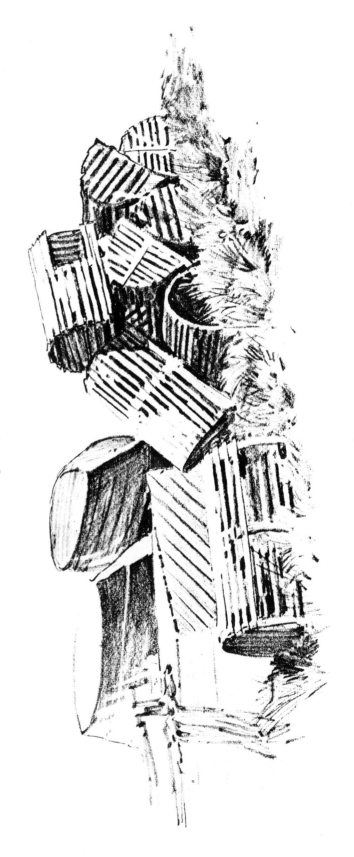

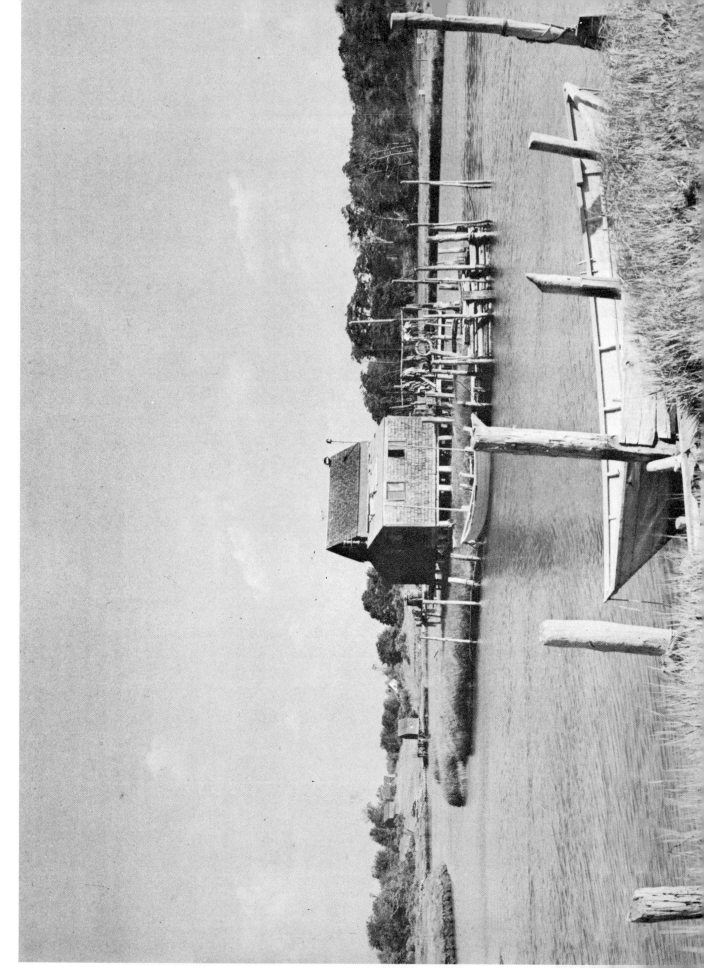

ASSIGNMENT 10

There are no new problems in this subject so I am not making any graphic suggestion. If I were doing it, I think, I would narrow the stretch of water to about one half its present width. This would raise the boat correspondingly. This done, it is possible that the narrow water area between the two boats might be rendered in a dark gray tone, at least that part of it directly under the sheds and dock. Chances are the rest of the water should be kept white, except for some light gray pattern of water movement which is indeed suggested in the photograph. We are all familiar with the interesting play of light and dark on water caused by a breeze that ripples its surface. These little waves, forming flowing, rhythmic shapes reflect the light of the sky in dazzling white pattern.

With the water area narrowed and the large boat raised, we can well create a more interesting foreground — a pile of boards, a barrel or crate and other objects that will come to mind.

Those posts in the foreground are rather monotonous; you can group them differently, vary their thickness and make a much more ingenious composition in the foreground.

We have already discovered that it is seldom practical to render distant landscape in the true dark tones of nature. If we do, the distance will come forward and destroy perspective. Whether those trees should be sketched in a light gray tone or be indicated merely in line is something every artist will have to decide. Probably a light tone will be effective.

Obviously this subject needs some kind of sky treatment. I have made numerous suggestions for the rendering of clouds in various drawings in the book.

The building certainly should be the focal point in this sketch. Then looking past the building on the left side, we have a secondary center of interest. Those small buildings are good copy, and of course a small sail boat would not be out of place back there.

In working from photographs we have to realize that the values very often are not true to nature. Dark shadows are likely to be dense, revealing little or no detail within them. We have to use our imagination and improvise detail in any too-empty shadow masses.

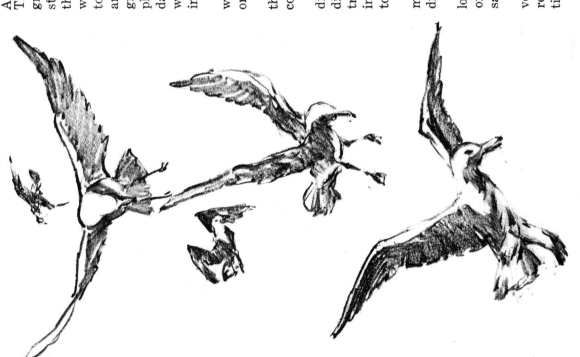

151

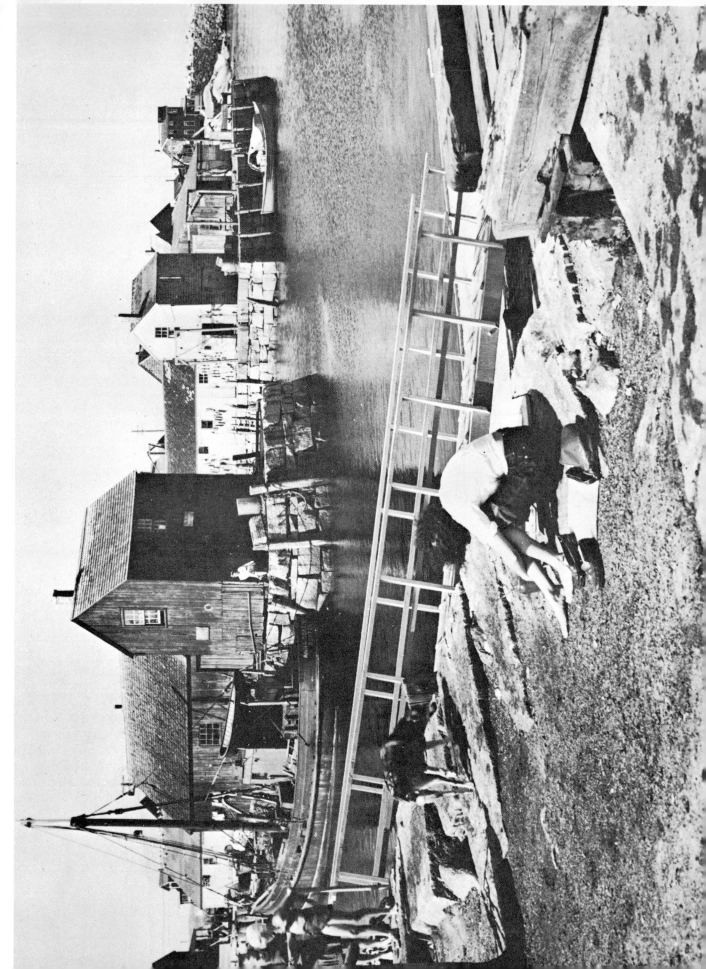

ASSIGNMENT 11

This is the celebrated Motif #1 at Rockport, Massachusetts. It is so called because for many years that old fisherman's shack has been the first subject to be painted by art students who have flocked by the thousands to this historic seaport on Cape Ann.

Now you will have to be imaginative in sketching this subject, albeit it is practically ready-made. If you were painting the shack you might well duplicate its tonal effect; color would be perhaps more important than light and shade. But with your pencil you will certainly want to treat the sunny side with a light tone. Then see how dramatically the superstructure of the fishing boat will silhouette against it.

Since, quite naturally, you will want to focus on the boat, it is evident that the sketch will have to be developed at the left some distance in front of the boat. Otherwise your focal point would be at the extreme left of the picture, which would not be good.

The gangplank in the foreground is a rather awkward element. Why not let the rocks and the old timbers take care of the foreground interest.

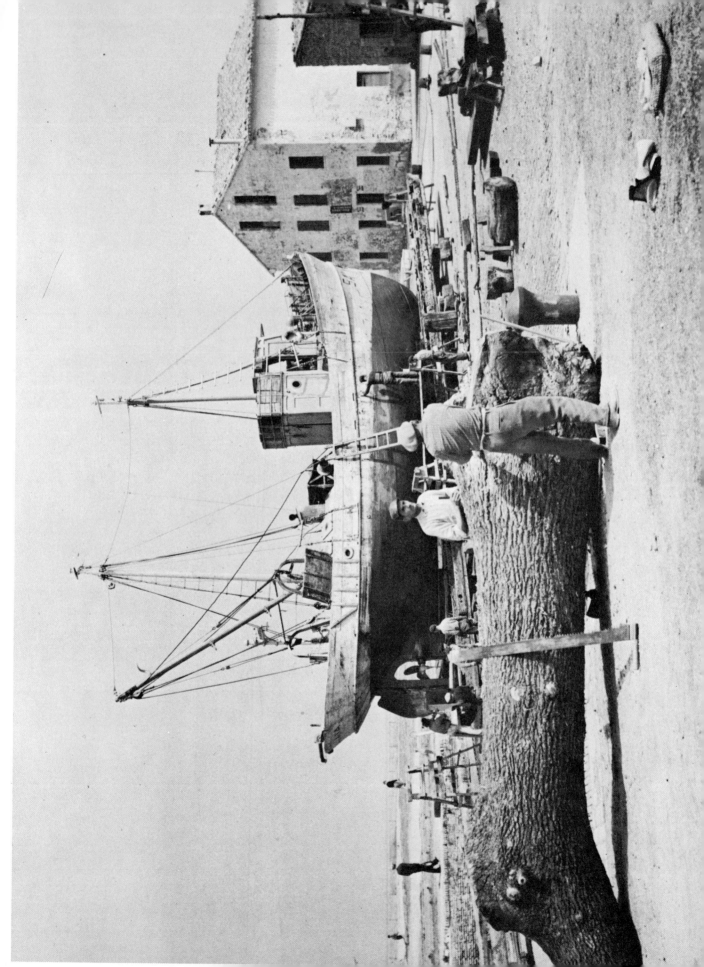

ASSIGNMENT 12

This "dragger", is much like the one I sketched in Rockland, Maine, and reproduced on page 125—even though the one pictured here is an Italian craft.

There are two points of interest here; one in the foreground, and the other beyond — the boat and buildings. My suggestion is to focus upon the latter, eliminating the log and workmen entirely.

When you do this you will have to supply some foreground interest. I have suggested the pile of timbers in my rough sketch, reproduced at exact size. You will do better to make your drawing larger. This will permit more detail of the boat, which is sharp enough in the photograph to give all the data you need for a meticulous rendering.

Although the photograph shows a pattern of light gray on the ground you will have to make your own: it will depend upon your disposition of the litter which you improvise to give the foreground interest and solidity.

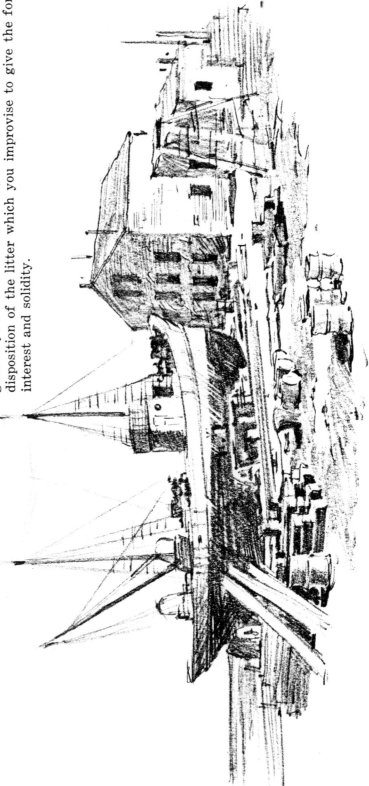

155

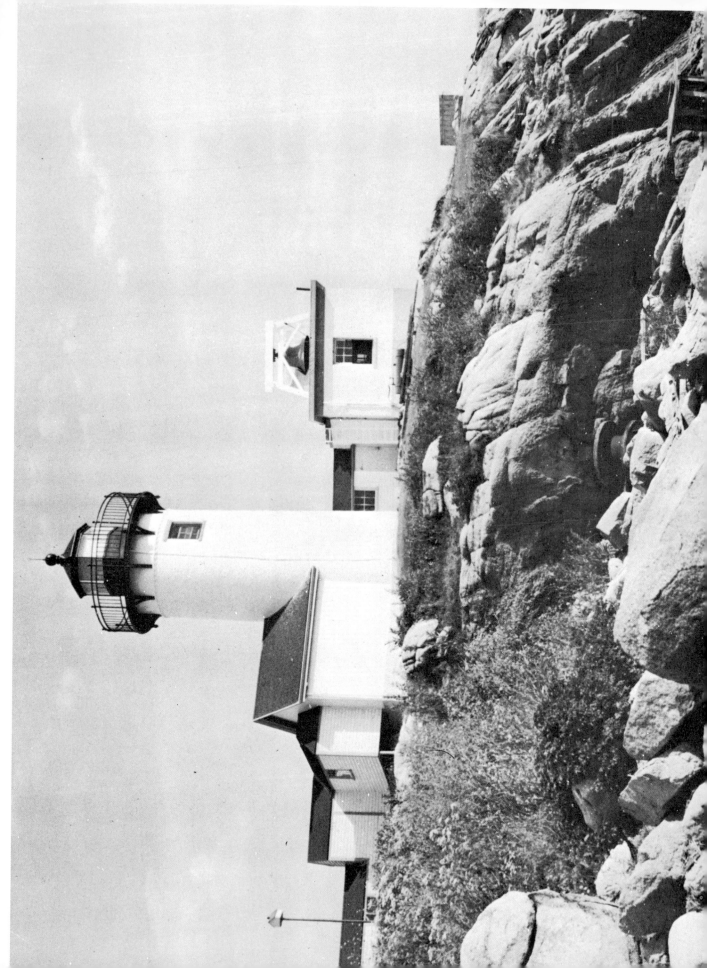

ASSIGNMENT 13

Rendering a white structure against a light sky is rather difficult because it loses its silhouette through lack of contrast. Of course you can put a dark cloud behind it, or you can put the sun directly behind it so that even the white buildings look somewhat dark. That is what I would do with the Eastern Point Lighthouse of Gloucester, Massachusetts.

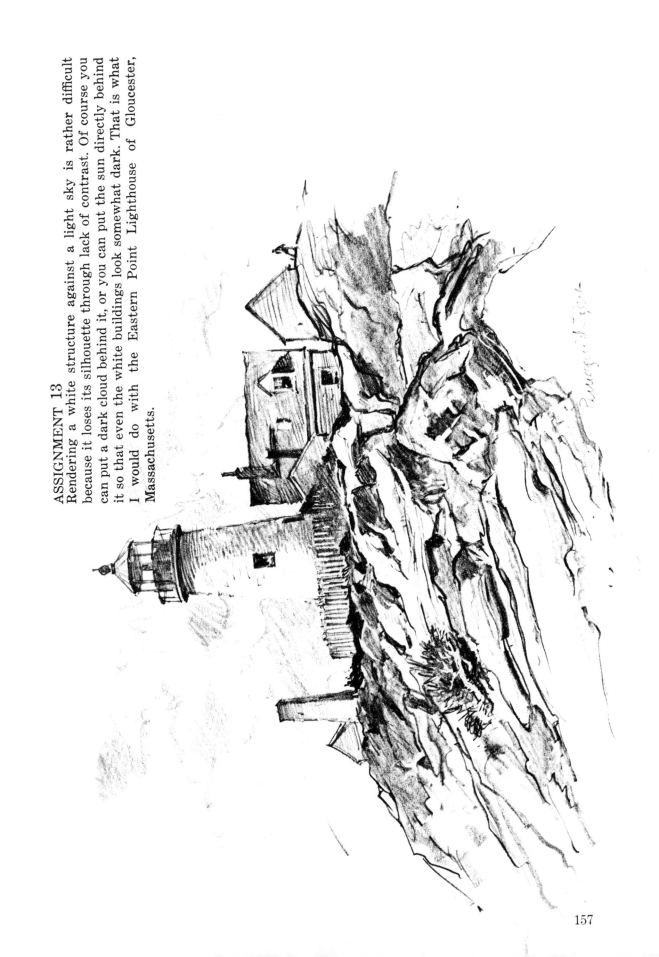

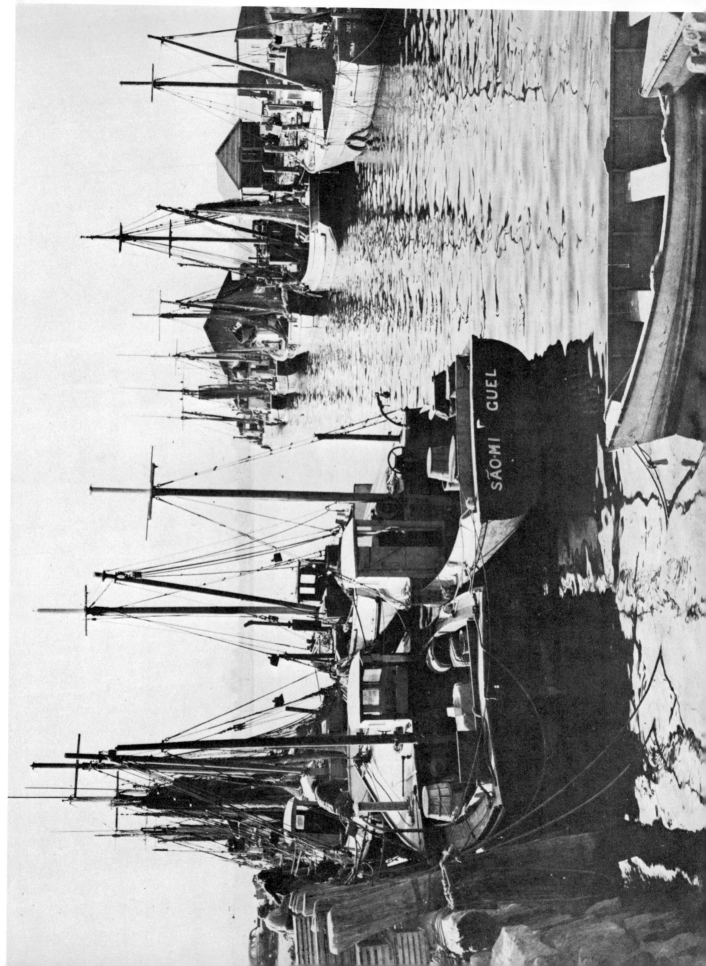

ASSIGNMENT 14

This subject offers opportunity for two different compositions. One can follow the photographic copy quite literally because the picture composes well as it is. To be sure, the two groups of ships are separated by the channel of water between them. Another boat going or coming might be sketched in the channel, just over the wheel of the SAOMI GUEL and on a level with the third boat at the right-hand dock. Would not that serve to unite the two sides of the picture?

Another possibility is to ignore the right-hand row of boats and concentrate on those directly in front of us. When we do that however, we feel the need of showing more of the dock at the left. Possibly my drawings on pages 112 and 119 will be of some help in this.

I have made the accompanying drawing to demonstrate three points for the pencil artist. The first is that, with the pencil, we just cannot duplicate those dark tones we see in the picture. The second point is that distant dark masses — the masts and drying nets of the more distant boats — should be made perspectively much lighter than they

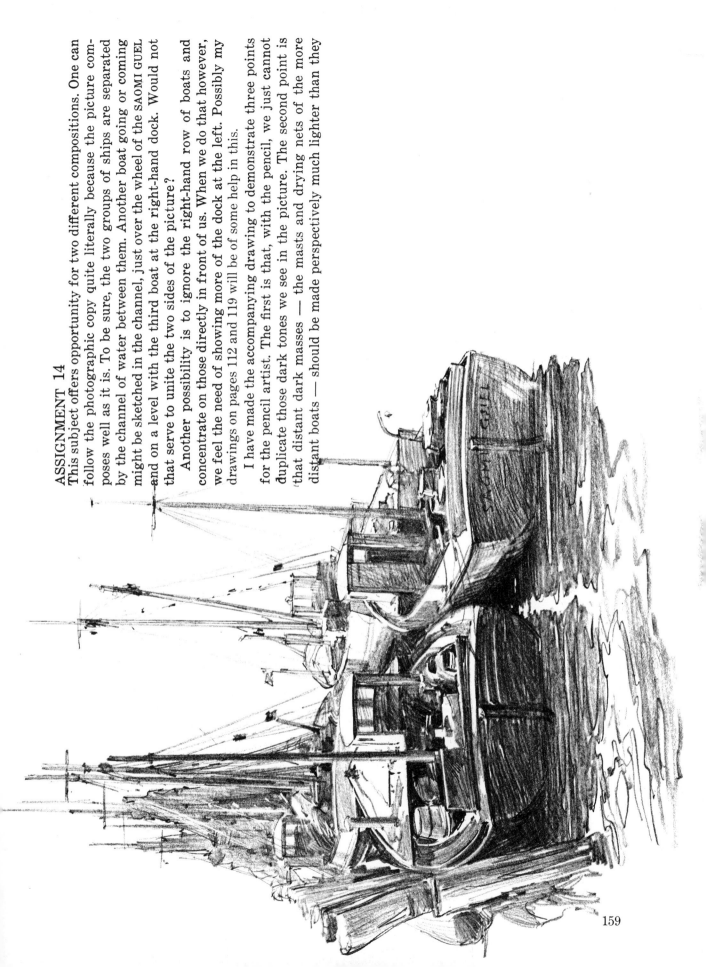

159

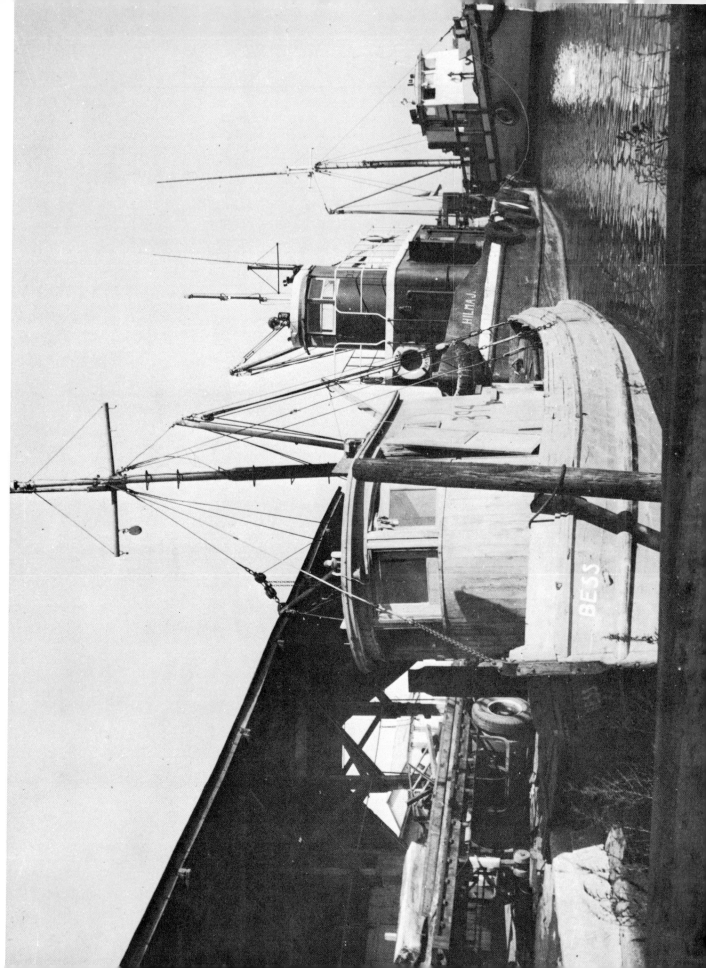

seem to appear even in nature. The third point is the advisability of concentrating our darks in a relatively restricted area. Now it might seem that there is no reason why the SAOMI GUEL should not be rendered in a tone as dark as its nameless companion on the left. However, as I proceeded with my sketch I instinctively made that boat and the one in front of it quite a little lighter in treatment. This does not mean giving it less interest, but it does give the sketch a more comfortable focal point. This would be even more evident if, as suggested, the picture were to be developed at the left, rendering a reasonable amount of the pier which barely shows in the photograph.

ASSIGNMENT 15

I took this photograph in Charleston, South Carolina, the day I made the sketch on page 117. In fact the very dock which I drew is seen just at the right in the photograph. If you want to take a more extensive scene than that represented in the photograph you can use the detail of my sketch to complete the picture, at the right.

These fishing boats make a very interesting subject. The troublesome thing about the picture is the dark shed on the dock that interferes with the nearest boat, which would be much better if its shaded side were silhouetted against something light. Certainly I would eliminate the shed. The truck seen on the dock is excellent background interest. That dark mooring pile which stands up in front of the pilothouse is disturbing. Cut it off a few feet and move it to the left or right a bit so that it will not continue the line of the mast above.

I think I would do something with the foreground; that horizontal line, which is a great timber lying on the edge of the dock, ends the picture too abruptly. Perhaps it would help to show a little more foreground.

Another recourse would be to eliminate the foreground pier and let the water flow right into the foreground — as though the boats were moored a bit further away.

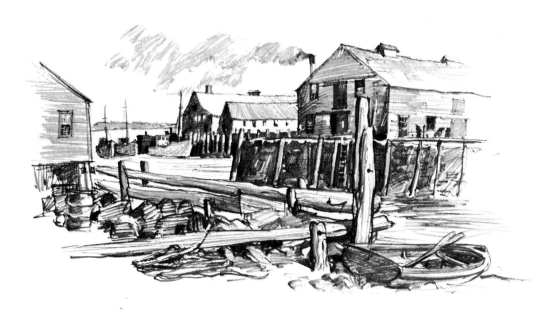

Fish Processing Plant, Rockland, Maine.

4

Contents

164 It comes down to this
165 To repeat
165 And explain
167 The basic fact
168 One-point perspective
170 The horizon line
171 The first step
172 Two-point perspective
177 Bastard two-point perspective
182 The point of view
187 The vanishing trace
191 The circle and the ellipse
202 The cone
204 Reflections
207 Analysis and measurement

it comes down to this

If you can correctly draw the model pictured here—a cube with circles inscribed on its faces—in any and every position, you can draw any object based on geometric form.

TO REPEAT

It comes down to this: If you can draw the model of the cube shown on the opposite page—a cube with circles inscribed on its surfaces—you can draw any object which is based upon geometric form.

AND EXPLAIN

Stating our premise more comprehensively: If you can draw the square and the circle in any conceivable relationship to each other, you can draw any object based upon geometric form. This is true in spite of the fact that drawing also involves other geometric forms such as the pyramid, the cone and the hexagon. But these all have form relationships either to the square or circle which are basic to their construction.

Perspective practice can, to be ·sure, present complicated and exacting problems to the professional illustrator who must on occasion violate the rules in order to achieve more dramatic effects or conform to the dictates of design. In my book, *How to Use Creative Perspective,* I have dealt with many situations of this kind; in the present book I am thinking of the needs of those artists who are concerned only with the simpler facts of normal perspective appearance in sketching.

One can, merely by reading, quickly acquire a theoretical knowledge of perspective, but as in all other arts and crafts it is of small benefit until knowledge is made usable through much practice. At the outset, therefore, the student should make a model 3-inch cube out of paper that is stiff enough to hold its form without buckling. The diagram at Figure 1 will serve as a pattern. After the pattern has been cut out with a sharp blade—perhaps a single-edged razor blade—the edges to be folded should be scored with a dull edge like that of a letter opener. The sides fold away from the scored edge, which will be on the outside of the cube. Transparent Scotch tape can be used to fasten the flaps down.

The circles should be drawn on the pattern before folding. If you have no compass, the end of a cylindrical grocery tin may be employed as a guide. It is necessary to inscribe circles upon three faces only, since never more than three faces are seen at a time. The circles can be drawn in outline only or filled in with a light gray tone, or cut out of gray paper. Draw diameter lines on three of the circles as indicated in the diagram.

Once the model is completed, you are ready for practice, and the model will be found useful to consult in future drawing problems.

It is obvious that your progress will be related to the extent of your practice. If you make a thousand drawings of the cube you will become more skillful than if you stop at a hundred or at two. Ignore the circles at first. Concentrate on the cube. There is no point in drawing the circles until you have achieved a reasonable proficiency in drawing the squares which contain them.

It will be natural in your practice drawings of cubes to look for

an explanation of the perspective theory involved, but it is best not to be too concerned with theory at first. In teaching perspective I always tell about my own learning experience during my first six weeks of art school study. It consisted primarily of drawing disordered piles of wooden grocery boxes. The boxes were rearranged by a monitor every hour or two, every day, during that six-week period. There was no teaching of perspective theory, no mention of foreshortening or convergence; the instructor's criticism focused only upon the accuracy of the student's observation. He was merely admonished to use his eyes more expertly. Perspective theory was taught only after he had learned to think of the lines on paper as actually having dimension in space instead of conforming to diagrammatical formulas.

That experience, naturally, was not inspiring to ambitious young students who had come expecting the excitement of drawing from living models. It was not until I became a teacher of perspective at Pratt Institute that I fully realized the logic of that method, which was learning to draw *in depth* rather than on a flat surface. *Drawing in depth* is our objective here. When the sketcher learns to think of distance—not the surface of the drawing paper—to feel depth instead of merely knowing about it, he shall have experienced a sensory conversion that he simply must make sooner or later.

So I repeat: make innumerable drawings from your model. Make many drawings of it in the same position, then compare them and decide which one is most accurate. Then draw it in a hundred other positions. You will not confine your drawing to this model; you will draw any rectangular object you see around you. However, keep the cube before you and continue to practice with it.

Make your cube drawings fairly large—at least 4 inches high, preferably larger. Draw with a soft pencil; try a 4B. Do not test the accuracy of converging lines diagrammatically for a while. Depend only upon your eye. Acquire a sense of depth before you begin experimenting with diagrams. You alone can decide when this will be.

Figure 1. A 3-inch cube of stiff paper serves as a model to help develop facility in drawing rectangular objects. Make cube and inscribe circles on three faces, with diameters indicated as shown.

THE BASIC FACT

The basic fact of perspective appearance is familiar to everyone: distant objects, we say, look smaller. This we know is not true. However, they do produce smaller images upon the retina of the eye as they would upon a camera film. Reference to the camera is frequently useful, even though there is a marked difference in the structure of its receiving surface: that of the film is flat; the retina of the eye is concave. Although impressions received by both differ in certain respects, they are sufficiently similar so that occasional references to photography are helpful to our study.

The simplest way to understand how three-dimensional appearance is translated upon a flat surface—the drawing paper—is to view a building or a street through a window and, with a china marker or lithographic pencil, to trace upon the glass lines which cover the outlines of the object seen. To draw them accurately the eye must be held stationary throughout.

This translation of three-dimensional space into two-dimensional expression is the goal of every student of perspective. Drawings made on paper are equivalent to the subject as it might be seen through a transparent plane. This imaginary plane is appropriately called the picture plane. In instrumental perspective the draftsman makes constant use of the picture plane. In freehand drawing it is useful chiefly in explaining a few facts about appearance. The student can and should soon forget it, since with practice in drawing from objects, the paper's surface magically disappears—it becomes as limitless in depth as all outdoors. When we draw an object 100 feet away we *feel* its distance; our pencil and our imagination travel deep into space. We learn to forget entirely our paper surface.

Now the basic fact of perspective appearance, which we noted in the first sentence of this chapter, accounts for everything that can happen in a perspective drawing—the fact of diminishing dimensions with increase in distance. It accounts for foreshortening and convergence in objects of any form whatsoever.

Figure 2.

ONE-POINT PERSPECTIVE

When the cube is viewed as in Figure 2, with only two faces visible, the line CD, being farther from the eye than AB, is drawn shorter to make it appear equal to AB when seen from this position. The position controls the directions of AC and BD, which necessarily converge to a vanishing point. The level of this vanishing point depends upon the position of the cube with relation to the eye, because converging horizontal lines always meet on the eye-level. The higher the eye, the higher the point of convergence in our drawing, the less violent the convergence of the AC-BD lines and the larger the area of the foreshortened surface. The ratio of fore-shortening of the horizontal surface to the eye-level is demonstrated in Figure 3, the foreshortened surface increasing in depth and area as the cube is lowered. Turn the page upside down to represent the same effects seen from varying distances *above* the eye.

It will be obvious, of course, that any number of cubes which are related to each other, as in Figure 4, are subject to the same law of convergence: all parallel horizontal lines converge to the same vanishing point.

Now let us think of the cube as a huge box (Figure 5), the interior of which becomes a room. The eye-level is that of the

Figure 3.

Figure 4.

Figure 5.

Figure 6.

person who stands at the near side, looking into the room (assuming him to be the viewer). If he should be seated, the eye-level and the vanishing point would of course drop down to his lowered eye-level. In Figure 6 we see the inside of a box converted into a street scene, the sides of the cube representing the façades of buildings on either side.

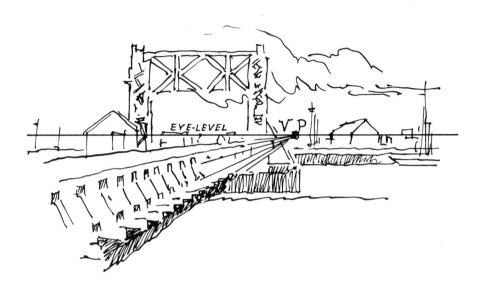

Figure 7. In one-point perspective all horizontal parallel retreating lines converge to a point on the level of the observer's eye.

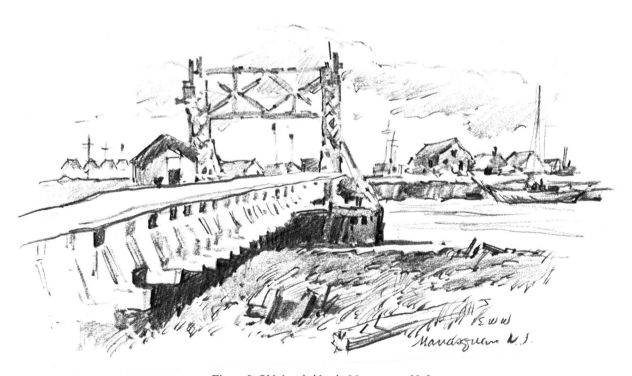

Figure 8. Old drawbridge in Manasquan, N. J.

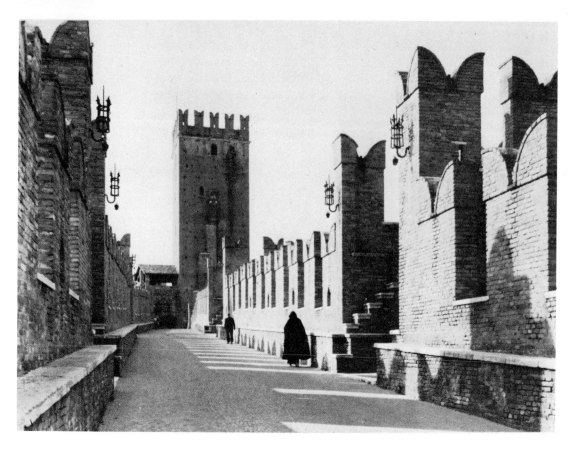

Figure 9. Scaligeri Bridge, Verona, Italy. Note that a horizontal line—the eye-level—passes across the converging wall just over the heads of passers-by. Chamberlain photo.

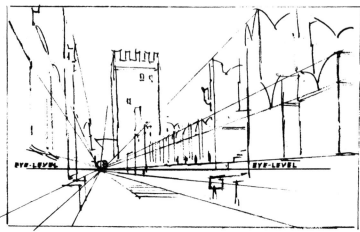

Figure 10.

THE HORIZON LINE

The horizon line corresponds with the observer's eye-level. Thus the terms "horizon" and "eye-level" are synonymous and are used interchangeably, the former seeming more appropriate when the horizon, be it the sea, as in Figures 11 and 12, or the desert, is visible—the apparent junction of earth or sea and sky. In other subjects, where the actual horizon is hidden, it is represented by a horizontal line that coincides with all horizontal converging lines of objects in the scene.

THE FIRST STEP

The first step in sketching is to discover this horizon line upon which all converging horizontal lines of the subject will find their vanishing points. In Figure 11 this line passes through the fish house at the level of the eaves, which becomes the horizon of the sea. In Figure 12 it is apparent that the artist was looking down upon the scene from a point equal in height to the horizon of the sea. In both sketches the horizontal lines of the building converge upon the horizon.

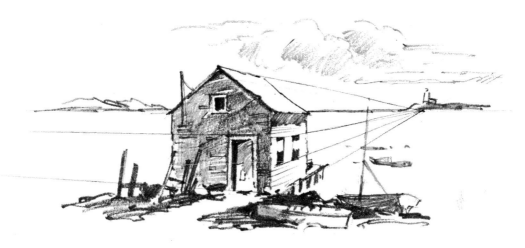

Figure 11. Here the observer's eye is on the level of the eaves of the fisherman's shack. This is also the horizon line.

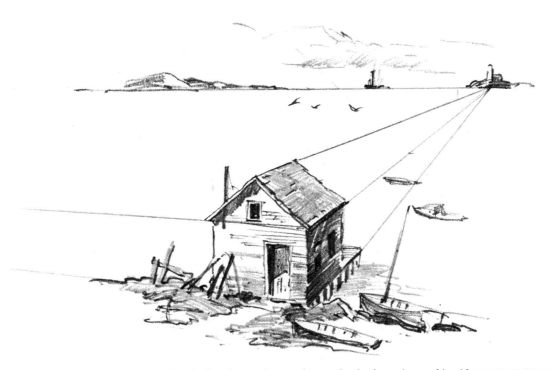

Figure 12. In this sketch the observer's eye, hence the horizon, is considerably above the roof of the building.

TWO-POINT PERSPECTIVE

Thus far we have been dealing with one-point perspective. When the cube is presented in a position, as in Figure 13, there are two vanishing points. And when accompanying cubes are added, as in the plan at the bottom of Figure 13, all vertical faces of the three cubes, being parallel, converge to the same two vanishing points.

In Figure 14 we have a different situation. The three cubes are placed at varying angles to the viewer, as shown in the accompanying plan. None of the vertical planes of these cubes is parallel with that of its neighbor. Hence each cube has its own two points of convergence; there are six vanishing points. The application of these perspective facts is illustrated in photographic subjects on the following pages. Shadows, being parallel to the lines which cast them, are subject to the same laws of convergence.

As shown in Figures 35 to 40, one vanishing point is certain

Figure 13.

V.P. 1

Horizon Line -- Eye-Level

V.P.

Showing relative position of cubes in plan

All sides parallel with each other

Figure 14.

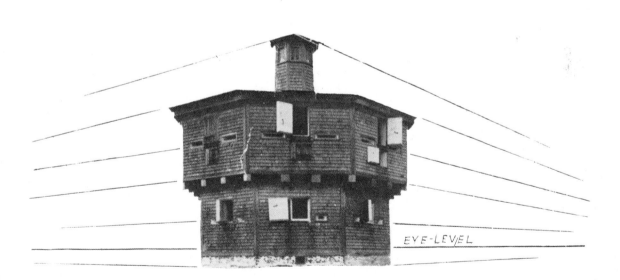

Figure 15. In this view of an octagonal blockhouse, the right converging face is turned somewhat more away from the observer than the left face. Thus the right vanishing point is closer to the building, and its lines converge more steeply.

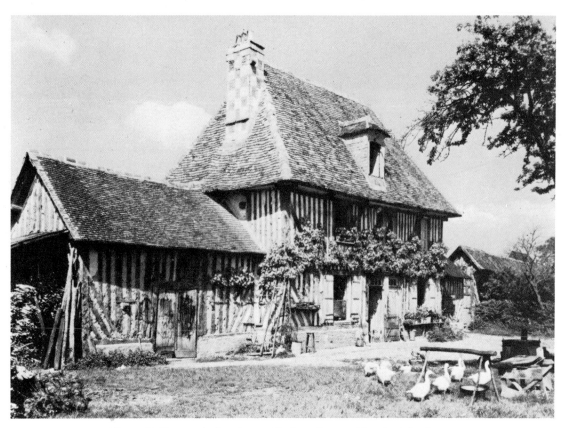

Figure 16. Normandy farmhouse, Corbon, France. Chamberlain photo.

to be at a considerable distance from the object when the other is close, as is VP 1 in the drawing of the Normandy farmhouse (Figure 17). The closer the one point is, the farther away the other will be. The closeness of both points depends upon the distance from which the building is viewed. After locating the position of the eye-level or horizon line, the artist must establish the directions of the main lines of the building with relation to vanishing points which are probably far beyond the confines of his paper. This is not difficult for the practiced artist, whose eye becomes very sensitive to relationships.

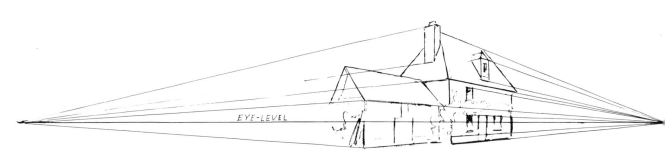

Figure 17. A ruler overlaid horizontally on this subject passes through the center rails of the two windows and thus establishes the eye-level for our diagram.

Figure 18. *The Banker's Table* by William Michael Harnett, American 1848-1892. Courtesy The Metropolitan Museum of Art.

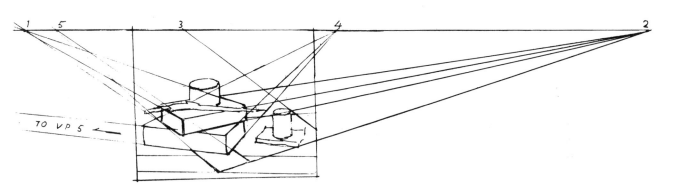

Figure 19. Harnett was a meticulous painter who insisted upon perspective accuracy. Each object in his still life has separate vanishing points.

Figure 20. This diagram represents an error common among those who are ignorant of the simple perspective law that all horizontal parallel lines converge to vanishing points on the eye-level. Here there are two eye-levels, one for the side and one for the front.

Figure 21.

Figure 22.

EYE-LEVEL

VP

Figure 23.

X Y

EYE-LEVEL

VP

STREET

Figure 24.

VP VP

Figure 25.

Figure 26. Figure 27.

BASTARD TWO-POINT PERSPECTIVE

I have given this name to a perspective practice which produces effects that are contrary to traditional scientific perspective but which nevertheless is a universally used device in sketching. It is one of many contributions which photography has made to representative drawing.

In Figures 21 and 22 we see interior views of what, before photography pointed the way, used to be accepted as a limitation: when both of the side walls of a room were shown in a drawing, the viewer's direction of sight was assumed to be parallel with the side walls even when, as in Figure 22, the viewer moved close to one side of the room. This is one-point perspective. According to this precept, the rear wall is necessarily rendered as a rectangle. As a matter of common practice now, neither artist nor photographer respects the limitation of such a rule.

Figure 23 represents a camera view of the room. The line diagram indicates the position of the camera and direction of focus toward corner Y, which appears shorter—not as high—as corner X, nearer the lens. This disparity of heights results in the convergence of the floor and ceiling lines of the rear wall and a second vanishing point outside the picture at the right. So we have two vanishing points, although they are not those of traditional two-point perspective.

Anyone can discover through experiment that when one views a room as in Figure 23, directing the eyes toward corner Y, the left wall of the room is but dimly noted, if at all, in the periphery of vision. Figure 23 therefore is what may be called a multiple vision, the eye encompassing the left wall only by turning from corner Y to focus upon it. The eye in a single look can actually see, *really see,* a relatively narrow field of vision; to see all that the camera instantly records, it has to turn in many directions. In photography the camera records the details of the two walls with equal clarity, and the artist wisely employs the same all-encompassing vision.

In the case of Figure 23, photography has contributed much by introducing bastard perspective; it is a much more interesting presentation than the limited one represented in Figures 21 and 22. It will be noted that the artist nearly always takes advantage of the more appealing viewpoint, as does the photographer—and as

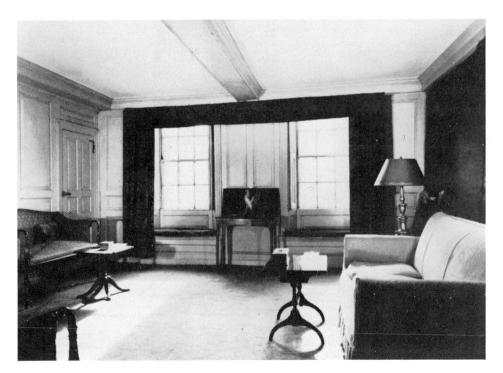

Figure 28. The Clark Morgan House, Salem, Mass. A typical example of bastard two-point perspective. Chamberlain photo.

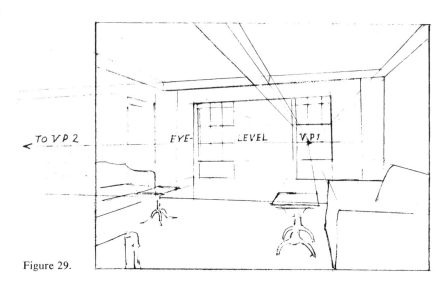

Figure 29.

did Samuel Chamberlain when he photographed an interior of the Clark Morgan House in Salem, Mass. (Figure 28). One can easily imagine the comparatively static effect which would have resulted if the camera had been pointed at right angles to the rear wall, producing an effect such as is demonstrated in Figure 22.

Of course there are many occasions when, focusing upon the corner of a room, as in Figure 25, there is no desire to include a third wall. We then revert to the traditional concept of two-point perspective which has already been demonstrated. A comparison of Figures 26 and 27 points up a very good reason for preferring

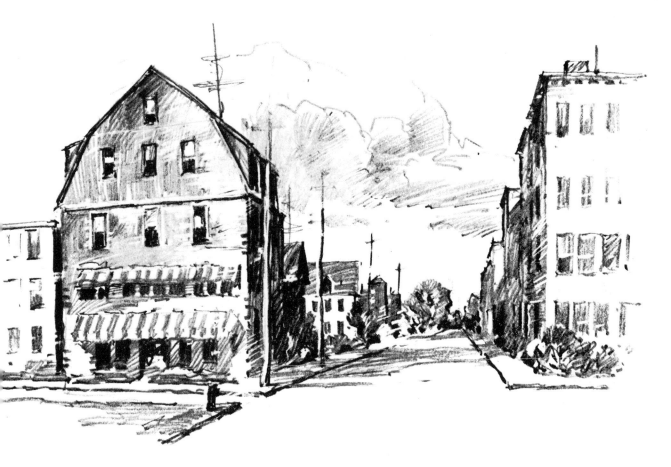

Figure 30. Author's pencil sketch of a street in Ocean Grove, N. J.

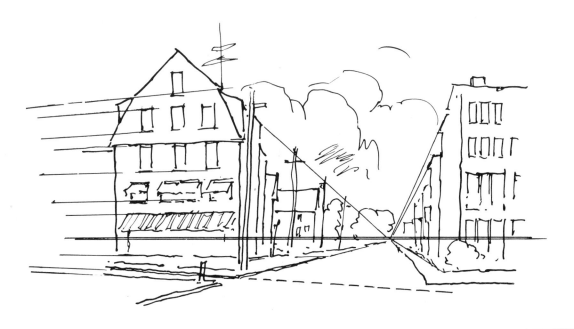

Figure 31. Another example of bastard two-point perspective, as explained in text.

bastard two-point perspective; considered as pure design, how much more interesting—as pattern—is the two-point version in Figure 27.

What has been said of interior viewpoints is equally true of exteriors, which can be thought of as interiors with the sky for a ceiling (Figures 6 and 24).

Figure 30, a street scene, illustrates how in an outdoor sketch one finds himself deviating from the conventional rule of perspective, which assumes a single, fixed point of view. This is a subject which traditionally would be treated as one-point perspective, inasmuch as the point opposite the eye is within the enclosure of a frame that might surround the sketch. The main focal point of convergence is at the end of the street, where all horizontal lines along the street meet at the level of the eye, perhaps 6 feet above the street level. Yet obviously the artist's interest is centered upon the house with the awning, on the left corner, which was in fact a sentimental incentive for the sketch. So he did not feel bound to direct his attention down the street to a distance which was of less interest to him than the house. Turning toward this house it seemed natural to make its front lines converge away from him, since they certainly appeared that way as he turned his gaze in that direction. But, be it noted, the front lines of the building on the right are horizontal, as is normal in one-point perspective.

This result (Figure 31) is, of course, inconsistent from a theoretical viewpoint, as is evident when the street line, in extending forward from the left (dotted line), meets the horizontal street line extending from the right side at an angle, instead of being an extension of it. A photograph would have shown the horizontal lines of the building on the right converging to the left with those on the opposite corner; but this would look unnatural. Thus the artist is habitually violating rules as he accommodates perspective practice to the natural way of viewing a subject—an illustration of the truism that perspective should be used to represent appearance rather than to demonstrate theory.

One might ask why the artist did not in this instance use regular two-point perspective, terminating his sketch at the right, along the center of the street, and eliminating the buildings on the right side. The answer is that he had a personal reason for showing the entire street, since this drawing was intended, for reasons best known to him, as a more complete record of the scene.

This type of perspective treatment is indeed commonly preferred in rendering of many kinds of subject matter. *Still life—Dead Leaves,* by Henry Lee McFee (Figures 32 and 33), illustrates a much-favored handling of this problem. There seems to be a psychological basis for it: locating the one-point vanishing point within the confines of the picture laterally. Keeping the eye from wandering outside of the picture gives a more satisfying feeling of pictorial completeness. Often, of course, the nearly horizontal long lines of the table converge slightly to a distant vanishing point. In the McFee picture they are parallel though not horizontal. Figure 33A shows how a table top or a box would actually appear when the front edge converges upward at the left, as does McFee's table;

Figure 32. *Still Life—Dead Leaves* by Henry Lee McFee.

the short retreating end lines seeking a point to the right of the object, the long lines converging slightly to a vanishing point at the left.

In Figure 33, note the reference to the distortion of the elliptical representation of the bowl of fruit. This is an intentional distortion intended to direct the observer's interest into the picture's center. The normal eye-view would show the long diameter of the ellipse as a horizontal line.

Figure 33A.

Figure 33. Line analysis of the McFee painting, showing incorrect (according to theory) placing of the vanishing point of the converging table sides.

THE POINT OF VIEW

Perspective effects vary greatly according to one's distance from the object. Thus in the photograph of the Arch of Titus (Figure 34), there are steep perspective lines in the structure of the arch. But the lines of all planes in the distant buildings appear so nearly horizontal that an artist will naturally draw them as horizontal.

As one moves closer to a structure, the vanishing points of converging lines draw nearer to it, as is seen in Figures 36 and 39. When the camera is as close to the subject as it was to the Museum of Modern Art (Figure 35), it produces great distortion—note the acute angle of the roof lines. The eye cannot possibly see such a perspective appearance. This is one of those differences between camera vision and human vision. If the human viewer were as close to the building as was the photographer—he had to be close to get his picture—his vision could not have encompassed its entire form. To see the roof lines he would have been obliged to raise his sight from the lower stories to the roof, actually tipping his head back to see the roof corner. Even then it would not have appeared an acute angle as in the photograph. The human eye never sees such a condition; the angle in such a relationship is always wider—a more obtuse angle—than a right angle. The only way we see a right angle *as a right angle,* when the rectangle is in a horizontal plane, is by looking directly down upon it as upon a sheet of paper or a book on the floor vertically beneath our eyes. However, modern photography has accustomed us to acceptance of many distortions now customarily employed by artists. Yet most artists drawing the Museum building from that point of view would see and draw the roof angle as in Figure 37, which assumes a vanishing point much farther to the right than in Figure 36. They would necessarily establish the same vanishing point for the building façade as that in the photograph.

The point to remember is that when one vanishing point is close to the object, as in Figure 40, the other is at a considerable distance.

The awkwardness of perspective effects due to close camera views is illustrated in the photograph of the First Presbyterian Church, in St. Augustine (Figures 38 and 39). There may have been a good reason for this close-up view; the tree probably prevented a more distant view, which would provide a more satisfying result, as is suggested in Figure 40.

There is an interesting demonstration of the varying perspective effects in circular objects in the comparison of the photograph of the circular barn (Figure 44) and the painting, *Carrousel* (Figure 41), by Robert W. Addison. The painter naturally had to adopt a close viewpoint of his subject in order to focus upon detail; the photographer of the barn stood at a greater distance from his in order to encompass surrounding objects. In the far view the ellipses are thinner.

Figure 34. Arch of Titus, Rome, Italy. Chamberlain photo.

Figure 35. Photograph of The Museum of Modern Art, New York.

Figure 36. Perspective analysis of The Museum of Modern Art photograph.

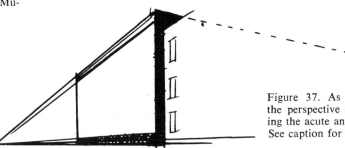

Figure 37. As an artist might treat the perspective of this subject, avoiding the acute angle of the roof corner. See caption for Fig. 40.

183

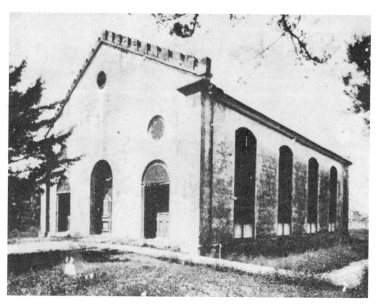

Figure 38. First Presbyterian Church, in St. Augustine, Fla. From *The Flagler Story,* by the Rev. Howard Lee, D.D.

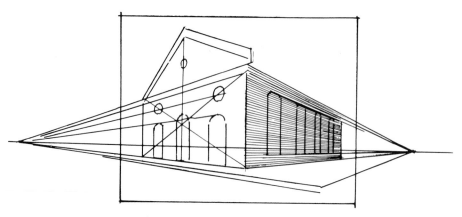

Figure 39. Perspective analysis of Fig. 38.

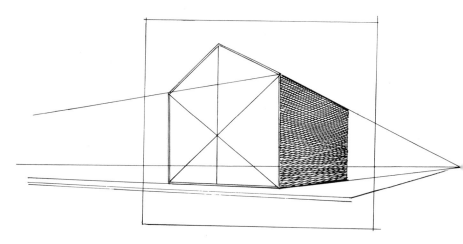

Figure 40. A more natural presentation of the subject in Fig. 38. When one vanishing point is near the object, the other should be at a much greater distance from it.

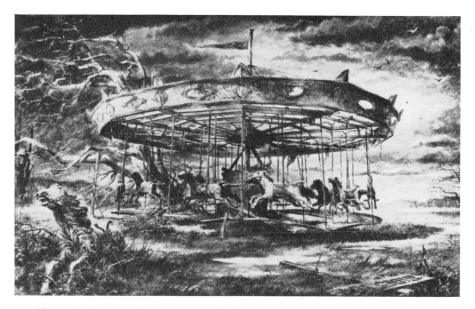

Figure 41. *Carrousel,* egg tempera painting by Robert W. Addison. From *Composition in Landscape and Still Life,* by Ernest W. Watson (Watson-Guptill Publications, Inc.).

Figure 42. Being close to the object, the ellipses of the circular forms have longer short diameters (relative to the long diameters) than those of the round barn (Figs. 43 and 44), which was viewed from a greater distance.

Figure 43.

Figure 44. Circular stone barn, Hancock, N. Y. Photo by author.

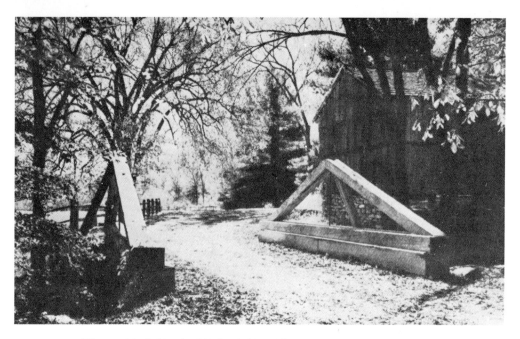

Figure 45A. Bridge in Old Sturbridge Village, Mass. Chamberlain photo.

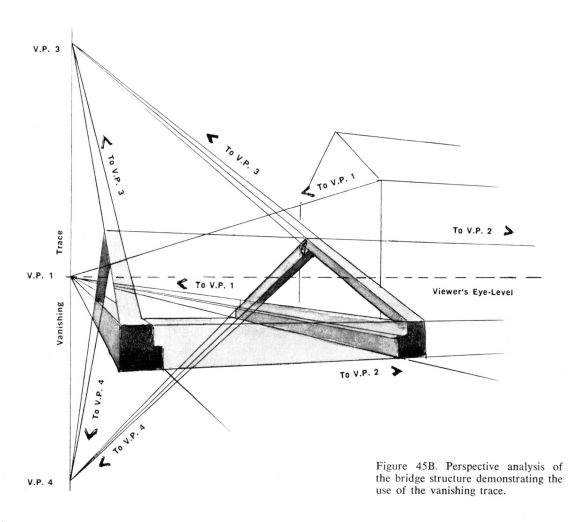

Figure 45B. Perspective analysis of the bridge structure demonstrating the use of the vanishing trace.

THE VANISHING TRACE

Thus far we have been dealing with the phenomenon of convergence of parallel lines which lie in *horizontal* planes. The country bridge in Sturbridge Village, Mass. (Figure 45A), introduces consideration of parallel lines which do not lie in horizontal planes but which have a definite relationship to them, as do the trusses supporting the bridge roadway. In Figure 45B, an analysis of the structure of the bridge, we note that the vanishing points of the sloping lines are located in a vertical line, known as the *vanishing trace,* which passes through the vanishing point of converging horizontals directly under them, the distances above and below depending upon the angle taken by the sloping lines. This is well illustrated in the hip-roofed barn in Figure 48, where there are two different roof planes, one steeper than the other. The vanishing points for these planes are likely to be beyond the confines of your drawing paper, so usually you will have to estimate the linear convergence rather than actually establish it diagrammatically. But in freehand sketching from nature you are obliged to do this with

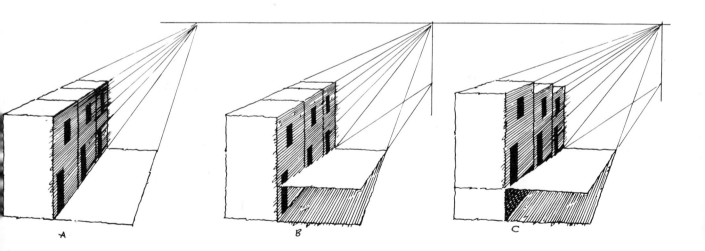

Figure 46. Diagrams illustrating the function of the vanishing trace in the drawing of inclined streets. From *The Watson Drawing Book,* by Ernest and Aldren Watson (Reinhold Publishing Corporation).

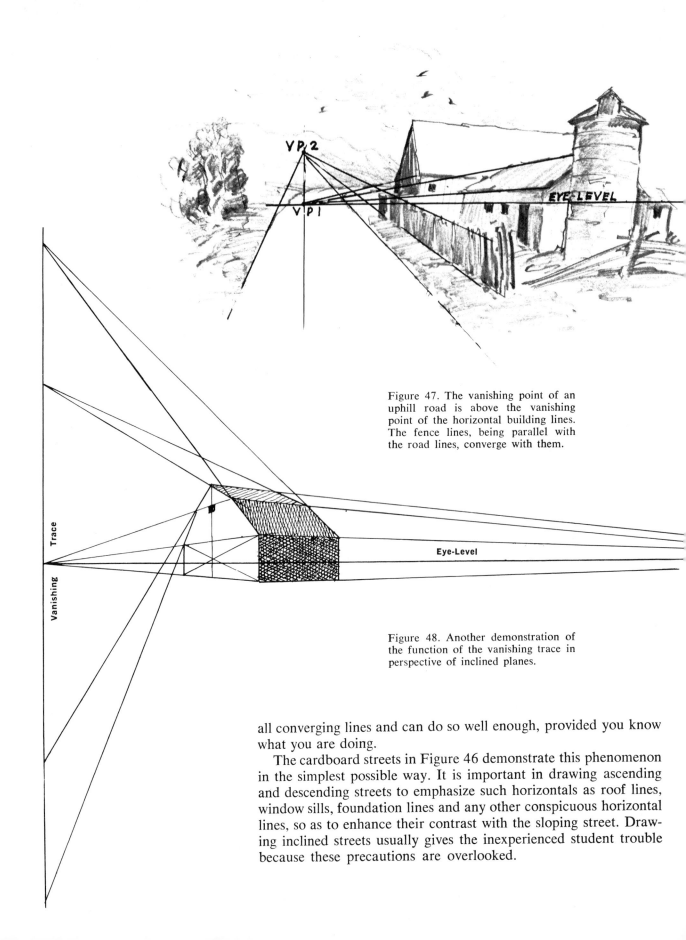

Figure 47. The vanishing point of an uphill road is above the vanishing point of the horizontal building lines. The fence lines, being parallel with the road lines, converge with them.

Figure 48. Another demonstration of the function of the vanishing trace in perspective of inclined planes.

all converging lines and can do so well enough, provided you know what you are doing.

The cardboard streets in Figure 46 demonstrate this phenomenon in the simplest possible way. It is important in drawing ascending and descending streets to emphasize such horizontals as roof lines, window sills, foundation lines and any other conspicuous horizontal lines, so as to enhance their contrast with the sloping street. Drawing inclined streets usually gives the inexperienced student trouble because these precautions are overlooked.

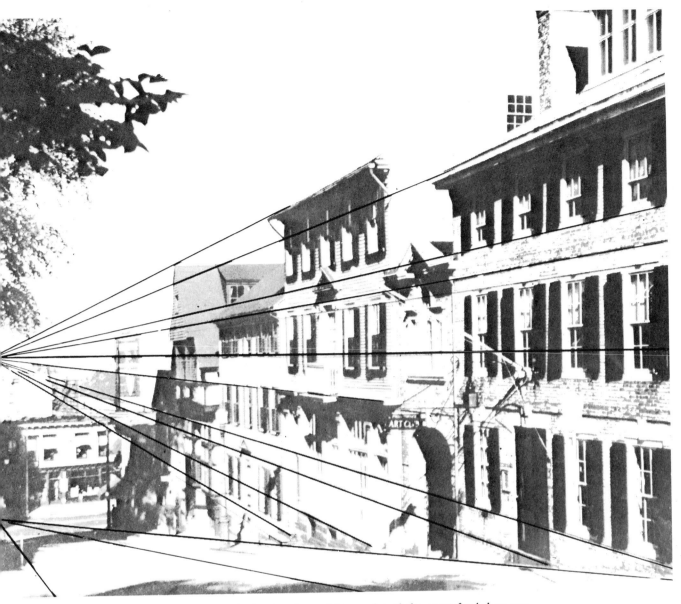

Figure 49. Line analysis showing the vanishing point of the street far below eye-level. The eye-level corresponds with a horizontal line that runs just below lower mullions of the second-story windows.

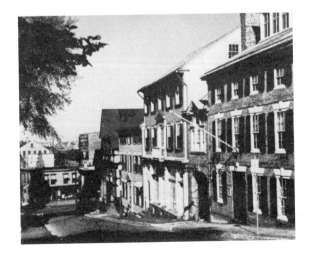

Figure 50. Street in Providence, R. I. Chamberlain photo.

EYE-LEVEL HORIZON

Figure 51. Lighthouse at West Quoddy Head, Maine. Chamberlain photo.

Figure 52. At eye-level the painted band appears as a straight horizontal line which coincides with the horizon of the sea beyond. The circular bands above become progressively "rounder" with increasing height.

THE CIRCLE AND THE ELLIPSE

The circle is seen as a sphere—the outline of a globe—when viewed from directly in front, as one normally looks at a clock face. When the viewer steps to one side or another for an acute-angle view, the circular clock face assumes the appearance of an ellipse, as does a dinner plate lying on the table. The proportion of the ellipse—its short to its long diameter—depends upon the angle from which the circle is viewed. It appears only as a line when the flat surface of the circle is seen in a horizontal position at eye-level, coinciding with the direction of sight. In the lighthouse (Figure 51), the eye-level is quite close to the ground and, be it noted, corresponds with the horizon line of the harbor. Ellipses representing the painted bands increase in "roundness" as the circles they represent are spaced progressively higher.

These facts of appearance are common knowledge; our demonstration is only a reminder, which may be useful in understanding the phenomena presented by such circular objects as those shown on the succeeding pages. When the circles lie in a horizontal plane, as do those in the lighthouse, the long diameters of their elliptical appearances are, of course, horizontal; when tilted, as are the circular elements of the Leaning Tower of Pisa (Figure 57), their long diameters are at right angles to the slanting sides of the tower.

What is an ellipse? It is not necessary to refer to the dictionary definition to demonstrate what the true ellipse looks like (Figure 53). It should be obvious that neither Figure 54 nor Figure 55 is an ellipse. The student's problem is to become expert in drawing true ellipses. This involves persistent practice. Draw hundreds, nay thousands, of ellipses of varying proportions—short to long diameters—to acquire the necessary facility. Draw with a very soft pencil with a rather blunt point, swinging the ellipses in with rapid arm movements. When you draw thus, your arm acts as a kind of compass and naturally produces the correct form, as the fingers will not. It is almost impossible when using arm movement to draw non-ellipses, like Figures 54 and 55.

Make continuous spirals, from narrow to rounder, without lifting the pencil from the paper. Do this with a free-swinging arm movement, letting only the little finger touch the paper. Make some spirals with horizontal and some with vertical long diameters. You will not produce perfect ellipses, but this is a good exercise preparatory to the correct drawing of them when the need arises in drawing from objects. Spoil a lot of cheap paper this way and acquire the kind of skill which will be needed in your later sketching work.

Figure 53.

Figure 54.

Figure 55.

Figure 56. The Leaning Tower of Pisa, Italy. Chamberlain photo.

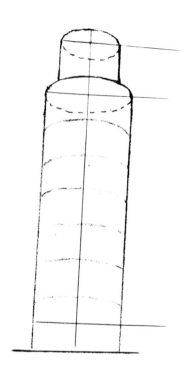

Figure 57. The long diameters of the ellipses are at right angles to the sloping axis line of the cylinder.

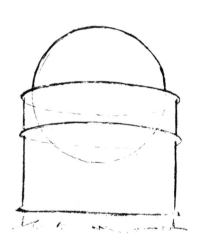

Figure 58. The artist thinks of his subject structurally and geometrically.

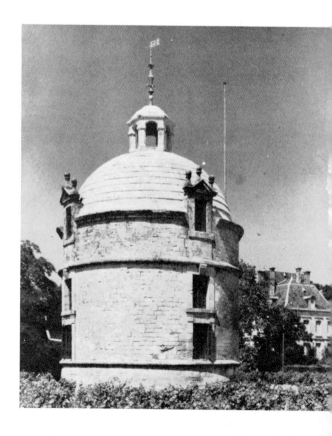

Figure 59. Chateau Latour, Province of Bordelais, France. Chamberlain photo.

192

Figure 60. The Colosseum, Rome, Italy.

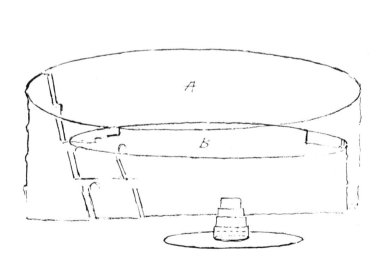

Figure 61. In all structural forms, however fragmented, the experienced artist visualizes the complete geometric basis upon which they are built.

Figure 62. This diagram refers to the semicylindrical projection of the Romanesque Basilica Church at Pisa (Fig. 56). The high viewpoint is used here in order to demonstrate most clearly the structural basis of the cylindrical form. The artist needs always to project his thinking beyond visible form.

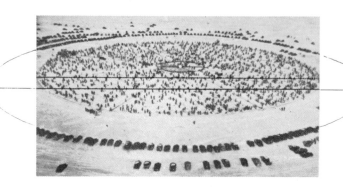

Figure 63. Ice fishing. Great Bear Lake, Canada. Associated Press photo. From *How to Use Creative Perspective*, by Ernest W. Watson (Reinhold Publishing Corporation).

Figure 64. Tracing from the above photograph to illustrate perspective phenomenon of concentric circles lying on a horizontal plane.

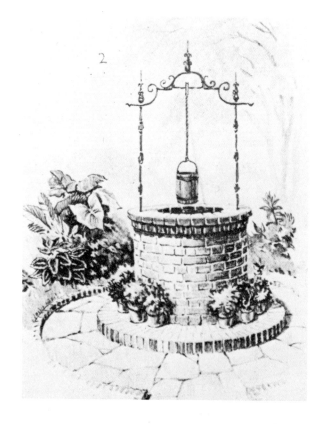

Figure 65. Concentric circles to be inscribed on 20-inch model of cardboard and used as indicated in the text.

Figure 66. Drawing by Arthur L. Guptill, from his book, *Pencil Drawing* (Reinhold Publishing Corporation). An application of the phenomenon of perspective appearance of concentric circles.

Tracing ellipses from photographs will be an aid in acquiring a true concept of elliptical form, because the camera always records them correctly.

The illustrations on the accompanying pages are examples of the application of the preceding text on circles and their ellipses.

We now consider a phenomenon that is demonstrated by the photo-diagram of ice fishing on Great Bear Lake (Figures 63 and 64), where there are three concentric circles. The first thing to note is that the space A, which separates the two largest ellipses in the foreground, is much greater than the corresponding space B on the far side. There is a similar disparity of dimension between space X and its corresponding space Y, of the two inner circles. These disparities are the effect of foreshortening of distances on the short diameter, MO, upon which equal distances diminish, perspectively, relative to their distance from the observer.

The next point to observe is that none of the long diameters of the ellipses coincide, those of the larger ellipses being in front of the smaller. Not one of them passes through the center of the circles themselves, although the smallest circle is so small that for all practical purposes—if not theoretically—its diameter does mark the circle's actual center.

Each ellipse will have the same proportion of long to short diameter. The most convincing experiment in this connection is with the aid of a large model—a 20-inch cardboard square upon which circles, such as those in Figure 65, are inscribed with a compass. Lay this on a horizontal surface about 10 inches below eye-level. In this position the circles will appear as ellipses, much like those of the photo-diagram. Place the point of your pencil on the largest circle where the ellipse's short diameter touches it at the rear. Gradually bring the point around the circumference at the right until it reaches a point that appears (as viewed at the prescribed angle) to mark the extremity of the circle on that side. Make a mark at that point. Do the same on the left side. The position of the eye should be static. When you connect the two points on the model you will discover that, as in the photo-diagram, the ellipse you have seen has a long diameter that lies in front of the actual center, the structural diameter of the circle. The explanation, of course, is simple: a line you have drawn through the circle, though shorter than the diameter of the circle, appears longer when seen in perspective because it is nearer the eye.

Thus far we have considered only the drawing of circles which lie in a horizontal plane, as on a table or the ground. In sketching those which lie in a vertical plane—the wheels of a vehicle or circular windows of a building—we encounter a phenomenon that may be unfamiliar to beginners. This phenomenon is dramatically

demonstrated in the photograph of the façade of the Como Cathedral (Figure 68). This may not be a subject you are likely to draw, but it serves admirably to illustrate conditions you encounter in drawing the simplest circular objects—a tower clock or a bicycle wheel.

Tracings of the circular elements of the photograph (Figure 69) point up the perspective fact we are considering: the relative appearance of circles (on vertical planes) seen at different heights. We note that the long diameter of the ellipse representing the arched top of the small door at the right, painted black, being nearly at eye-level—that is, the level of the camera lens—is vertical. The vertical dimensions of the circles themselves (dotted lines), as distinct from their elliptical appearances, are less than the slanting long diameters of the ellipses. If that upper circle were a clock face, the dotted lines would connect the numerals VI and XII.

To demonstrate this phenomenon further—duplicating the perspective effects in the photograph—try a simple experiment. From stiff cardboard which will not buckle, cut three circles, each about 18 inches in diameter. With a heavy line draw a diagonal on each circle. Attach the circles to a wall of your room, near one corner, as in Figure 67, placing one at the height of your eye as you are seated, one near the ceiling and one near the floor, with the diagonals vertical. Draw these circles from a seated position, about 4 feet from the same wall in the opposite corner. What you see and draw will approximate the appearance of circles in our diagram (Figure 67).

Figure 67.

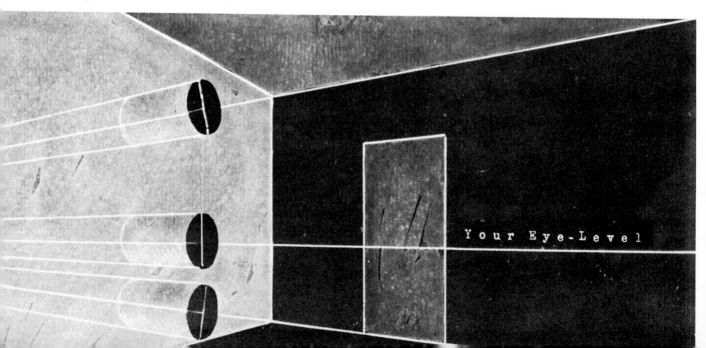

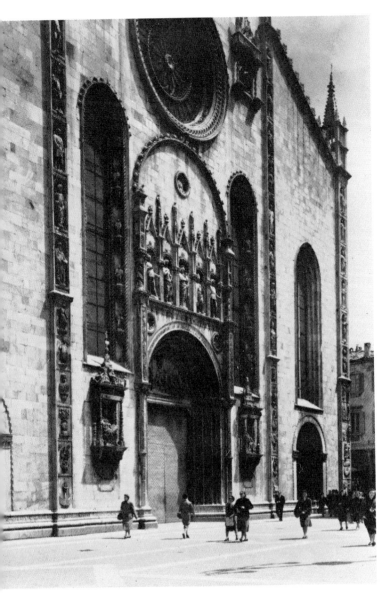

Figure 68. Cathedral Façade, Como, Italy. Chamberlain photo.

Figure 69. Tracing of windows of the Como Cathedral, to demonstrate the phenomenon of elliptical appearance of circles on vertical planes.

How do we account for the phenomenon of slanting ellipses above and below eye-level? How explain the fact that the vertical diameter of the high circle—when seen as an ellipse—is shorter than that of the diameter of the ellipse? The explanation is very simple: as we look up at the high circle, we see its vertical diameter foreshortened. The slanting line which becomes the long diameter of the ellipse, being at right angles to our line of vision, is not fore-shortened and thus is the longest diameter of the circle as it appears to our eye in that position.

The next question is how to determine the correct slant of the long diameter of the ellipse. The model at Figure 70, a cylinder fitted within a cube, gives the answer. If you make a careful draw-ing of this model, on a level considerably below eye-level (you should make your own paper model from which to draw), you will discover that for practical purposes the long diameter of the ellipse is at right angles to the sides of the cylinder. Because the cylinder sides converge, as they plainly do in Figure 67, neither side can be *quite* at a right angle to the diameter of the ellipse, but the axis of the cylinder is. So we say that the long diameter of the ellipse should be drawn at right angles to the cylinder axis.

More often than not, the circles we have to draw are not actually the ends of cylinders; we have to imagine that they are. Thus we can imagine the cathedral windows to be the ends of cylinders that project into the building, like the circles you have attached to your room wall, the ends of cylinders that pierce the wall and project into the adjoining room.

But we have to know something more. In what position do the cylinders lie? How do we establish the direction of their diameters?

When you draw from the model (Figure 70), the lines of the cube which are parallel with the cylinder supply the answer. Are there any converging lines in the corner of your room (Figure 67) to serve similarly? Yes, the converging lines of the adjacent wall. The cylinders' axes, being parallel with them, follow their direction as they seek their vanishing point far to the left. This factor is con-vincingly demonstrated in Figure 71, an abstract form that may be translated as an automobile or any wheeled vehicle wherein the circular elements are associated with rectangular elements. Many times, of course, there is no such rectangular plane to give the cylinders direction, as in the case of the bicycle which stands alone (Figure 72). Therefore we can envision an imaginary box into which the bicycle fits, as shown. This calls for a bit of under-standing, which is acquired through practice and soon becomes natural.

Figure 70. Drawing from a model such as the student is advised to use to demonstrate the perspective facts involved in drawing circles that are similarly related to rectangular forms.

Figure 71. An abstract diagram which refers to all vehicular objects.

Figure 72. In drawing free-standing circular forms such as the bicycle, the artist unconsciously relates them to a rectangular form as an aid to correct drawing.

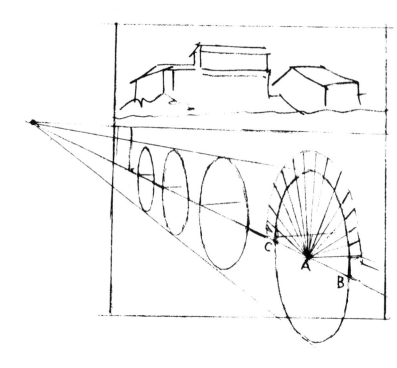

Figure 73. Tracing (reduced size) from the Rimini Bridge (Fig. 74) to demonstrate the structure of the stones of the arches. The stone joints radiate from the center (A) of the circle, which is the structural center of the semicircular arch rather than the center of the ellipse.

Figure 74. Ponte di Tiberio, Rimini, Italy. Chamberlain photo.

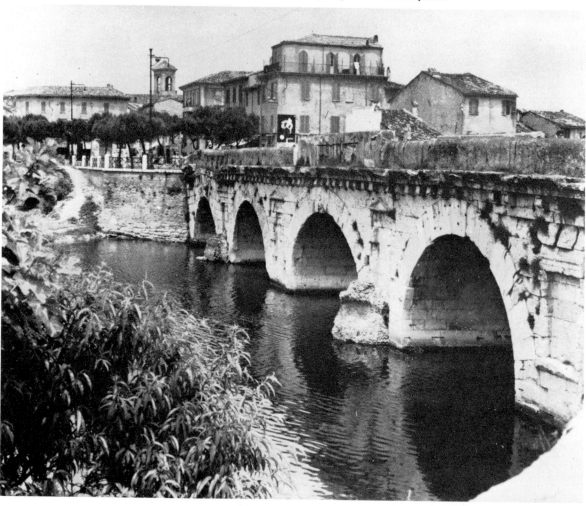

The photograph of Ponte di Tiberio, in Rimini (Figure 74), presents an interesting reference to the problems we have been considering. The bridge roadway may be thought of as resting upon four cylinders of which the arches are halves, or slightly more than halves. Figure 73 is a tracing, reduced in size, from the photograph. It introduces another point that is important in the drawing of cylindrical forms: that the ellipses of their circular ends when seen in such relationships increase in "roundness" with the distance from the observer's eye. In Figure 75 the outlined ellipse at the right (C) is "rounder" than ellipse B, which in turn is "rounder" than ellipse A, which is nearest the eye. In cylinders at still greater distance from the observer, as in cylinder 4, the difference in roundness of their two elliptical ends is less; that is, both of their ends appear more alike in proportion (short to long diameters).

In Figure 73 the stones of the bridge arch are seen to radiate from A, the center of the cylinder. This point is the center of the circle, and, as was demonstrated in the exercise recommended in Figure 64, it is not identical with that of its elliptical appearance. Thus in Figure 73 we note that point A, the center of the circle, is beyond the point where the long diameter of the ellipse (dotted line) intersects line CB, which is the diameter of the circle at the water level.

Now note in Figure 70 that the ellipse is tangent to the top and bottom lines of the cube at points that are not at the ends of its long diameter but at structural centers of the cube faces. We are thus once more reminded that *the long diameter of the ellipse is not a structural line at all but a line of appearance*. Its slant depends wholly upon the relation of the circle to the observer's eye.

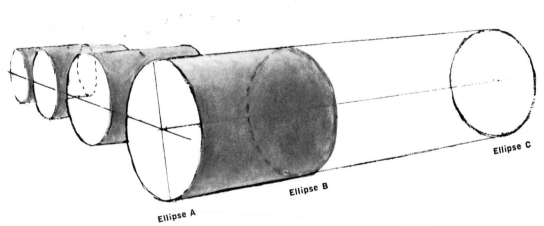

Ellipse A

Ellipse B

Ellipse C

Figure 75. Diagram to help visualize the perspective phenomena involved in drawing the arched bridge.

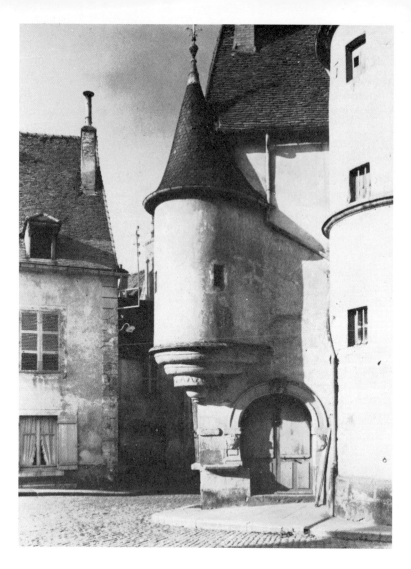

Figure 76. Medieval street corner, Arnay-Le-Duc, France. Chamberlain photo.

THE CONE

Conical objects present no problem to those who have acquired skill in drawing the circle in its various aspects. However, in drawings wherein the cone is related to the cylinder, on page 203, we see the importance of a structural approach. Observe how useful is reference to the cylinder in such situations as the grouping of the tumbler and large glass bottle (top, center), where, without the cylindrical enclosure, one might easily make the tumbler intersect instead of merely touch the bottle.

In the lower left we note how in constructing a saucepan we make use of two cones—one to form the pan itself, the other to serve as a guide in drawing the handle; the axis lines of the handles take their direction from the apex of a flat cone resting on the rim of the pan.

The drawing of intersecting cones (bottom, center) calls attention to the way each cone is tangent to the ellipse representing the cross section of its juncture with the other cone, the upper cone tangent to the ellipse on its near side, the bottom one tangent on the far side, at the ends of the dotted line.

OPPOSITE

Figure 77. Drawings from *How to Use Creative Perspective* by Ernest W. Watson (Reinhold Publishing Corporation).

202

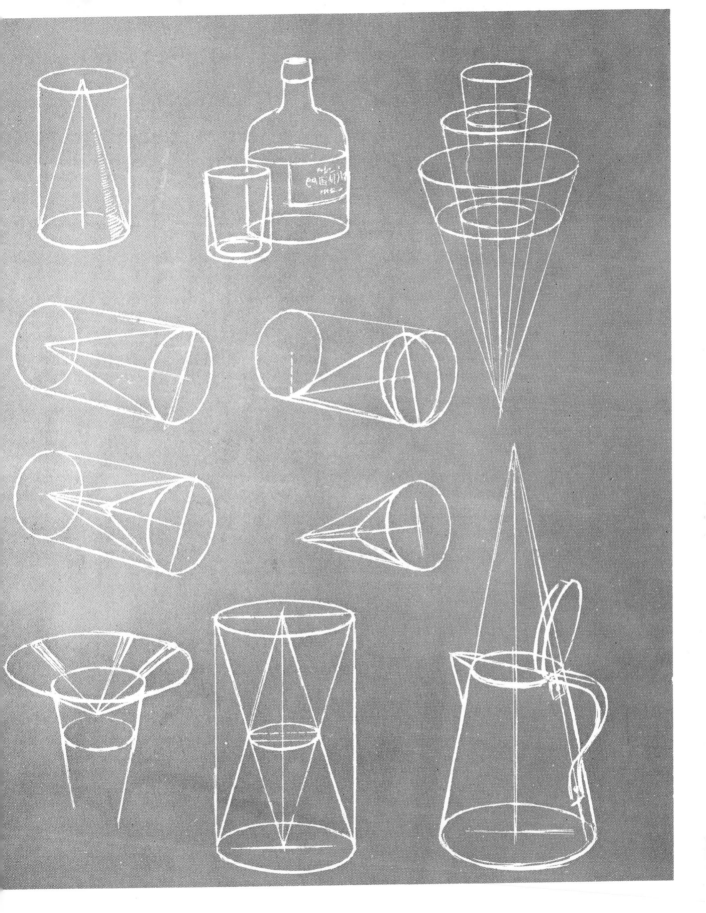

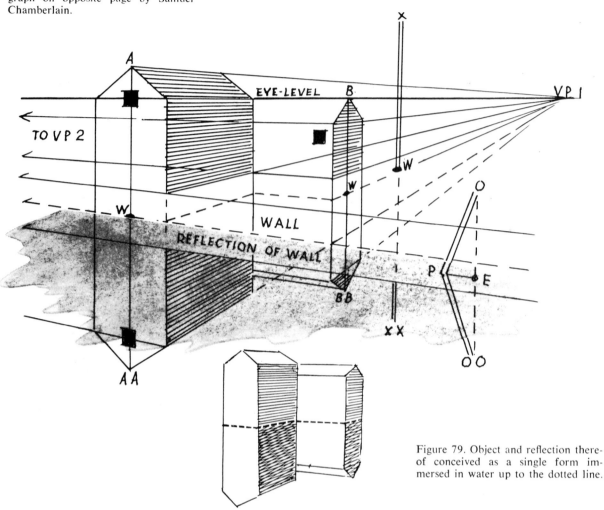

Figure 79. Object and reflection thereof conceived as a single form immersed in water up to the dotted line.

REFLECTIONS

All phenomena of reflections are explained by one statement: Every point of the reflection is the same distance below the reflecting surface—water or mirror—as the point of the object reflected is above it. In Figure 78 the line AA-W (where W is the surface of the water) is equal to the line AW, the vertical distance being reflected. The line BB-W reflects the line BW. The line XX-W reflects the line XW, W being the surface of the water projected back under the bank, which is the thickness of the retaining wall. It helps to visualize the reflection of the object and the object itself as a single form which has been immersed in the water to a point which coincides with the waterline (Figure 79). The lines of the reflection are seen to converge with those of the reflecting object.

Figure 80. →

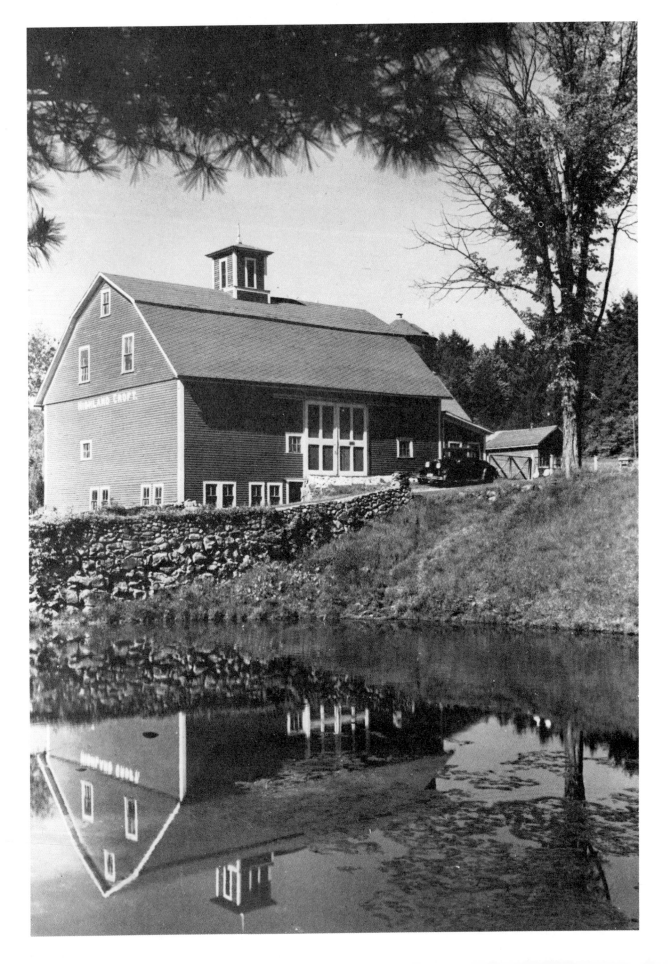

Figure 81. Temple of Ceres, Paestum, Italy. Chamberlain photo.

Figure 82.

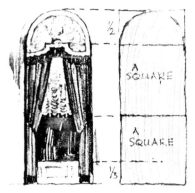

Figure 83.　　　Figure 84.

Figure 85.

Figure 86.　　　Figure 87.

Figures 82-88. These diagrams demonstrate the usefulness of the square as a unit of measure in establishing proportions. The system can, of course, be applied to objects of whatever kind, including such nongeometric forms as trees, animals, etc. How can the square be used to measure the Italian subject (Fig. 85)? The only square form to be seen is the entrance portico. This does not help much as it is only a detail. But if you have become "square conscious" you will discover that the right-hand line of the tower projected down through the building makes a square. (A, Fig. 87). This is a very helpful measurement. Now note that in Fig. 87 we have discovered a square (B), a partly enclosed space to the left of the tower. Moving your square over the tower itself should reveal another important measurement: the top of the central window conveniently cuts off a square (C, Fig. 86). The remaining part measures about ⅓ of a square high.

Figure 88.

Figure 89. Figure 90. Figure 91.

ANALYSIS AND MEASUREMENT

Analysis is the first step in the solution of all challenging problems. Analysis in perspective drawing relates any object to its simplest geometric basis and establishes the correct relationship of all its components, no matter how complicated the object may be. Analysis implies an orderly structural approach as contrasted with a hit-and-miss method.

Take a very elementary example—the drawing of the gable end of a simple house (Figure 89). What is our first problem? Is it not measurement? Given the form of the house in Figure 89, we certainly do not want to represent it as in Figure 90 or Figure 91. So, studying the house before us, we have to measure it, as we have to measure everything we propose to draw. We need not carry a ladder and tape measure with us on our sketching trips. In drawing the house we are not concerned with actual linear dimensions, such as the height of a wall and its width. But we are very much concerned with proportion. The aim of all our measurements is to determine proportion.

One way to take measurements is by sighting along a pencil held at arm's length before us, marking off with the thumb the vertical and horizontal dimensions as the pencil is turned to cover the lines of the object. Although not entirely useless, this method is far from reliable and is seldom employed by professional artists, who use a simpler and more accurate method.

Obtain a piece of transparent acetate (Figure 92) about 5 inches square and draw upon it, with ink, the outline of a 2-inch square through which you can view and measure your subjects.

The illustrations on the opposite page suggest how essential the square is as a unit of measure in establishing proportions of objects to be drawn.

Figure 92.

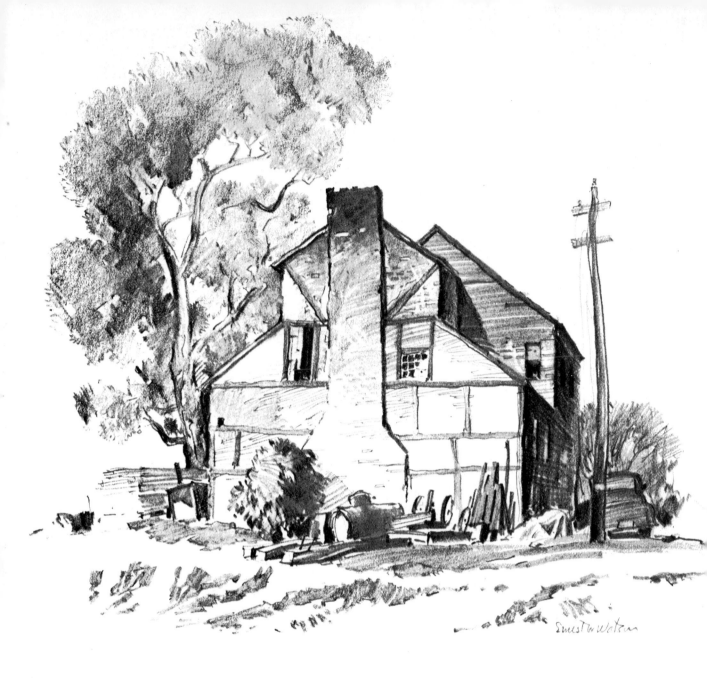

Figure 93. Old Mill at Lime Rock, Connecticut. Pencil sketch by the author from *Course in Pencil Sketching, Book 1* by Ernest W. Watson, (Reinhold Publishing Corporation).

Figure 94. The diagram illustrates how the author "measured" the proportions of the old mill. It will be seen that the entire end, including the chimney, is enclosed in a perfect square. Square A gives an important measurement for the top gable section. Squares B and C divide the rectangular area below the eaves line. Once the proportion of this end façade has been established the rest of the building falls readily into place.